D1217298

JOHN PIPER

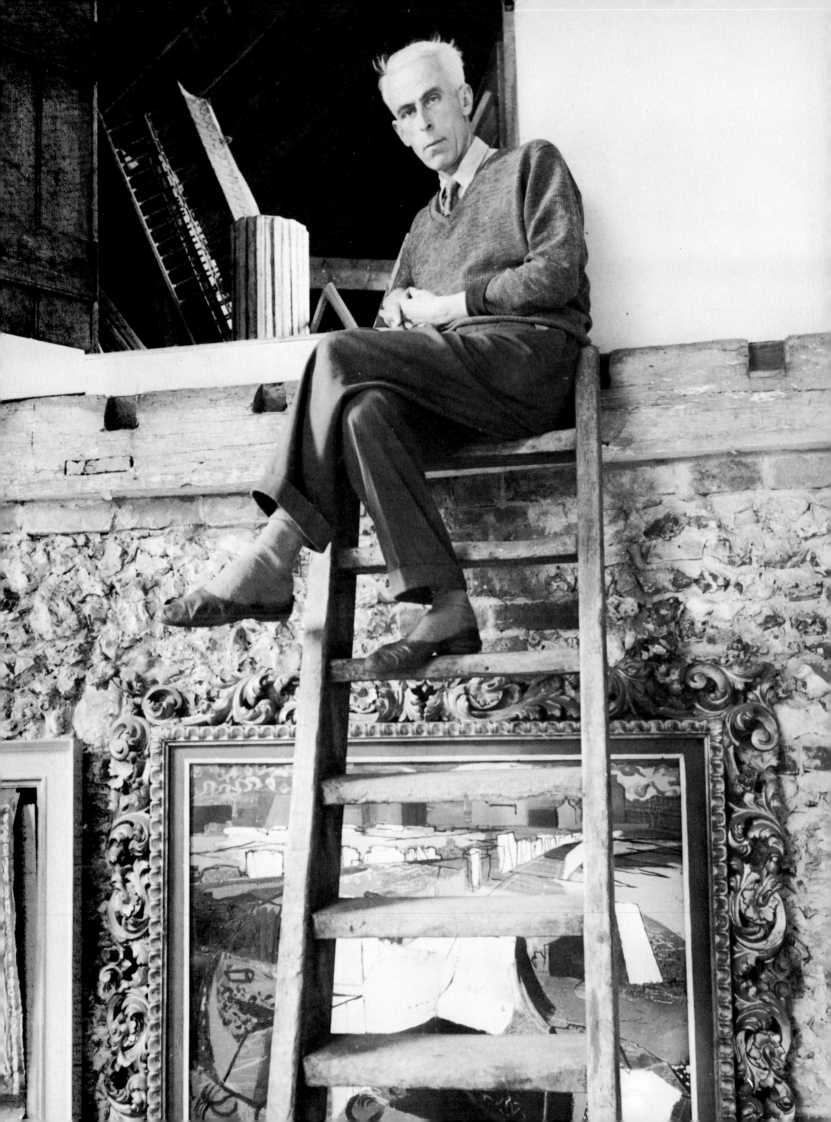

John Piper

MFA Object, cat. no. 141

THE TATE GALLERY

LIBRARY
MUSEUM OF
FINE ARTS
BOSTON, MA
02115

cover
Backcloth, Scene V (detail)
from *The Quest*, 1943 (Cat. no. 68)

frontispiece
John Piper, 1954, photograph by Ida Kar
by permission of Victor Musgrave

ISBN 0 905005 94 5
Published by order of the Trustees 1983
for the exhibition of 30 November 1983–22 January 1984
Copyright © 1983 The Tate Gallery
Published by the Tate Gallery Publications Department,
Millbank, London SW1P 4RG
Designed by Caroline Johnston
Printed in Great Britain by Westerham Press, Westerham, Kent

This exhibition is sponsored by Mobil

Contents

N6797
p56
A4
1983

Foreword

John Piper celebrates his eightieth birthday in December 1983, and this exhibition honours a great British artist, and one to whom the Tate Gallery owes an immense debt of gratitude. He served the Gallery as Trustee on three separate occasions, and his long term of office, though unlikely to be equalled, is easily explained. He is remembered for his enthusiasm, his open mindedness, his good sense, his natural modesty and his excellent taste.

These are all qualities that John Russell brings out so well in his introduction, and we are most grateful to Mr Russell for his readiness to find time in a very busy schedule to return to the past in such a vivid and illuminating way. But as Mr Russell says, everyone who has ever come into contact with John Piper has come away enriched, and he must be thought of with gratitude and affection by an enormous number of people.

We hope that the Tate Gallery exhibition will reflect the nature of his art, which is so special in its varied and wide-ranging character. To show paintings and drawings alone would not have been enough, so the exhibition is designed to take the visitor in a roughly chronological sequence through the many facets of the artist's career.

But how do you show to the public a man of so many parts? For Piper has been the maker of abstract paintings and reliefs, the designer of books, the photographer, the landscape painter, and watercolourist, the theatre designer, the stained glass artist, the print maker, the ceramicist. If the exhibition cannot be comprehensive, it must be selective, and we have accordingly tried to choose the best and thus draw together in the Tate's galleries the many interlinking strains of John Piper's art.

The artist has worked with us closely on the project since its inception, and we are deeply indebted to him, and of course to Myfanwy Piper for her help and advice. David Fraser Jenkins, Assistant Keeper in the Modern Collection, has made the selection and catalogued the exhibition, writing at length about the paintings and watercolours. We are grateful to Rigby Graham and Michael Northen for their essays on book illustration and stage design. Mr Northen, who has often worked with Piper in the theatre as designer and lighting expert, has remade some of the models and has designed the stained glass and theatre rooms, working with the Gallery's Exhibitions Department, who supervised the overall design.

Her Majesty Queen Elizabeth the Queen Mother, and Her Royal Highness Princess Margaret have graciously lent to the exhibition. We are most grateful to them and to all the lenders without whom such an exhibition would not be possible. The artist's dealers, Marlborough Fine Art, have readily answered all our inquiries. And once again we would like to sincerely thank Mobil for their sponsorship of the exhibition. As with the Graham Sutherland exhibition, it has been a pleasure collaborating with them.

Alan Bowness *Director*

Acknowledgments

Myfanwy and John Piper have been generous beyond measure with their time and patience, especially so as there were also other exhibitions to be prepared, and as they were often asked to recollect events of fifty years ago. Their outstanding hospitality has made working on this exhibition a particular pleasure. John Piper is the principal lender, and has worked closely with the Gallery on the selection and display.

I am grateful for help from Tony Reichardt, who made available the photographic record of Marlborough Fine Art, and located many works; from S. John Woods, who recalled 1930s exhibitions; from Richard Ingrams, who let me read the text of 'Piper's Places'; from Ian Tregarthen Jenkins and Conal Shields, who arranged the restoration of the tapestry cartoon at Camberwell and Gillian Roy and Ray Wright who carried out the restoration; from Francesca Franchi, at the Archive of the Royal Opera House; from Professor Moelwyn Merchant, who lent his correspondence with the artist; from Mary Coxon, who painted the *Quest* backcloth; from Paul Joyce who advised on the selection of photographs and printed them; and from Michael Northen, for remaking theatre models and helping with the selection of the stage and stained glass rooms, which he also designed.

The Gallery is grateful to the Trustees of the Paul Nash Estate and to the Librarian of the University of Victoria, British Columbia, for permission to reproduce material in copyright, and also to the Directors of Arthur Sanderson & Son Ltd for reprinting fabric for the exhibition.

I should further like to thank Peggy Angus, Douglas Billingsley, Ann Compton, Lucy Aldwinckle, Ron Costley, Richard Digby Day, Major L.M.E. Dent, John Evans, Janet Green, Bevis Hillier, John Hoole, Orde Levinson, John Lowe, Colin Mabberley, Jamie Muir, Colin Parris, Edward Piper, Angela Weight.

The lenders to the exhibition, and also many private collectors whose work was not selected, have been extremely helpful, both tolerating visits and providing necessary information, and I am most grateful to them all for their vital assistance.

David Fraser Jenkins

Introduction

John Russell

The subject of John Piper is not one as to which I shall feign to be objective. Not only have we been friends for more than forty years, but it was he as much as anyone who taught me to look, to read and to travel. How could I not be disposed in his favour?

We first met in one of the more lugubrious years in human history. In England in the early 1940s there was not much to look at, very little that was new to read, and no place to go to. The people whom I had known in peacetime had had a cosmopolitan orientation. Museums in France and Italy, bookstores in Paris and Geneva and Milan, a quick dash to Victoria Station to catch the Channel packet – that was the kind of thing they dreamed about, with three weeks in a not-yet-too-crowded Salzburg to look forward to in the summer. I caught the contagion.

But in 1942 and 1943 there was nothing of that. All day we worked as hard as we could at something to do with the war, but in the evenings we floundered, undeniably. We needed a whole new set of challenges, but where were they? It was at that low point in human affairs that John Piper read something of mine and sent me what remains to this day the single most generous and encouraging letter that I have ever received.

Our acquaintance burgeoned. I asked him to make a watercolour of the house in which I was lodging at the time, and forthwith he made it (at an agreed price of seven pounds ten shillings). We visited back and forth, lunched at the Charing Cross Hotel in London, corresponded. From all this, from his *Brighton Aquatints* (1939), from his book on English Romantic Artists (1942), and from nosing around in his studio, I learned an enormous amount. (Myfanwy Piper helped too, by the way. Like all their other friends, I soon had great difficulty in thinking of the one without the other.)

What did I learn, precisely? Well, I learned to take things as they came, and without prior prejudice. This applied as much to buildings as to books, and to paintings as to people. What I read, what I looked at, what I made awkward wartime journeys to see – all these I owed to John Piper. I also learned a great deal from his disdain for the accepted hierarchies of experience. He did not see any one period or any one activity as necessarily more rewarding than any other. He was as interested in the 1930s semi-detached villas on the Bath Road, not far out of London, as he was in the nave window in the church at Grateley, in Hampshire, that had once been in Salisbury Cathedral. A little station dated 1898 on the Lambourn Valley line was as rewarding to him as St Pancras itself. Buoys, pierhead lighthouses, harbour marks, painted farm carts, watercress beds beside clear chalk streams – all mattered to him just as much as the great standard sights that he was asked to draw and paint in 1940 for the 'Recording Britain' scheme. There was no such thing, in his eyes, as a place that was dull

beyond redemption or a period in English history that had had nothing to give.

Everyone knows that now, more or less, and those who don't can always look it up. Even in the state of Connecticut, where I now live, there is at a 45-minutes' distance a centre for the study of British art, British topographical and illustrated books, and British things in general that has few rivals. But in 1942 it was each man for himself in this matter. English art was condescended to. English vernacular architecture was the concern of five or six people. English monumental sculpture, likewise. English eighteenth-century churches were regarded as indecent. The Victorian age was an embarrassment to almost everyone. As for the idea of an unprejudiced and panoramic survey of every building of interest that had ever been built in Britain, Nikolaus Pevsner was the only person who thought it both possible and desirable. Nor did it seem likely that anyone would sponsor so huge an enterprise.

John Piper could not right all these wrongs single-handedly, but in collusion with John Betjeman, J.M. Richards and other friends he set about opening a door here, a window there, and a locked gate somewhere else. He worked at Windsor Castle, and at many another great English house, but he also worked with derelict cottages, with Welsh Nonconformist chapels and with High Streets and Market Squares all over England and Wales. (Scotland never seems to have said much to him, by the way.)

He had his favourite places, but fundamentally he would go anywhere, from Romney Marsh to Middlesbrough and from Norwich to Snowdonia. He would read anything, old or new, and talk to anyone. He especially liked talking to country clergymen, but he did not at all mind the nouveau riche landowners, let alone the faintly scandalous old freaks whom not everyone wanted to be seen with. (His *Brighton Aquatints* had a foreword by Lord Alfred Douglas.) He very much liked reading living poets like R.S. Thomas who had something to say about his fields of interest, and he was very patient with minor poets from the past who just might have something important to say about this place or that. Though as attentive as anyone else to Wordsworth's *Guide to the Lakes*, he also collected the almost anonymous local guidebooks for which the secondhand booksellers of the day had very little regard.

He was a student of colour in all its manifestations – colour as signal, colour as definition, colour as defiance. He liked colour plain and strong, and he also liked the the non-colour of rocks and stones, and the way in which that non-colour was sometimes adjusted by lichen. And then again he liked printed matter of all kinds. If anything, he preferred a small town printer's repertory of typeface and ornament to the august confections of the private presses in which it had been hazarded a decade or so before that 'every book should weigh a pound and cost a pound'.

He was an aesthete, in all these matters, but he was also a moralist. Visiting Norwich in 1943, he noted – in terms that few others would have used at that time – 'the extraordinary efflorescence of heavy Baroque that seems to have become fashionable in Norwich around 1906, and blossoms at its fullest in Telephone House, St Giles'. But he also noted that the two most memorable views of the city were to be had from 'a bridge over the river Wensum near St Martin's-at-Palace (where Cotman's house, over-large for an unprosperous artist, still stands)'.

Of one of these views he said that 'the Wensum curves away towards the east and south, still with built-up banks, beginning to half-circle the city towards Thorpe station. The view includes a palatial building of dark East Anglian bricks that now houses Messrs Jarrold's printing works. A fading inscription on it, in raised Egyptian letters, reads "Norwich Yarn Company, 1809". This was part of a grandiose scheme of factory lay-out that was never completed, with balancing blocks on each side of the river, and other blocks westwards of them ... The dome with its white-painted cupola, the rows of tall windows, the flat pilasters and stucco dressings, all speak of an architecture adapting itself to commercial uses that properly belonged to the usages of the country house. It has more comments to make, this building, on the vanity of commercial aspiration and on the changing life of the city, than all the rather slender remains of medieval houses with their "wealth of old beams" and their "period flavour", in which Norwich abounds'.

John Piper could have seen all these things, and arrived at those measured conclusions, and still been a discerning outsider – someone who cared about England, and wanted to get the right ideas about it into the open, but whose professional concerns lay elsewhere. In this he could have been like his father, who had built up a good business as a solicitor in the City of Westminster. His father loved nothing more than to explore England, inch by inch, taking notes, making lists, and carefully copying other people's watercolours. He also liked to take his son with him, just as he liked to take time off from his office in Westminster and show him the Turners in the Tate Gallery. John Piper was after all a promising lad, who had been tracing stained glass in Surrey churches since he was ten, and had not long after become secretary to the County Archaeological Society.

If John Piper's involvement with art came to be on an altogether different level of intensity, some of the credit must go to D.H. Lawrence. Piper was seventeen when *Women in Love* was first published, and twenty-seven when Lawrence died. His was the generation that read every word of Lawrence as and when it came out. 'When I read his attack on John Galsworthy', he once said, 'I thought to myself "That's IT! He's killed that sort of work for ever". Lawrence gave you a new way of life. You didn't talk about art any more. You behaved it'.

Quite apart from that, the work of Lawrence is a school of exact seeing. As much as Gilbert White, but with an added emotional drive, Lawrence got the look of England right once and for all. He wrote as all good writers write – as if no one would ever again see what he was writing about – and he prompted others to do the same. I doubt for instance that John Piper would have written as he did about Romney Marsh if he had not read Lawrence. 'In winter', he said, 'the reeds still blow in the dykes, showing a pale yellow flank of close stalks with feathered crowns of grey or purple-black fronds, and there are pea-stacks, built on a tripod of sticks for aeration, as well as the many dyke-side potato and swede clamps. The fences are mostly made of three long split oak or elm rails joining stout posts, the whole low and sturdy, and they grow an emerald lichen that at first seems to dust, and finally screens the pale-grey wood ... They look excellent against the blackthorn hedges in winter when these are dark purple-brown, and against the oranges and reds of massed willow branches...'

So much for exactitude. (That passage dates from 1950, by the way.) Piper at

such times ranks high among writers of English prose, and is the equal beyond question of any of those whom he had sought out in dusty places and brought home for scrutiny. As a seeing man, he has all his credentials. But he wanted to be a *doing* man, as well as a seeing man, and he didn't mind starting late. He also had a much wider experience, both of seeing and of doing, than could be inferred from what I have said so far.

Piper by 1942 was in fact a veteran both of the journeyman practice of tracing, rubbing and motif-hunting and of the international movement, in so far as the modern movement had crossed the Channel. He had always been interested to make his own guide books – Anthony West in his book on John Piper dates the beginnings of the habit to Piper's twelfth year – and initially they were modelled upon published guide books of a painstaking but old-fashioned sort. But by 1938, when his *Shell Guide to Oxfordshire* came out, he had a breadth of reference that was something quite new in English books of the kind.

Writing about Rousham, for instance, he remarked on the way in which Horace Walpole 'had complimented the architect Kent on his alterations to the Rousham mansion. He liked the nice nonsense of Kent's new wings, and stables, and the temples and gates and sculptured wrestlers, and the sham castle over a mile away on a hill that makes a living Claude'. But he also remarked of some of the coats of arms on stained glass panels in the local church that 'they might have been painted by Fernand Léger, the cubist: gay and angular'. (To this day, that entry stands up well against even the majestic inventorising of Nikolaus Pevsner in his *Oxfordshire* (1974).)

The point of the reference to Léger is that by 1938 John Piper had been for five years and more in the very centre of the modern movement in England. It was European painting, as much as or more than English painting, that had fired his imagination. Already in his teens he had 'shaken with excitement' (by his own recollection) when he first saw a painting by Monet of Rouen Cathedral. When he saw Miró's historic exhibition at the Galeries des Cahiers d'Art in May 1934 he said to himself (again, by his recollection) 'That's painting: you can throw the rest away'. As far as was possible in those days, he also kept abreast of everything that Picasso was doing. When still in his middle twenties, he had met Braque, and while under his spell in 1929 he painted the big box – ornamented motifs taken from music and from architecture – that still stands at the top of the staircase in his house.

Piper has always had exceptional powers of assimilation. Not only can he see the point of almost anything that is good of its kind, but he has an understated comic sense that comes out strongly in his collages of the early 1930s and is no less evident in other areas of life. On one of my earliest visits to Fawley Bottom I was astonished by both the glee and the dexterity with which he was able to sit down at the piano and parody the textures of Brahms's string sextets. As for the conversational style of our more notorious bores and stuffed shirts, it could hardly be sent up more deftly than by John Piper.

This trait has not always worked to his advantage in the art world, where artists, curators, dealers, collectors and critics all incline to set a high valuation upon themselves. Piper also differs from many of his colleagues in that he is a born collaborator, and one who instinctively treats every other party to the

activity in question as an equal, even if they do no more than sweep the floors or bring the tea. Other things being equal, he would as soon work with other people as not.

My own opinion – one for which I have no warrant – is that this disposition goes back to the evenings that he had spent at Diaghilev's Ballets Russes. Ballet today is so much an integral part of big-city life that very few people can imagine the impact of Diaghilev at that time, any more than they can imagine the impact of stage-pictures that were unlike any that had ever been seen in an English theatre. And all this from a collaboration of equals! How can we be surprised that John Piper should have jumped at the chance of working with the Group Theatre on Stephen Spender's *Trial of a Judge* in 1938, and with Edith Sitwell, William Walton and Constant Lambert (a past master of declamation) on *Façade* in 1942, with Benjamin Britten from 1946 until 1973, and with much-missed John Cranko for the too few years during which they were acquainted.

I even think, though once again I have no warrant for saying so, that many of John Piper's collages and abstract paintings have that particular tension that belongs to the kind of perfectly conceived and very well executed 'flat' that seizes the attention of a full house in the theatre and leaves us in no doubt that something extraordinary is about to occur. There is a sharpness about the edges of the forms in those abstract paintings, and a debonair readiness to take risks about some of the collages, that belong to the theatre. And in case that may sound like a put-down, I must add that I think of the theatre as a school of attention, in which audience and performers are equally matched.

In particular there is a construction made in 1934 of oil on canvas with rods and zinc mesh that works as an icon of energy strung up to a high pitch of tension and offset by huge slow-moving circles. Those circles are either cut off in mid-career or can be presumed to complete themselves in an imaged Elsewhere. And from 1936 there is a painting called 'Forms on Dark Blue' that is made of flat planes that overlap in the thinnest imaginable third dimension.

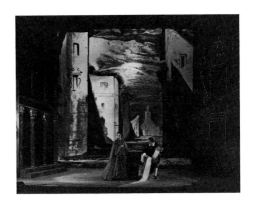

Don Giovanni, 1951

Somewhere in those early works there is the essence of the flat, head-on frontal presentation that worked so well in the theatre. Who that saw them will forget the starlit Scene v in *The Quest* in 1943, the enfiladed opening scene of *Don Giovanni* in 1951, and the tall thin Venetian house-ends that butt into our field of vision in the designs for *Death in Venice?*

When people say that something is 'theatrical', they often mean that it is stagey – heightened for effect, and with no moral or emotional thrust behind it. John Piper's work has often been theatrical in the other, truer, more challenging sense. It is a matter in other words of timing and placement, lighting and concentration, ellipsis and the subliminal hint. When he turned almost overnight from the painter whom nobody knew to the painter whom everybody knew, it was with paintings that were in that sense theatrical. 'Autumn at Stourhead' of 1939 could go straight ahead into the theatre, for instance. It would put the actors very much on their mettle, and it would put the audience on their mettle, too.

The theatre – the traditional theatre, at any rate – needs a drop curtain, as well as a back-cloth. The function of the drop curtain is to be part cliff face, part portcullis. We cannot see through it – in fact it is there to keep us out – but it tells us that something important is going to happen. Piper in that sense has

always been a front cloth man – someone who likes to take a big architectural subject head-on. Sneaking up from the side is not his way. This also applies to his architectural photographs, where the big frontal cliff-like image pre-dominates. Those are images meant for climbing up, as distinct from images meant for walking through.

Piper in wartime was very much a man of mass, whether the mass in question was a stone wall in Anglesey or the huge blocklike façade of Seaton Delaval. He was also a man of duty, in that thanks to Kenneth Clark he worked as a war artist on a wide range of subjects, some of them innately dear to him, some of them not. Once or twice the results had a look of the modern movement that he had otherwise put aside. In painting an underground passage at S.W. Regional Headquarters, Bristol, in 1940 he made intelligent play with the monumental numbers and imperious directions that keep the visitor straight in such places. Sometimes, on the other hand, he worked strictly as a recorder, as when he was sent to Cardiff to detail the look of the American locomotives that had just arrived there in 1944.

John Piper at that time looked exactly as he does now. He was tall, trim, spare and erect, with the features of an accessible Montezuma and the gait of one limbering up for the hop, step and jump. His journeys were not all for pleasure, by any means, but they suited what many years later he called 'the basic and unexplainable thing about my painting – a feeling for places. Not for "travel", but just for going somewhere, anywhere, really – and trying to see what hasn't been seen before. When I was ten, and read Hilaire Belloc's *Stane Street*, about the road from Epsom to Chichester, I was already trying to draw trees to go with it. Later, when I tried to write a novel, it was full of people going to places in the upper Thames Valley and descriptions of sunsets and thunderstorms...'

'I tried', he went on, 'to like architecture and landscape in the way that Cotman liked them. His "Greta Bridge" in the British Museum is a beautiful idea, with the big single arch and all the rocks in the stream and the feeling for salmon fishing and the light you sometimes get in England that flattens buildings and trees into silhouetty, Art Nouveau patterns.'

Wartime did of course give a particular load of intensity to subjects, and to ambitions, such as these. In anthologies like Geoffrey Grigson's *The Romantics* of 1942 (dedicated by the way to John Piper) and *English, Scottish and Welsh Landscape*, chosen by John Betjeman and Geoffrey Taylor, with illustrations by Piper, readers of the day found an enduring comfort. Here were books, that is to say, in which our country was quintessentialised by people who had known how to look at it. It was the particularity of the vision that pleased, in these anthologies; and that same particularity recurred when Piper took his sketch-books up into the Welsh mountains and began to look at rock after rock, individually, and noted 'the *milles feuilles* action of the ice and frost. Some done up like portmanteaux with incised lines in place of the straps; large areas of quartz veining and speckling. Tumbled and angled in all directions, some very long coffin-shaped ones ...'.

This was the kind of steadiness of vision that he brought to sights almost without precedent since the Great Fire of London – the look for instance of Christ Church, Newgate Street, after it had been destroyed by bombing. Who could have foreseen that in the shattered and roofless nave three columns should

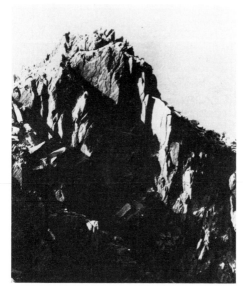

Summit of Tryfan

stand in isolation, the way they do in the great temple at Karnak? In painting scenes such as this, Piper acted as the messenger acts in classic drama, in that he brought the news that people both wanted and dreaded to hear.

Haunted as he still was by the reunion of the arts that had found its momentary apotheosis under Diaghilev, it seemed only natural that when the war was over John Piper should alternate between summers in Snowdonia and the search for the collaborative ideal. Veterans of the period will remember a time in which John Piper seemed to be the pre-destined partner of everyone who was out to do something new in the theatre, in the opera house, in ballet, in book illustration, and in printmaking. What was the first great achievement of the post-war theatre in England, if not the Old Vic production of *Oedipus Rex*, in which Piper's classical city stood up even to the outsized playing of Laurence Olivier and Sybil Thorndike? Who that was there will forget the stage picture when the curtain went up on Britten's *The Rape of Lucretia* at a re-animated Glyndebourne in 1946? Or the atmospheric detail, so nicely observed and so lightly touched in, with which he abetted the comedy of *Albert Herring* a year later? Illustrating the last chapter of Thomas Browne's *Urne Buriall*, preparing new guidebooks in partnership with John Betjeman, designing for ballet at Covent Garden and opera at Sadler's Wells, he seemed to be everywhere in the late 1940s. His would in fact have been a dangerous ubiquity, were it not that in 1947 something quite special happened to him.

Chateau de Chambord

This was that he went abroad for the first time since 1939. He had of course been abroad before, but he had never treated France or Italy as raw material, in the way that he had treated England and Wales. He had gone with his mind on the modern movement – as secretary of the Seven and Five Group from 1933 to 1938, as co-worker with Myfanwy Evans from 1934 onwards on the magazine *AXIS*, and as a young painter for whom new art was the art that mattered. Now, in 1947, he went abroad with Osbert Sitwell, primarily to see the Sitwell family house near Florence.

'Osbert was the most generous person I've ever known', he said later. 'He could give all of himself, emotionally, to all that he knew. He was never too tired or too ill to go another ten miles out of the way to look at another church in Italy, and he was sophisticated in the only right way. By that I mean that he had a genuine understanding of art, allied to a kind of worldliness that was neither scatter-brained nor unpleasant. He had a selflessness that strangers never credited him with.'

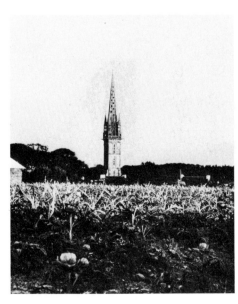

Brittany church and spire

Then and since, Piper has often worked in France, and in Italy. To both countries he brings the kind of unprejudiced curiosity and sharp judgment that have always served him well in England and Wales. He reacts as strongly as everyone else to the great monuments – the cathedrals, the country houses that come on like palaces, and the remote country churches that so well repay the journey – but he is amused by featureless landscapes, like the country round Arras in northern France, or much of the Morbihan. Kingsized photographs indicate where he has found subjects that combine imposing mass with a frenzy of calligraphic detail. Where he has looked at something from the past that bears upon his own immediate preoccupations he is as lucid as ever in his judgments. In Strasbourg Cathedral, for instance, he will say that 'the Charlemagne window is unique in its odd, squarish components and the similarity in size, shape and

tone of the *pieces* of glass that add up to a composition resembling an early Mondrian in abstract feeling'.

Here he is on the glass in Chartres, as opposed to the glass in Bourges: 'The glass in Chartres is very different from the glass in Bourges, which is so much more mauve and pinkish-purple in effect, so much more feminine, more suitable to the feminine, flying-buttressed, crinolined architecture of the east end'.

Those are the words of a true professional, and Piper has of course been active in the domain of stained glass ever since 1954, when he found in Patrick Reyntiens the man who could help him to carry out his intentions. It may well in fact be in his stained glass windows that his work has gained a universal currency. Paintings and drawings and prints gets scattered. Books go out of print. Theatrical productions, no matter how compelling, come to an end, and their components are lost or destroyed. Tapestries may get taken down and rolled up. Windows are for ever, by comparison, and John Piper has opportunities as challenging as any artist could wish.

The huge baptistery window in Coventry Cathedral sets the tone for the whole building, for instance, just as it sets the tone of life for those who are baptised beneath it. Like the even larger commission for Liverpool Cathedral, it is an abstract window – one that depends on colour and scale alone. But he has also carried out commissions that turn upon close attention to subject matter. For the windows at Oundle, which were the first thing of the kind that he did, he relied wholly upon the standing figure. In Eton College chapel, he devised classic antitheses like that which separates the Light Hidden Under a Bushel from the Light That Shines Forth.

For St Andrew's, Plymouth, he began with a memorial window on the theme of the Instruments of the Passion. This was so well liked that he was asked to do three more. Once again, particularity was the secret, for he had taken immense pains not merely with the general scene but with every least detail – the dice, the spice-boxes and the vernicle, to name three only.

Piper's is a brisk, enquiring nature; in his windows he is no more to be put off with the second-hand than with the second-rate. When one of his supplementary windows in Plymouth demanded a musical theme he was not satisfied until he had found the exact look of the Minoan harp, which is the oldest musical instrument known to man. Nor is he the kind of artist whose inspiration takes no account of practical realities: working to a tight budget in the re-built church of St Andrew's, Wolverhampton, he invented a subject, the Sargasso Sea, which made a great effect with an absolute minimum of expense: a deep blue ocean, in short, with just enough fish to keep our imaginations active. He is always ready, also, to give new materials a try: for the blitzed church of All Saints in Clifton, a suburb of Bristol, he prepared a window made of fibreglass. As was the case with his old friend and ally Benjamin Britten, Piper enjoys a commission and responds very well to exact and unusual requirements. In the church of St Margaret's, Westminster there is one of the finest stained glass windows of its date (early sixteenth century) in England. When Piper was asked to design new windows for the nave there could be no question of employing his habitually forthright idiom.

It was for his windows to defer to the masterpiece of the past, rather than to rival it. Imagery of a recognisable kind would clash, beyond a doubt, with the

complicated iconography of the earlier window. So would strong colour. A distinguished pallor had never before been the mark of John Piper's work, though sometimes in oil paintings and watercolours of Venice something of the bone-white quality of Istrian stone long mated with salt breezes off the sea had entered into the final result. But in St Margaret's his windows are wonderfully discreet, and we leave the church wondering if any other solution could possibly have looked so right.

Others are better placed than I to go into the detail of John Piper's long career. Much that he has lately done I have not even seen. To be away for ten years is, after all, to risk missing what for another artist might be an entire career. In domain after domain, John Piper has been a late starter, only to make his mark in no time at all. Possibly this is a reflection of the fact that he is one of the rare human beings who are at home and at ease in all societies. It never occurs to him to treat one human being differently from any other human being. Likewise in his work he took as much trouble with pre-war prints that were virtually given away as he did with commissions that made him for the time being the keeper of the national conscience. It is not in his nature to show off. But now that we are faced with this implausible birthday of his I have to say that the best metaphor for his career is not the hop, step and jump that I mentioned earlier but the decathlon – and a decathlon in which chance has played a part.

For what can there be in common, at first sight, between the stained glass windows that will contribute almost in perpetuity to the education of English schoolboys and the boisterous and insubordinate ceramics? Or between the tapestries that were unrolled in triumph in the market square of the village in France where they were made and the gouaches in which he has been taking new risks for decade after decade?

But something does bind them all together – that they are part of the continuing autobiography of one of the most remarkable men that we shall be privileged to know.

left portrait drawing by Ceri Richards, 1933
right portrait drawing by Peggy Angus, 1938

 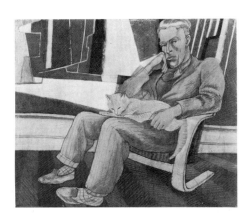

Book Illustrations

Rigby Graham

In an article 'The Lithographs by Eric Ravilious of Shop Fronts' in *Signature*, March 1937, Piper described Ravilious as being 'a particularly English artist' and '... English in the most important way; in this matter of control over line – line that can express fluently movement or stillness, and grace as well as volume'. In writing this, he saw, in the work of Ravilious, qualities which were even more pronounced than in his own. Quick though we are to recognise our own faults in others, we are even quicker to respond to our strengths in them, and this is certainly what Piper was doing, here, as in his writing on many other occasions. Emphasis on the linear is a characteristic which Piper readily recognises, and to which he has always responded.

In spite of his paintings, drawings, aquatints and lithographs of French chateau and church, Venetian palace, or campanile, Piper is essentially an English artist: English in vision, English in subject matter, English in treatment. His work as an illustrator of books and as a decorator of texts, is an extension and a reflection of his work as a painter. These things have long run parallel, influencing, developing and changing together.

Looking back through the history of English painting, back through the English Renaissance to mediaeval times, you find that you are looking at English book illustration and English illumination. Comparatively few mediaeval paintings have survived in any state of completeness or preservation. Fabrics have rotted, stained glass has been destroyed or broken, wooden panels have warped and split, or have been attacked by worm or beetle, plaster has flaked as it has deteriorated through damp. But manuscripts and incunabula, having spent the greater part of their lives shut in bookcases, have preserved an enormous amount of illustration, historiation and illumination, and therefore most of these remain as bright today as when they were drawn and painted.

Again, in mediaeval England, as elsewhere, the rich and colourful painting on the walls of buildings, inside and out, of sculpture, of stained glass, banners and books, meant that ideas and imagery were transferred easily and readily from one craft to another. Embroiderers, tapestry weavers, wood carvers, stuccadores, and smiths were equally susceptible to influence one from another; and though such influence was transumed, or transmuted, through the demands of different techniques and media, the strong linear definition of symbol and imagery remained common to all, immediately recognisable and almost universally understood.

Piper not only knew and understood this, but his early interest in mediaeval England, and then in the English Renaissance, and eventually in the many subsequent revivals, restorations and rehashes, was reflected in much of his work. The work itself revealed the easy transportation of idea and technique. His own drawing, recording, photography, design for murals, tapestries, stained

glass, stage settings and costumes, demonstrate this. His work in book illustration shows it too, just as extensively. It reflects his own development of, and interest in, lithography; collage; montage; photography; work with wax resist, or washout; sgraffito and engraving; etching and aquatint; and shows something of the outside developments in trade and commercial practice, which are taking place in the printing, graphic, photographic and publishing industries in recent times.

The general drift of all this is evident enough in Piper's work, and particularly in the many examples of his book illustration. Perhaps if J.M. Richards' *The Castles on the Ground*, Architectural Press 1946, is examined carefully, it will be seen to demonstrate something of Piper's particular approach, which is characteristic, not only of him, but of the way in which, through his work and interests, he has shown us how to look, and what to look for. It is an aspect of book illustration which belongs to this time. Although there are traditions and precedents – Bewick's work, though very different, springs immediately to mind, – much of Piper's work is, in approach, in subject and in treatment, a reflection of a sympathetic, perceptive, and understanding observer. In this volume Piper illustrated English suburban villas with eight full page two-colour autolithographs, which he worked on at the Baynard Press in London. The book also had a dustwrapper by Piper, which was a three-colour lithograph. The illustrations consist of a key-working in black using pen, brush and lithographic chalk. This is direct, clearly representational and would be read by those who live in their castles on the ground, 'whose popular taste is exemplified in the suburbs ...', people 'who know what ordinary people really like ... as distinct from what more sophisticated people feel they ought to like'. The second colour, the background colour, is a dark grey-umber and has, for the most part, been brushed-in in large areas, with the result that the unprinted parts of the image stand out as bright accents, or flashes of white. This changes the appearance of the black plate, and has the effect of heightening the drama and elevating the image, so that it is no longer, in the words of the dustwrapper of the book, '... what ordinary people like ...', but would be something, which, with further familiarity, many would come to appreciate.

When, in 1973, the book was republished by John Murray, many things had changed. Slightly larger in format than previously, it was still called *The Castles on the Ground*, but with a sub-title, 'The Anatomy of Suburbia', taken from chapter three. It had a new introduction, re-setting 'what might then have struck the reader as a period piece' in the later changed context. In the meantime, the whole pattern of printing and publishing too had changed, costs had risen in a way which precluded a reprint in anything like its original form, even had that been considered appropriate or desirable. The volume was now printed lithographically by William Clowes and Son Ltd, and the design and layout of the whole was much more in keeping with the times. There were still eight illustrations, printed offset, but they were now photographically screened reproductions, backed to form an eight page section as two insets. They were still reproduced line and tone, although they were printed in a single colour black, and the illustrations were in a lighter key than in the previous edition. They were not so heavy, much more appropriate to the mechanical method of reproduction, yet acceptable for all that. The volume was a commercial produc-

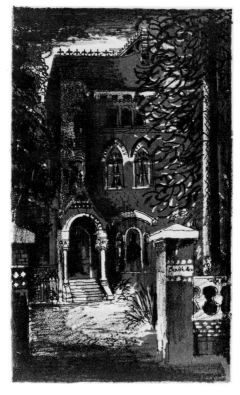

The Castles on the Ground, J.M. Richards. The Architectural Press, 1946, frontispiece

The Anatomy of Suburbia, The Castles on the Ground, J.M. Richards. Second edition, John Murray, 1973, opp. p.9

tion, the autographic contribution of the artist and lithographic printer were no longer there.

Many of the subjects had been changed. Four of the subjects from the earlier volume were now omitted, as the landscape format of those had meant that the volume had had to be turned. One of the four had been re-drawn in vertical format to become a new illustration, and used again as part of the dustwrapper design. The other three of the original subjects had been completely re-drawn, and four new illustrations added. These reflected some of the rather more lavish life style of the suburbs than would have existed in the 1940s. Cars appear on the roads, the front of a large and expensive motor launch protrudes into the street from a front garden, newer houses are built without chimney pots or stacks. The dustwrapper design by Mon Mohan incorporates two large Piper illustrations, but the whole concept and feel of the book is a much more commercial production, in a substantial edition offered at £1.95, and soon to be remaindered at a quarter of that price. The pattern of book production had changed and Piper's illustration had, appropriately, changed accordingly. In discussion with Stephen Spender, an account of which was published in *Encounter* no.116, May 1963, Piper described his view of topography as '.. a branch of Romantic art, and it is also a branch of particularisation. For Romantic art consists of seeing the wing of a bird – a tower – a hopfield – and interpreting all nature through the particular. Topography at its best is the interpretation of the world as the vision of the place. The best topographical paintings have the spirit of the place in time, not just the representation of the place, as Cotman expresses the atmosphere of places in Norfolk in the nineteenth century. Giorgione's *La Tempesta* is the epitome of every virtue topographical art should have.' He was stating something of the argument he had put forward in his introduction to his *British Romantic Artists*, Collins 1942. Not only is much of Piper's own work topographical but so, too, is his book illustration. He has produced topographical illustrations for some of the Shell Guides, for his own *Brighton Aquatints*, Gerald Duckworth 1939, one of his most deservedly famous productions, as well as for John Betjeman's *Collins' Guide to Parish Churches* Collins 1958, Gilbert White's *The Natural History of Selborne*, Folio Society 1962, Henry Thorold's *Lincolnshire Churches*, Lincolnshire Old Churches Trust 1976, and Ronald Blythe's *Places – An Anthology of Britain*, Oxford University Press 1981. In fact, a considerable amount of his topographical work has been used for, or adapted to, illustration in books, guides, and in magazines: *The Architectural Review, The Ambassador, The Cornhill Magazine, International Textiles, Time and Tide*, and *House and Garden*, for example. Piper has used his illustrative drawings directly in his *Romney Marsh*, Penguin Books 1950, and has re-drawn and transmuted others into lithographical separations for John Betjeman and Geoffrey Taylor's *English, Scottish and Welsh Landscapes*, Frederick Muller Ltd, 1944, where Piper has produced lithographs of Pistyll Cain, Weathercote Cave, Tomen-y-Mur and Roman Amphitheatre, Grongar Hill, Lewknor, Trawsfynnydd, Rievaulx Abbey, Stonesfield, Park Place, Easegill and Gordale Scar. There are subjects which he has drawn, photographed and painted on many occasions, in some instances over long periods of time, and some of the ideas and variations upon these topographical motifs occur in different contexts and situations.

Regency Square from the West Pier
from *Brighton Aquatints*, 1939

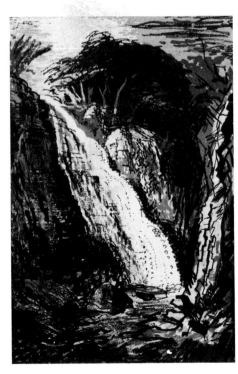

Pistyll Cain
from *English, Scottish and Welsh Landscapes*, 1944

Piper grew up to enjoy English topography, the result of the location, the wind and the weather, and the effect which man has had on our landscape. In his art, in painting, in writing and in illustration, Piper has shown us how our environment reflects so much of our culture: buildings, gardens, landscape, agricultural patterns; man in his life and his work, and his memorials, whether that is his verse, his monument or his mausoleum.

Piper, like so many romantic artists before him, has revelled in the dramatic contrasts of darkening skies with buildings or parts of landscape standing out against them. This has almost become a characteristic by which we recognise his illustrative work, just as readily as we do his paintings. It happens too, and just as markedly, in the Shell Guides, where he has used many of his own photographs as illustrations. The Shell Guides started in the years before World War II and at that time were edited by Christopher Hobhouse, Lord Clanmore, Robert Byron and John Betjeman, who was also the general editor of the series. Paul Nash compiled and wrote the *Dorset* in 1935. Nash included reproductions of four of his own watercolours, twelve of his photographs and one photograph of the Saxon font at Toller Fratrum by John Piper. Three years later, in 1938, Piper produced *Oxfordshire*. This was later reprinted in a new and updated edition in 1953, by which time not only the text was by Piper, but sixty-five of the eighty-three photographic and drawn illustrations were by him. Over the decades since, Piper not only contributed a great deal of photographic illustration to most of the Shell Guides, but he became joint editor with Betjeman and eventually general editor alone and responsible for Norman Scarfe's *Essex* 1968, Pennethorne Hughes' *Kent* 1969, Thomas Sharp's *Northumberland* 1969, W.G. Hoskin's *Leicestershire* 1970, Elisabeth Beazley and Lionel Brett's *North Wales* 1971 etc. He had earlier produced *Shropshire* 1951, as co-author with Betjeman, and then *Wiltshire* with J.H. Cheetham, a replacement for David Verey's earlier volume of 1956, which in turn had replaced Robert Byron's *Wiltshire* 1935. For a period, John Betjeman and John Piper were also joint editors of Murray's Architectural Guides, *Buckinghamshire* 1949, *Berkshire* 1949 and *Lancashire* 1955. Larger in format and thicker than the Shell Guides, these Murray's Guides were similar in conception and in the pattern of editorship, which did not distinguish 'between the eye of the painter and the voice of the poet'. Murray's Guides, like the Shell Guides which were first published by the Architectural Press, and by Batsford, and later by Faber and Faber, were exhilarating.

Piper's long association and increasing involvement with the Shell Guides, spread as they have been over half a century, demonstrate something of his ready adaptability, his enthusiastic and persuasive manner, for it is his painter's eye which has influenced their production, and his illustrator's understanding of the topography and of the editorial requirements, which have produced his own photographs and selected those of others, to enliven so many of the volumes. In some, like *Oxfordshire* and *Shropshire*, there have been plenty of his drawn illustrations, too.

In the recent Stourton Press edition of *Grongar Hill* by John Dyer, to which Piper has contributed not only seven original two-colour lithographs printed at the Curwen Press, but also a foreword, we are given as much information about Piper and his particular enthusiasms as about Dyer and Grongar Hill. Piper

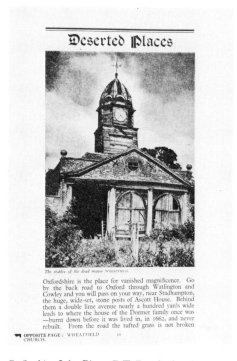

Deserted Places

The stables of the dead manor WHEATFIELD

Oxfordshire is the place for vanished magnificence. Go by the back road to Oxford through Watlington and Cowley and you will pass on your way, near Stadhampton, the huge, wide-set, stone posts of Ascott House. Behind them a double lime avenue nearly a hundred yards wide leads to where the house of the Dormer family once was —burnt down before it was lived in, in 1662, and never rebuilt. From the road the tufted grass is not broken

OPPOSITE PAGE : WHEATFIELD CHURCH.

Oxforshire, John Piper. B.T. Batsford Ltd, 1938, p.11

described how, when he first visited the Vale of Towy, he saw the illustrations in the English aquatint books with which he was familiar '... blossom into life at every bend, as if not only some, but all of them, had been done there'. Some time later, Piper discovered Dyer's poem, 'Grongar Hill', which, because of its particular visual qualities, he felt '... was one of the best topographical poems in existence'. Piper had drawn and painted Grongar Hill and when in 1982 the opportunity again presented itself, Piper produced these lithographs as illustrations. They reflect something of the long tradition of topographical illustration, and of Piper's own responses to such a landscape setting, '... the Towy vale quite unchanged. Dryslwyn Castle still on its knoll, Paxton's Tower on its hilltop,' and, unlike the suburban scene described in *The Castles on the Ground*, he found 'no development, no tourists, comparatively few motor-cars: only the single-line railway (rusty) that had been there for a hundred years anyway, and which must have startled some of the inhabitants when it first appeared, as much as the one in the Derbyshire dales startled Ruskin'.

Dyer's poem is itself an evocation of the landscape seen through the excited eye of one who, born at the turn of the eighteenth century, had his visual perception heightened by his training as a painter, and Piper's introductory comments, and his lithographs which were the distillation of a long familiarity with this particular landscape, combine with the poem in weight and balance and imagery. Dyer's eloquent early eighteenth century style, and Piper's topography of the late twentieth century, are so well matched in this slim volume that the offering becomes almost a benediction.

Some of Piper's drawn work has been translated by others to become wood engravings, a medium with which Piper, as he told me in a recent conversation, was himself involved early on. He was a regular customer of T.N. Lawrence in those early days, and has described to me how he contributed 'many' to magazines like the *London Mercury* and the *New Leader*. In Kenneth Lindley's *Of Graves and Epitaphs*, Hutchinson and Co. Ltd 1965, Piper has drawn the Harmony Chapel, Llanwrida and Fawley Churchyard, Buckinghamshire, and Lindley has engraved these on to boxwood. The prints were used as frontispiece and endpapers in *Of Graves and Epitaphs*, and were used again in Lindley's *Urns and Angels*, produced in an edition of only eighteen copies by his own Pointing Finger Press in 1965. Recently, Lindley, in continuing this 'tradition' has done an engraving from a Piper drawing of Garn Fawr.

In *Edward Sydney Woods*, Victor Gollancz Ltd 1954, there are two illustrations by Piper, one of the Palace, Lichfield, and the other of the Cathedral; the Cathedral has been engraved on wood by Reynolds Stone. In 1969, the Chilmark Press of New York issued R.S. Thomas' *The Mountains*. This consisted of 350 copies of which 110 were signed by Thomas, Piper and Reynolds Stone, who did the wood engravings. The signed copies had different bindings and an extra set of the ten wood engravings. Piper described how the illustrations were done. He and Stone had spoken a great deal about the topographical guides of the late eighteenth and nineteenth centuries which had often been illustrated with wood, steel, or copper engravings. Piper had spent much time doing drawings in Wales, and reading about and visiting many of the sites described in Thomas Pennant's *Tour in Wales* and in Pugh's *Cambria Depicta*. They discussed the possibility of a new guide to the mountains of Snowdonia, illustrated not with

Rhayadr Ogwen (or Benlog Falls)

The Mountains, R.S. Thomas. Drawing by John Piper, engraved on wood by Reynolds Stone. Chilmark Press, New York, 1969, frontispiece

photographs, but with factual engravings which might have something of the authenticity, the clear, precise observation of scenery 'beyond mere external form' of the old books, but newly observed. Piper did a series of drawings from which Stone made careful yet spirited and intensely felt engravings. Together Piper and Stone visited the places depicted in the book. A few of the drawings were made directly on to the boxwood block, a practice favoured by many engravers of the second half of the nineteenth century. Some were photographed down on to the wood, a process which had first been used as early as 1854. For a long while nothing came of this projected volume, for though they had some of the drawings and engraved blocks, they had no satisfactory text. Then, years later, the poet R.S. Thomas produced *The Mountains*, which seemed somehow to be just what they wanted. It appeared as a parallel and a corollary. The older blocks were sorted out, one or two more engravings were done, and the volume was printed by Will and Sebastian Carter at the Rampant Lions Press in Cambridge, using Hermann Zapf's Palatino type.

Piper has, for many years, used collage extensively in his painting and in his designing for tapestries and for stained glass. He found collage particularly useful for glass, for he said cutting paper was 'much more like a glass technique than merely taking a brush and swishing it about on paper.' From the 1930s onwards Piper experimented with using collage and Robert Melville has described how one of his real and distinctive contributions to the abstract movement arose from his personal handling of the papier collés of his beach scenes. Piper had used a variety of different materials and had done many of his collages out in the open air, using a folder of cut and torn patterned papers, marbles, sheet music and printers' trial proofs as a palette. It was natural enough then that this activity should reappear in much of his book illustration. The dustwrapper to Ivan Sanderson and Sacheverell Sitwell's *A Century of Sanderson*, 1960, is a reproduction of a study for the stained glass panel in the firm's Berners Street head office in London. His illustrations to John Betjeman's *First and Last Loves*, John Murray, 1952, of nonconformist architecture at Legborne, Louth, Tisbury, Broad Town, Great Yarmouth, Mawgan-in-Meneage, Kilgelly, Blaenconin, Oundle, Donhead and Swaffham, all make extensive use of collage. For Ronald Duncan's *Judas*, Anthony Blond 1960, Piper produced eight illustrations of symbols of the passion: the crown of thorns, the pincers, nails, pierced hands, bleeding heart, a ladder and the cross, which were printed as collotypes at the Chiswick Press. The originals from which the collotypes were produced were pieces of cut and stuck paper on which Piper had done further work using paint brushes and other things, to build up the textures which he wanted. Piper used collage for the title page drawing to the *Shell Guide to Shropshire* 1951, and collage effects for the lithographed dustwrapper and title page spread of Norman Hancock's *An Innocent Grows Up*, 1947. Again, in William Wordsworth's *Guide through the District of the Lakes*, Rupert Hart Davies, 1951, the line blocks were reproduced from Piper's designs which are in ink and collage, and collages were used on other dustwrappers like Palinurus' (pseudonym of Cyril Connolly) *The Unquiet Grave*, Hamish Hamilton 1945.

Among Piper's earliest book illustrations were line drawings for volumes of his own, *The Wind in the Trees*, 1921, and *The Gaudy Saint and other poems*, 1924, both produced by the Horseshoe Publishing Co. Ltd, Bristol. *The Gaudy Saint*

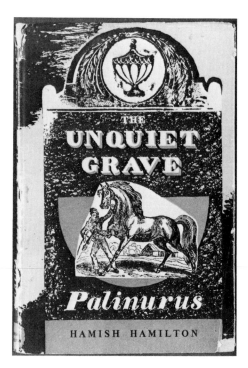

The Unquiet Grave, Palinurus. Hamish Hamilton, 1945, (revised edition), dustwrapper

and other poems contained six small decorations as head and tail pieces. These were done in indian ink using a brush and a reed or quill pen. They are reminiscent of some of the work of Lovat Fraser, certainly a casual glance might suggest that they could be the work of any of a hundred hack illustrators of the late nineteenth and early twentieth centuries. They give little indication of what was to come, or so it might appear, until they are compared with a volume which was to come out soon after. This was Charles Piper's *Sixty Three: Not Out*, a book of recollections. It was privately printed for Piper's father by the Curwen Press in 1925. When the work in *Sixty Three: Not Out* is seen in relation to the *Gaudy Saint and other poems*, and *The Wind in the Trees*, a pattern is established and a direction indicated. The nineteen ink drawings in the form of vignettes, again show, in the imagery, little more than a suggestion of what was to develop later, although close examination of the head and tail pieces does show signs, in the calligraphy, of the speed at which Piper worked, and the quality of the resulting marks. The drawings of Vincent Square; the White House, Coleshill; Peppering, Sussex; or Ewell; slight though they are, and done mainly with a brush and indian ink, although one or two of the decorations have been worked on with a pen, are already as recognisable as handwriting; while the tail piece, Horseferry Road, is probably the earliest reproduced example of work which shows contrasting textures on the façades of buildings, which was to manifest itself in so much of his later work in book illustration, as in painting. In the beginnings of his technique in this, there are signs of what was to come in illustrations, such as the detail from the cover of *The Curwen Press News-Letter* no.16 1939; or many of his illustrations of the Market Place, Devizes which accompanied his 'Topographical Letter from Devizes' in *The Cornhill Magazine* no.963, November 1944. Parts of these were re-drawn, rearranged and new separations prepared, to become the dustwrapper and title page spread for his own *Buildings and Prospects*, The Architectural Press, 1948.

There have been many books which Piper has illustrated with lithographs, too many to be dealt with here, but one small volume which is an outstanding example in many ways is Walter de la Mare's *The Traveller*, Faber and Faber 1946. It was a first edition of a long philosophical poem by de la Mare, with drawings by Piper, which were lithographed in six colours at the Baynard Press. The separations were done by T.E. Griffits, one of the best known interpretative lithographic craftsmen in England. It was a very attractive little production, printed on handmade paper, by R. MacLehose and Co., clothbound, with gold and colour stamping. It sold at a modest 7/6, and remained in print for many years.

In 1955, Piper illustrated an anthology edited by John Hadfield, of *Elizabethan Love Songs* for the Cupid Press of Barham Manor in Suffolk. This was a handsome volume, the third in a set, the earlier ones being *Georgian Love Songs*, 1949 and *Restoration Love Songs*, 1950, both of which had been illustrated with collotypes of drawings by the late Rex Whistler. For this third volume Piper drew on to plastocowell film, and printing was done by Cowells of Ipswich. Plastocowell is a process developed to facilitate the transfer process of lithography. Instead of drawing on Solnhofen stone or zinc plates, the artist draws on to a transparent sheet of stable plastic which is grained like a lithographic plate. The advantage is that any opaque material: ink, paint, crayon, chalk or pencil, can be

used, for the sheets of plastic are not transferred but are used in just the same way as a photographic positive would be. A sheet which has been worked on is placed in a printing down frame against a lithographic machine plate which has been covered with a light-sensitive coating and then exposed to light. Colour separations are easier to do because the artist can superimpose, or 'overlay' one sheet upon another, on a 'shiner' or light box. This was the process used by Piper, and the resulting eight illustrations, in four colour workings, are based on Elizabethan imagery – portraits, monuments, skeletons, shades or spectres, and a fine illustration of the two lonely gateways, all that remain of the outer courtyard of Holdenby House, Sir Christopher Hatton's magnificent mansion in Northamptonshire.

In March 1965, the Lion and Unicorn Press at the Royal College of Art, produced Adrian Stokes's *Venice*. The text is haunting and evocative, and reflects Stokes's knowledge of the city, its history, its architecture and its daily life. He had lived there for many years and few contemporary writers can have known it from a visual point of view as well as he. Piper visited a Venice family frequently, and had been inspired not only as a painter but as one who had the further stimulus of Stokes's writing, which Piper had long held in high regard. It was designed as a student project by Christine Malone and Roy Giles, and Piper produced the illustrations. Within six months a commercial edition had been published by Gerald Duckworth and Co. The lithographs are in four colours and although they may look like autolithographs, some of the workings are screened. There are twenty six illustrations in the Lion and Unicorn edition, and twenty seven, plus endpapers and dustwrapper, in the Duckworth.

In 1969, Her Majesty's Stationery Office published *Caernarvon Castle* by Arnold J. Taylor, Chief Inspector of Ancient Monuments in the Ministry of Public Buildings and Works. The book was designed by Adrian Knowles and it contained, bound in at the back, 'the three detachable lithographs' specially prepared by Piper. They are not as one might easily assume, autolithographs, they are screened in the normal way of four colour separations, and produced by photo-mechanical means. They are an attractive set on a perforated fold-out sheet, and they show Caernarvon Castle from the south-east, the south, and the north-west.

Piper's book illustrations adapt easily to dustwrapper design for books he has illustrated, like John Betjeman and Geoffrey Taylor's *English Scottish and Welsh Landscape*, 1944, or J.M. Richards's *The Castles on the Ground*, 1946, or John Betjeman's *First and Last Loves*, 1952, to volumes like Evelyn Waugh's *Scott-Kings Modern Europe*, 1947, or Norman Hancock's *An Innocent Grows Up*, of the same year, or his own *Buildings and Prospects*, of a year later, where his contribution is to the frontispiece and the dustwrapper.

From Piper's dustwrappers it is but a short step to those activities which, in one sense, are not really illustrations at all, yet, for instance, his film posters for Ealing Studios, *Pink String and Sealing Wax*, and *Painted Boats*, both done in 1945, are exactly the same as his dustwrappers and frontispieces for *An Innocent Grows Up* and *The Castles on the Ground*. Looking at the content, the treatment of the imagery, or the techniques involved, it is not easy to separate one from the other. Form and content have sprung from a common source and are become integral and inseparable.

Illustration from *Venice* by Adrian Stokes, 1965

Some of Piper's recent ceramics of 'Obelisks with Architectural Decoration,' 'Obelisks with Ruined Arches and Buildings', suggested by Inigo Jones's theatre designs, and some of his plates – 'Homage to John Crome', 'Reminders of Cotman' and 'Recollections of Richard Wilson' – intended as a homage to Gainsborough, show just how far his 'illustration' experiments have extended.

The range of his work and the kind of volumes published are extensive. John Betjeman's *Poems in the Porch*, S.P.C.K. 1954, was published at 3/-, and *Romney Marsh*, Penguin Books, for half a crown. Both were intended to fit into a jacket or raincoat pocket and to be read on a trolley-bus, or in a station waiting-room. Other books like Ronald Duncan's *The Rape of Lucretia*, Bodley Head 1948, Sir George Sitwell's *On the Making of Gardens*, Dropmore Press, 1949, *Elizabethan Love Songs*, Cupid Press, 1955, or Tambimuttu's *India Love Poems*, Paradine/ Editions Poetry London, 1977, are all much more sumptuous productions. In these, Piper's work is reproduced with care, using some of the finest materials, such as handmade paper, handset type, leather or buckram for the spines, marbled paper sides. These books are examples of fine typography, printing and production, and Piper's work is seen and enjoyed in a more lavish setting. Thirteen years ago I wrote in 'John Piper as a Book Illustrator', for the *American Book Collector* vol.22, no.4 January 1972, referring to his *Brighton Aquatints*, that what has rarely ever 'been mentioned is the fact that Piper designed and intended to produce a companion volume on Stowe. I have been privileged to see and handle Piper's mock-up of this and to borrow many of the preliminary studies and working drawings for this book. It is over thirty years since this was laid aside, and it may well be that it will never be produced. But in Piper's lovely farmhouse, in the secluded Oxfordshire valley not so very far from Henley, where he lives, when he showed me the book and described what he intended, he was just as enthusiastic and eager as he must have been those thirty years ago. It is not yet too late.'

Luckily, by the time this exhibition opens, Piper's *Stowe* will have appeared. Published by the Hurtwood Press of Westerham, with a Foreword by Piper and an introduction by Mark Girouard, it promises to be a magnificent volume with some sixty illustrations of Piper's beloved Stowe – that 'landscape delight unique in England'. There is to be a special edition containing autographic prints by Piper. It should prove to be not only a fine production, but something of a summation of the experience of a lifetime's illustrative work, of travelling, seeing, recording, drawing and painting the English topographic scene, and a long and varied experience of working in graphic processes, not merely as a follower but as an innovator.

Piper forms part of the context of his times, not only as an illustrator, but as a painter, a designer, a decorator, a worker in furnishing fabric, ceramics, tapestry and stained glass, a photographer and a writer. His illustration is part of this whole activity. Though his work in the field of illustration is significant, a greater significance lies probably in its relation to his other work, and the influence of it all, as motifs, ideas and themes, permeates his different activities, and is extended and developed in each. In this he is different from many of his contemporaries, such as Barnett Freedman, Rex Whistler, and Edward Ardizzone, who were primarily book-illustrators. Although Freedman was a man of many parts, even his large oils, as, for instance, *15 Inch Gun Turret, HMS Repulse*

1942, in the Imperial War Museum, were primarily illustrative. Rex Whistler's murals in the Tate and elsewhere, are, in one sense, illustration on a large scale, for they tell a continuing story with grace and elegance, in a sequence of spirited conceits. Edward Ardizzone has worked consistently as an illustrator and draughtsman of the human figure in very human situations – humorous, benevolent, and on an intimate scale. Each artist has usually set out to illustrate, to elucidate, to authenticate and to explicate, by depicting the situation, and by portraying the characters. With painters like Paul Nash or Graham Sutherland, Piper's approach and work have more obvious similarities. Although they are clearly different in so many ways, in the paintings and in their book illustrations, these artists developed and enlarged the presence of the setting in which action might take place. Illustration became frequently an extension of other work upon which they were engaged, and they usually, in their book illustration, added or accompanied. Piper's contribution, like those of Paul Nash and Graham Sutherland, is a visual addition, rather than a visual explanation or interpretation.

Piper's contribution is particular and considerable. As his experience widened, his best work in illustration, as in his other areas, has become a synthesis of his knowledge and his sensitivity. He is wise enough to stop when his intention has become clearly established. He has usually understated his case, leaving the spectator the opportunity of taking an active part, by allowing him to contribute should he wish to do so. He works quickly and deftly. Seeing Piper at work, the casual observer might assume that his work is casual, even careless. This assumption would be inaccurate and unfair, for many skills often look easy. Piper's free movement of pen or loaded brush has the spontaneity born of sureness of touch, certainty of mind, and a knowing control which careful practising of his 'craft and sullen art' has given him.

Illustration from *Venice* by Adrian Stokes, 1965

Designs for the Theatre

Michael Northen

From an early age John Piper had absorbed so much from his associations with the worlds of art and literature, that there was little doubt that sooner or later he would be drawn to the theatre.

By the time he was asked to design his first production in 1938, he was already an established painter, with a great knowledge of music, architecture and photography, all of which were to serve him well in his many diverse productions in the future. So it was not surprising that 'the theatre', already desperate for new ideas and new blood, should ask him to contribute his own highly specialised technique and style, which was to bring a new and exciting impact to the theatrical scene. It is strange that at this period in Britain serious painters had not been asked to design for the theatre. Abroad artists such as Picasso and Derain, whom Piper so much admired, and who had such a great influence on him, already had many productions to their credit.

Piper launched himself into his first production, with an abstract design for a play *Trial of a Judge* by Stephen Spender, at the tiny Unity Theatre and this was followed in 1942, when he designed 'an entertainment by Edith Sitwell and William Walton' *Façade* at the Aeolian Hall. This called for a single painted backcloth. Although small it had incorporated in the design a large concealed magaphone, behind which Edith Sitwell poured forth her verse unseen by the audience.

His work must have impressed William Walton as he was commissioned the following year to design *The Quest* for the Sadler's Wells Ballet Company at the New Theatre. The dancers included Fonteyn, Shearer and Grey, with choreography by Frederick Ashton. *The Quest* was a large work allowing Piper to use his extraordinary powers of composition, colour and architectural detail which the public saw for the first time on full-size stage backcloths. Two years later the Old Vic Company asked him to design *Oedipus Rex* again at the New Theatre. His designs for this production were in total contrast to those for his ballet *The Quest*. The production demanded more free standing scenery compared with the almost empty stage required by a ballet company, where only cloths and 'wings' were employed. Free standing statues, large rostra and flights of steps made their first appearance in his designs, but these were always backed by an unmistakably exciting and dramatic Piper sky cloth.

In the following year Piper designed for his first opera *The Rape of Lucretia* at Glyndebourne produced by Eric Crozier, and this was the beginning of his very long and happy association with Benjamin Britten. It was also the first time Piper had come up against the problem of designing his sets to be adapted to fit two different sizes of stage. Glyndebourne had a relatively small proscenium arch, but at the King's Theatre Edinburgh, where the production was to transfer for the Festival, there was a larger and higher proscenium arch with

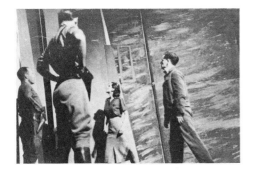

Trial of a Judge, 1938, Group Theatre, produced by Rupert Doone

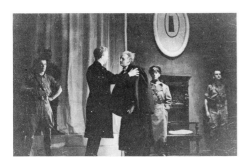

Trial of a Judge, 1938

totally different proportions. He managed to overcome these difficulties by using two permanent entrances on either side of the stage which successfully acted as a frame for a cloth, behind which scenes could be changed, the design on the front cloth merging into the side entrances wherever they were set.

In 1947, Frederick Ashton asked him to design the sets and the costumes for *Albert Herring* once again for Glyndebourne. This was the second opera by Benjamin Britten for this house. It was an immediate success, and proved to be a very popular work, being chosen the following year to open the first Aldeburgh Festival at the Jubilee Hall. *Albert Herring* was a much lighter work than the *Rape of Lucretia* and this was reflected in Piper's designs which were easily adapted to a small stage with a small cast. The Opera has been revived many times, including a new production with Piper designs for the Aldeburgh Festival in 1962.

As well as *Albert Herring*, Piper was hard at work on a major new ballet for the Royal Opera House. *Job* was produced on 20 May 1948, with music by Vaughan Williams and choreography by Ninette de Valois. Piper based his magnificent settings and costumes on William Blake's illustrations to the book of Job. Unlike the *Rape of Lucretia* which had moved to Covent Garden from a smaller stage, *Job* was conceived for the huge stage at Covent Garden, allowing Piper to use the full resources of that house from the start. Reproduction of his designs for this ballet have been used in all major books devoted to the ballet.

In the same year he also managed to design a production of *Simone Boccanega* for the Sadler's Wells Opera Company in collaboration with John Moody.

In 1949, John Cranko came into the Piper family life. He and Piper worked together on a number of very successful ballets until his early death. Their first two ballets were *Sea Change* and *Harlequin in April* once again for the Sadler's Wells Theatre Ballet Company, followed in 1953 by *The Shadow*.

John Piper became actively involved with Benjamin Britten and Peter Pears in creating The English Opera Group, a small company which was formed to produce 'Chamber Opera'. They gave a short season at the Lyric Theatre, Hammersmith, with a production of *Combattimento di Trancredi e Clorinda* with choreography by Walter Gore.

John Piper returned again to Glyndebourne for Carl Ebert's production of *Don Giovanni* in 1951, on which I was lucky enough to be asked to work as technical adviser and lighting designer. Ebert had insisted that each scene must have a separate set, and this caused Piper an extraordinary amount of hard work, especially as the old problem of transferring to Edinburgh was again on the cards. However he came up with a remarkable solution for the numerous scene changes by designing two large houses in three dimensions in perspective and set on trucks, which could be moved to various positions on the stage. In turn they 'married' with the perspective on the backcloth where ever they were placed. They were very beautiful designs and greatly enhanced the production. An interesting side line was the fact that when it came to the lighting, I discovered that any light falling directly onto the painted scenery destroyed the atmosphere that Piper had intended, so that I decided that the scenery should be lit entirely from light spilling over from the acting areas which achieved the effect that Piper wished to create.

During the production of *Don Giovanni*, Piper was already at work on his

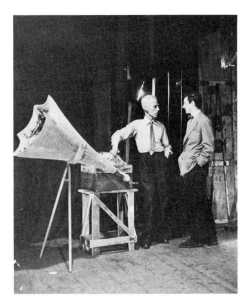

John Piper and John Cranko at the
Kenton Theatre, Henley, 1952

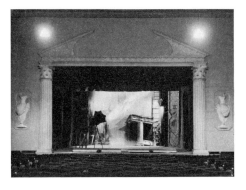

Dancing, Kenton Theatre, Henley, 1952

next production for Covent Garden, which was to open in December of the same year, *Billy Budd*. Britten had written the score to a libretto by E.M. Forster, and produced by Basil Coleman. Working on the models for him I realised that Piper had produced designs completely different from any of his previous work. Gone was any sign of paint or canvas, and in their place was an entire three dimensional structure of a warship. It was basically abstract in design with the upper deck sliced in half and set at an angle to the audience, and complete with two masts and rigging. The second set 'between decks' consisted of six open ribs of the ship built in perspective and again set at an angle to the audience. Piper decided that the unpainted models made in balsa wood should be reproduced exactly in full size, with the colour of the unpainted wood. A black velvet surround completed the sets. Only one cloth was used for a short scene, representing fog, painted in the true style of John Piper. His costumes, predominately blue, were the only source of colour. It may be interesting to quote from an article that appeared in *Tempo* which was in the form of a discussion between the producer (Basil Coleman) and the designer who wrote: 'And so we agreed in general that we shall suggest, and not portray, the sea and the ship, and that we must make the set so abstract that the absence or presence of particular details will not be noticed, so long as the shapes themselves are all intensely "Ship-like", and so long as the practical demands of the libretto and the score are satisfied'. This certainly was the case.

In the following year 1952, John Piper returned to his country home for a well earned rest from the theatre, but not for long. For sometime he had thought about restoring the beautiful little theatre in Henley which had fallen into disrepair and was sadly neglected. He and his wife Myfanwy gathered round them their friends who spent the summer repairing the fabric of the theatre. Piper concentrated on building and painting a new proscenium, while the rest of us cleaned and repaired the stage and auditorium. To launch the restored theatre, John Cranko devised an entertainment based on ballet with a cast which included Kenneth Macmillan. Very little money was available for sets and costumes. This did not deter Piper for a moment. He painted the back wall of the stage and created a set from a broken key board of an old piano, a column, a stage ladder, and a gigantic gramophone horn made out of scraps, all of which had been left abandoned in the theatre. His set caught entirely the spirit of Cranko's evening of *Dancing*.

1953 was the year of the Coronation of the Queen. Britten was commissioned to write an opera for the Gala performance at Covent Garden on 8 June, *Gloriana*. It was a vast work as befitted the occasion, with a libretto by William Plomer, choreography John Cranko, and produced by Basil Coleman. Piper once again designed both the sets and the costumes. He reverted to his former style of painted cloths and scenery centred round a long raised rostrum which was permanently positioned at the back of the stage from which moveable steps were arranged. His costumes were rich and magnificent. Although the opera did not appeal to the critics or the public, Piper's designs gave to the production the pageantry required for such an occasion.

In the meantime, Myfanwy Piper had been working on the libretto for another opera composed by Britten, based on a story by Henry James *The Turn of the Screw*. Although it had only a cast of six and an orchestra of thirteen *The*

Turn of the Screw was one of the most ambitious productions that the English Opera Group had undertaken. It was commissioned for the Venice Biennale and first performed at the Teatro La Fenice. This caused a problem with the setting. Piper had designed a composite setting with units set in a permanent position on the stage throughout the opera. A tall gothic tower with a gauzed window set up stage allowed the presence of Quint to appear and disappear in a subtle and sinister way. A gothic entrance and balcony above was set down stage right with moveable arches or windows which could be used for exteriors or interiors as required. His gauzes beautifully designed and painted were suspended on tracks enabling him to shut off areas of the stage when not required, and allowed him to change the atmosphere demanded by the libretto with the minimum delay for scene changing. The scenery was built and painted in London and was shipped out to Venice in advance of the company. In the meantime it was decided to hold the rehearsals in the Jubilee Hall in Aldeburgh with a minimal set built and painted by Piper. It was a wise decision resulting in most of the difficulties being ironed out at an early stage and saving precious and expensive time at the Fenice with the inevitable language problems over technicalities. The Opera was a great success, and before returning to England for a season at the Scala Theatre had three performances in Florence.

Still engaged on opera, *The Magic Flute* produced by Christopher West and conducted by Kubelik, followed at Covent Garden in 1955. The production was designed almost entirely with painted gauzes, a medium which had been used with great effect in *The Turn of the Screw* and which Piper found more and more interesting to use.

In 1957 John Cranko decided to turn his talents to writing a small scale revue. It was 'way out' for the period. He felt that it would have little chance of being a commercial success, but it would be great fun and a worth while experience for him and his company. John Addison was asked to write the music, and Cranko assembled a cast of four, Anthony Newley, Annie Ross, Hugh Bryant, and Gilbert Vernon. A small try-out theatre the Watergate by Charing Cross Station offered to give it a short run. Once again as in *Dancing* there was very little money. In fact I think we all gave our services for nothing. John Piper came to the rescue and painted and built an abstract setting for the tiny stage. Much to the great surprise of us all the show was an immediate success. After the short run at the Watergate, the show was taken up by a Management who transferred it to the St Martin's Theatre in the West End. Obviously John Piper's set and the show had to be re-thought and re-designed for the much larger theatre. Traditional flats and cloths were substituted for the painted back wall of the Watergate. The show was still a box office success but somehow on its transfer it lost its freshness, probably because John Cranko had never envisaged or written the revue for a sophisticated West End Theatre. The show however, went into a second edition, and transferred yet again to the Lyric Theatre Hammersmith, but it never regained the same impact as its first performance at the Watergate.

With *Cranks* safely launched, Piper turned to the straight theatre, designing the settings for two plays at the Arts Theatre, the first by Derek Monsey *Less than Kind* produced by his wife Yvonne Mitchell both neighbours of Piper's in Henley. The second in 1960 was *Abelard and Heloise* by Ronald Duncan produced by Hugh Hunt.

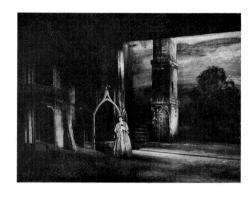

The Turn of the Screw, Fenice Theatre, Venice, 1954

There were also two more ballet productions with John Cranko *Il Ballo delle Ingrate* for the Aldeburgh Festival and *Reflections* for the Edinburgh Ballet Company for the Edinburgh Festival.

Piper was associated with Britten on three further operas. The Aldeburgh Festival of 1960 included *Midsummer Night's Dream*, first produced by John Cranko. In the following year the opera was revised with John Gielgud as producer, for a season under the banner of The English Opera Group at Covent Garden. With a new producer suggesting fresh ideas, John Piper naturally had to re-think his original designs, and he once again used gauze cutcloths and full width gauze backcloths.

There was a considerable gap before his next production with Britten. B.B.C. Television commissioned Britten to write an opera on another Henry James story *Owen Wingrave*, and Myfanwy Piper was asked to write the libretto. It was recorded in 1970, but did not have its first performance at Covent Garden until 1973. The designs showed yet another facet of Piper's stagecraft, with the setting for the Hall at Paramore consisting of a high balcony along both sides of the stage, dropping down to a central rostrum from which a flight of steps led down to the stage level. The whole structure was built in open metal work giving a very light appearance. High arches were silhouetted against a cloth painted with vast portraits. The interesting fact was that the portraits were painted on the model by his eldest son Edward.

The last of the three operas was again based on a work by Henry James with the libretto by Myfanwy Piper *Death in Venice*, which was to have its premiere at the Maltings Aldeburgh in 1973. Frederick Ashton was responsible for the choreography, and Colin Graham for the production. It was a great success and toured Venice, Brussels, Edinburgh and New York. It was revived, with additional projections and cloths by Piper for the Festival in Aldeburgh in 1975.

Involved in so many stage productions, it is a surprise that Piper had any time left for his other activities, painting, stained glass, ceramics, tapestries, book illustrations, and his many private commissions. His stage scenery aroused enormous interest and excitement but never intruded into or distracted from the performances. They were always a major contribution to a production's success. His complete understanding of a score and the libretto, and of the producer's demands were interpreted in his own very special way, which was seldom altered from his original conception.

John Piper on his painting

Abstraction is a luxury. Yet some painters today indulge in it as if it was the bread of life. The early Christian sculptors, wall-painters and glass-painters had a sensible attitude towards abstraction. However hard one tries (many attempts have been made to make them tow the line with modern art) one cannot catch them out indulging in pure abstraction. Their abstraction, such as it is, is always subservient to an end – the Christian end, as it happened.

Abstraction is a luxury that has been left to the present day to exploit. It is a luxury just as any single ideal is, and like a single ideal it should be *approached* all the time, but not pre-supposed all the time. To pre-suppose it always, if you are a painter, is to paint the same picture always: or else to give up painting altogether because there is nothing left to paint....

Louring clouds that belong to romantic painting hanging over a bare beach that might have been made for Courbet. At the edge of the sea, sand. Then, unwashed by the waves at low tide, grey-blue shingle against the warm brown sand: an intense contradiction in colour, in the same tone, on the same plane. Fringing this, dark seaweed, an irregular litter of it, with a jagged edge towards the sea broken here and there by washed-up objects; boxes, tins, waterlogged sand shoes, banana skins, starfish, cuttle fish, dead seagulls, sides of boxes with THIS SIDE UP on them, fragments of sea-chewed linoleum with a washed-out pattern. This line of magnificent wreckage vanishes out of sight in the distance, but it is a continuous line that girdles England, and can be seen reappearing on the skyline in the other direction along this flat beach. Behind this rich constricting belt against the sand dunes there is drier sand, sparser shingle, unwashed even at high tides, with dirty banana skins now and sides of boxes with the THIS SIDE UP almost unreadable. That, in whatever direction you look, is a subject worthy of contemporary painting. Pure abstraction is undernourished. It should at least be allowed to feed on a bare beach with tins and broken bottles.

From 'Abstraction on the Beach', *Vingtième Siècle*, 1 July 1938, p.41

There's one very odd thing about painters who like drawing architecture. They hardly ever like drawing the architecture of their own time.

I know perfectly well that I would rather paint a ruined abbey half-covered with ivy and standing among long grass than I would paint it after it has been taken over by the Office of Works, when they have taken all the ivy off and mown all the grass with an Atco. And also I would rather paint a new house when it's twenty years old than when it's new. You can call it reaction, or prejudice, or anything you like – but sitting down to paint a new house would give me the same feeling as sitting down to paint a new-born baby. It's just one of those things I'd rather not do.

From 'Buildings in English Art', in 'John Piper at the A.A.', *The Architect & Building News*, 9 May 1941, p.85

Well, Constable may not be romantic; but if not how do you account for 'The world is wide; no two days are alike, nor even two hours; neither were there ever two leaves of a tree alike since the creation of the world', and a thousand or so remarks of the same kind? But what do you mean by romantic, and what do I? Do you mean only Blake, Fuseli, S. Palmer, John Martin at their *queerest*? ('Queerest' not meant derogatorily, but as dealing with the 'unusual' or 'inspired'). If you don't include the English illustrators of the sixties whom do you include? And if, including them, you don't include Sickert who held the fort of inspired illustration against all comers – including Roger Fry and yourself – if not, why not?

To me, dreams are *not* as romantic as bits of real experience. To me, similarly, Ernst, Dali, you at your most surrealist are not *ever* as romantic as Rouault, Braque, and you searching with calm excitement for the reality that will clinch the bargain of your vision on the Chiltern slopes or the Dorset Downs. And I don't care what Herbert Read may say, or all the boys with double barrelled foreign names and addresses in St Johns Wood. The value of abstract painting to me, and the value of Surrealist painting to me are (paradoxically, if you like) that they are *classical* exercises, not romantic expressions. They are disciplines – even dreams can be disciplinarian – which open a road to ones own heart – but they are not the heart itself. I doubt if under their complete domination one masterpiece will ever be created. After an abstract period – what a release one feels! The avenue at Stadhampton, or the watercress beds at Ewelme are seen with such new intensity! But if one abstracts them finally, so that those posts are areas of colour, and the waterfall into the watercress bed becomes like a Ben relief, then the result can be hung perhaps in Cork Street, but not hung against one's heart. And so, too, with classical old, domineering old Surrealism.

From a letter to Paul Nash, 12 January 1943, Tate Gallery Archives

'There is nothing I tell you with more earnest desire that you should believe than this – that you will never love art well till you love what she mirrors better.' For years I ignored the purport of these words of Ruskin's, and in doing so ignored early, intense loves. In ignoring them I tended to paint, and to look at painting, for itself alone, for its manner and its past and present habits, for its language of form and colour, discounting its message. There is a lot to be said for this attitude in a student. The placing side by side of areas of pure colour, the relating of them to each other in fairly simple and schematized patterns, I found a useful training; for there is as much to unlearn for a student of painting in the twentieth century as there is to learn. Similarly, I taught myself something of the emotional power of colour by copying stained glass and admiring Rouault for his powerful use of colour irrespective of the even more powerful story he has to tell. Today, I hope to be a painter who reacts in favour of early loves without being reactionary, and who paints churches both medieval and Victorian, mountains, beaches, downs and valleys, without for a moment forgetting that on most downs there is an aerodrome, from most mountains you can see factories in the valleys, that many churches are nearly empty on Sundays, and that on any English beach there may be an unexploded mine.

Complete introduction by the artist, in catalogue *John Piper*, Buchholz Gallery, New York, February 1948

'My aims in painting are to express a personal love of country and architecture, and the humanity that inhabits them, and to increase my own understanding and nourish my own love of the work of other painters of the past and present'

Complete statement in catalogue *Painters' Progress*, Whitechapel Art Gallery, May–June 1950

The titles are the names of places, meaning that there was an involvement *there*, at a special time: an experience affected by the weather, the season and the country, but above all concerned with the exact location and its spirit for me. The spread of moss on a wall, a pattern of vineyards or a perspective of hop-poles may be the peg, but it is not hop-poles or vineyards or church towers that these pictures are meant to be about, but the emotion generated by them at one moment in one special place. They are about what Paul Nash liked to call the *genius loci*. Romantic painting is about the particular, not the general. I have enjoyed the fields and stone walls and small hills of south-west Wales, and the darker, more insular-feeling West of Scotland landscape, and the poplars and water-meadows and the figs and mistletoe and walnuts of northern and central France.

From statement in catalogue *John Piper, European Topography 1967–69*, Marlborough Fine Art, May–June 1969

Summary Biography

A selection of publications and illustrated books (listed in full in bibliography), stained glass (listed in full in Kettle's Yard 1982 catalogue) and exhibitions, with a complete list of stage works.

1903
13 December: born at Alresford House, Epsom, Surrey. Father senior partner in firm of London solicitors. Youngest of three brothers.

1917–21
Day boy at Epsom College (Graham Sutherland left the term before he arrived). Visited Diaghilev ballets in London, from 1918.

1921
September: visited North and Central Italy with parents.
From 1920s continued to make topographical notebooks of English architecture, with drawings, photographs and summaries of guidebooks. *Wind in the Trees* by John Piper, poems, printed privately.

1921–6
Articled clerk in his father's office, Piper, Smith & Piper, Vincent Square.

1924
The Gaudy Saint and Other Poems by John Piper, Horseshoe Publishing Co., Bristol.

1925
Illustrated *Sixty-three: not out* by C. A. Piper, his father's autobiography.

1926
Father died (mother died in 1957 aged 93). Abandoned study of law and attended Richmond School of Art, under Raymond Coxon.

1927
Moved to Chalkpit Cottage, Betchworth, Surrey. Exhibited wood engravings at the Arlington Galleries. Met Braque at Jim Ede's house in Hampstead.

September: transferred to Royal College of Art (taught painting by Morris Kestelman, and lithography and stained glass by Francis Spear).

1928
First published art criticism, in *The Nation and Athenaeum*.

1929
Left Royal College of Art early in order to marry Eileen Holding, a fellow student from Richmond College of Art. Moved to flat at 22 St Peter's Square, Hammersmith, retaining studio only at Betchworth. Copied medieval stained glass at Grateley, Hampshire.

1930
Painting subjects on South Coast.

1931
Copied early Segonzac oil, 'Bucolic Landscape', in Michael Sadler's collection.
March: watercolours at group exhibition, Heal's Mansard Annexe.
October: 2 exhibits at *London Group*.

1932
October: 1 exhibit at *London Group*.

1933
Art & theatre criticism in *The Listener* and *New Statesman*, and continued to write in these and other periodicals throughout the thirties. Friendship and exchange of paintings with Ivon Hitchens. Exhibition of gouache and collage landscapes of South Coast at Lefevre Gallery, probably in 1933 (no catalogue).
22 & 29 March: 'Younger English Painters' in *The Listener* discussed, among others, Hitchens, Winifred & Ben Nicholson, Frances Hodgkins, Victor Pasmore.
October: 'Foreword' to Hitchens exhibition at Lefevre Gallery.
November: 3 exhibits at *London Group*.

1934
Made abstract constructions in studio at Betchworth.
January: elected member of *7 & 5 Society*.
March: appointed Secretary. 5 exhibits with

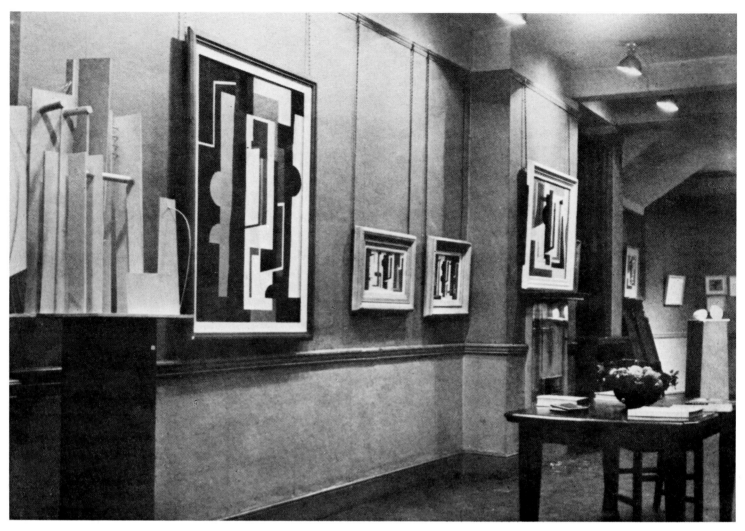

7 & 5 exhibition, Zwemmer Gallery, October 1935 (from *Decoration*, 7 November 1935, p.39)
Left to right: 'Construction' by Eileen Holding. Five abstract paintings by John Piper,
including: 'Painting 1935' (Cat. no. 17) on left, 'Abstract Painting 1935' (Cat. no. 18),
the small painting on the right of two.

7 & 5 Society at The Leicester Galleries
(including 'String Solo').
May: general meeting of *7 & 5 Society*
approved revised rules allowing only 'non-
representational' work to be displayed.
Summer: met Myfanwy Evans, who became
his second wife, while both visiting Hitchens
at Sizewell, Suffolk.
August & September: Myfanwy visited
artists' studios in Paris (Mondrian, Arp and
Sophie Tauber-Arp, Brancusi, Hélion,
Giacometti, Kandinsky) and was
encouraged by Hélion to edit a magazine of
abstract art in Britain.
Autumn: worked on magazine *AXIS*,
visiting artists to collect articles and
photographs, and prepared colour blocks
and layout.

1935
First abstract oil paintings.
January: *AXIS 1* published. Exhibited

constructions at Experimental Theatre,
Finchley Road, reviewed by Hugh Gordon
Porteus in *AXIS 1*
22 January: BBC radio broadcast 'To
Unemployed Listeners, 17, John Hilton and
John Piper' discussed abstract constructions.
February: moved to Fawley Bottom
Farmhouse, near Henley-on-Thames.
March: visited exhibition of Picasso papiers-
collé (1912–14) at Galerie Pierre, Paris,
reviewed in *AXIS 3*.
Visited studios of abstract artists in Paris
(Arp, Hélion, Brancusi, Domela) and Calder
at Varengeville.
October: 7 exhibits at final and exclusively
abstract exhibition of *7 & 5 Society*,
Zwemmer Gallery.
November: group exhibition of abstract
artists, foyer of Everyman Cinema,
Hampstead, organised by S. John Woods.
Two articles on his abstract work in *AXIS*

4 by Hugh Gordon Porteus and Herta
Wescher.

1936
Designed advertisements for Imperial
Airways for Marcus Brumwell. Organised
with Robert Wellington *Contemporary
Lithographs* to publish at Curwen and
Baynard Presses autolithographs by young
artists. Made landscape collages of torn
papers, but did not exhibit them until 1938.
Met John Betjeman, through *Architectural
Review*. First painting visit to South and
West Wales.
February: group exhibition *Abstract and
Concrete*, Oxford, organised by Nicolete
Gray, and at Lefevre Gallery, April.
April: group exhibition *Modern Pictures in
Modern Homes*, Duncan Miller Ltd.
September: with S. John Woods proposed a
series of arts programmes, 'Eyes to See', to
BBC Television.

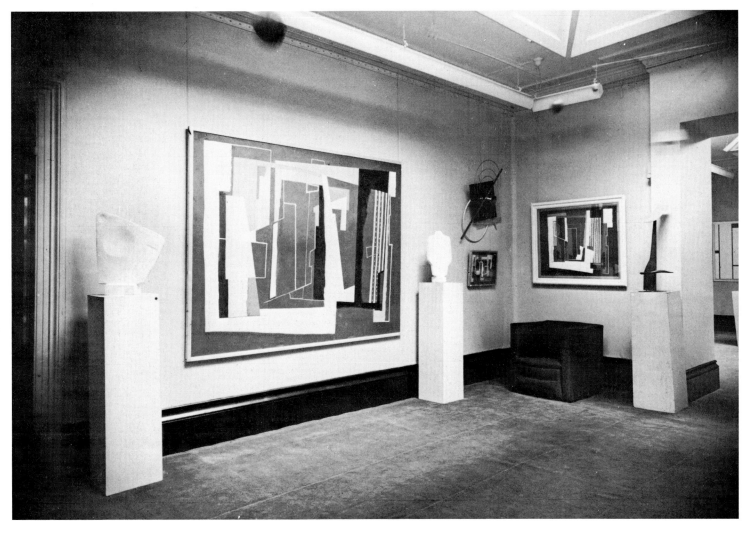

Abstract and Concrete, Lefevre Gallery, April 1936 (photograph by A.J. Hepworth)
Left to right: three abstract paintings by John Piper: 'Forms on Dark Blue' 1936 (destroyed)
'Abstract II' 1935 (Cat. no. 20), 'Painting' 1936 (Collection A. West)

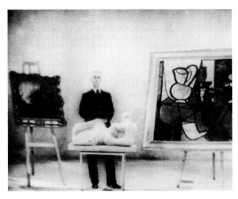

Still from a television broadcast, 1936/7.
John Piper at Alexandra Palace, with Henry
Moore 'Reclining Figure' 1935–6 (Albright Art
Gallery, Buffalo) and Picasso 'Pichet et
Coupe de Fruits', 1931

October: 'England's Early Sculptors',
Architectural Review, first article for this
periodical.
Autumn: 'England's Climate' by Geoffrey
Grigson and John Piper in *AXIS 7*.
November: 3 exhibits at *London Group*.
Reviewed paintings lent by London dealers
on BBC Television in fortnightly
programmes until March 1937, also reviews
of individual artists.

1937
Friendships with Paul Nash, Frances
Hodgkins, Eric Ravilious. Toured Ireland
with American critic James Johnson
Sweeney. Commissioned by John Betjeman
to write *Shell Guide* to Oxfordshire. Joined
Group Theatre as designer, with Robert
Medley, and worked with Britten,
Isherwood, Rupert Doone. Divorced Eileen
Holding and married Myfanwy Evans.
'Lost, a Valuable Object' in *The Painter's*

Object, edited by Myfanwy Evans.
27 January: 'A Discussion between John
Piper and Serge Chermayeff', BBC
Television.
21 February: 'Modern Art and Stage
Design. John Piper and Robert Medley',
BBC Television.
April: group exhibition *Artists' International
Association*, 41 Grosvenor Square.
June: photographed Paul Nash's 'objects'.
July: work reproduced in *Circle*. Group
exhibition *Constructive Art*, The London
Gallery.
Summer: visited Paris International
Exhibition (including display of Dufy,
'L'Electricité'; Calder, 'Mercury Fountain';
Picasso, 'Guernica').
Autumn: Calder made constructions for
exhibition in Mayor Gallery in December
while staying with Pipers.
November: group exhibition *Surrealist
Objects and Poems*, London Gallery (two

'Found Objects', from Seaford Beach).
Made free-standing wood and metal
constructions.

1938
Shell Guide to Oxfordshire by John Piper.
January: 'The Nautical Style', in
Architectural Review. Scenery for *Trial of a
Judge*, Group Theatre at Unity Theatre
Club (play by Stephen Spender). First
performance 18 March.
April: 'A Trip to the Seaside', an anthology
of poetry and paintings by Myfanwy Evans
and John Piper, filmed for BBC Television;
broadcast 10 June, and included work of
Piper, Wadsworth and Paul Nash.
May: *John Piper Paintings & Collages*,
London Gallery, introduction by Paul Nash.
Abstract oils, landscape collages and designs
for *Trial of a Judge*.
July: 'Abstraction on the Beach', in *XXème-
Siècle*.
September: group exhibition *Contemporary
Lithographs*, The Leicester Galleries,
introduction by Michael Sadler.
Winter: abstract mural for Francis Skinner's
flat in 'Highpoint Two', Highgate.

1939
Brighton Aquatints (Duckworths),
introduced by Lord Alfred Douglas. Visited
Shropshire with John Betjeman to prepare
Shell Guide (published 1951). Cover for first
issue of *Horizon*. Painted at Hafod, Fonthill,
Stourhead, Brighton.

1940
Architectural watercolours commissioned by
Pilgrim Trust for *Recording Britain*. Met Sir
Osbert Sitwell after his review of *Brighton
Aquatints* (*The Listener*, 4 January).
Volunteered for RAF, but commissioned by
War Artists' Advisory Committee.
March: *Paintings and watercolours by John
Piper*, The Leicester Galleries. Subjects at
Hafod.
April: A.R.P. Control Room subjects for
Ministry of Information.
June: group exhibition at Lefevre Gallery.
July: group exhibition *British War Artists*,
National Gallery.
November: painted bombed churches at
Coventry.
December: painted bombed churches at
Bristol and London.

1941
May: painted bombed interior of House of
Commons.
July: *3 British Artists. Henry Moore, John*

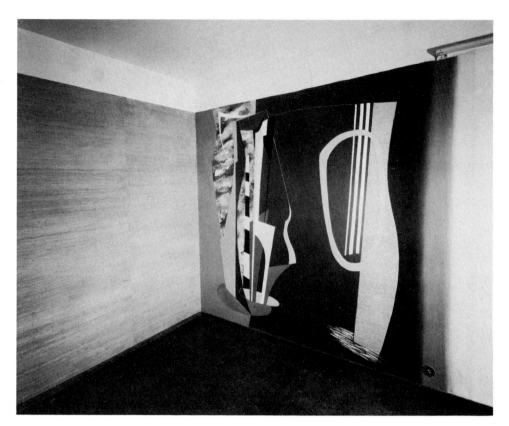

Mural at Highpoint Two, Highgate, 1938

Piper, Graham Sutherland, Temple
Newsham, Leeds, arranged by C.E.M.A.,
foreword by Philip Hendy. Retrospective
exhibition of work 1932–1940.
Painted country houses (Seaton Delaval)
and ruined barns.

1942
Front cloth for revival of recital *Façade*,
Aeolian Hall (Edith Sitwell, William
Walton). Commissioned by Sir Osbert
Sitwell to paint Renishaw Hall.
January: completed text of *British Romantic
Artists*, published later in the year (Collins).
March: group exhibition *New Movements in
Art*, London Museum, Lancaster House.
April: painted bombed churches at Bath.
September: John Betjeman commissioned
by Sir Kenneth Clark to write monograph
on Piper for Penguin Modern Painters.
Painted in Yorkshire (Gordale Scar,
Easegill).

1943
Visited Snowdonia to paint Manod quarry.
Commissioned by Edward Sackville-West to
paint Knole. Murals at Merton Priory Civic
Restaurant, London. Organised *The Artist
and the Church* exhibition for C.E.M.A.
Scenery and costumes for *The Quest*, Sadlers
Wells Ballet at New Theatre, Shaftesbury

Avenue (Walton; choreography by
Frederick Ashton). First performance
6 April.
Painted in Devon and Cornwall.

1944
John Piper by John Betjeman (Penguin
Modern Painters).
June: appointed Official War Artist,
attached to Ministry of War Transport.
Painted shipping at Cardiff and Avonmouth
and, later, agricultural subjects. Rented
cottage at Pentre, Nant Ffrancon Valley,
Snowdonia, and visited until 1949 when
moved to another cottage.

1945
Film poster for S. John Woods at Ealing
Studios (and 1947). *Left Hand, Right Hand*
by Sir Osbert Sitwell, with reproductions of
paintings and watercolours by John Piper,
first of five volumes of autobiography, all
illustrated by Piper.
January: *The Sitwell Country, Derbyshire
Domains, background to an autobiography and
other paintings and drawings by John Piper*,
The Leicester Galleries, 'Preface' by Sir
Osbert Sitwell.
Scenery for *Oedipus Rex*, Old Vic Theatre
Company at New Theatre (W. B. Yeats after
Sophocles; produced by Michael Saint-

North end of the Main Vista, Festival of Britain, 1951

Denis). First performance October.
October: Group exhibition *National War Pictures*, Royal Academy.

1946
Group exhibition *British Contemporary Painters*, Albright Art Gallery, Buffalo, USA.
Appointed Trustee of Tate Gallery (served 1946–53, 1953–61 and 1968–74).
Scenery and costumes for *The Rape of Lucretia*, Glyndebourne English Opera Group at Glyndebourne (Britten; produced by Eric Crozier). First performance 12 July.
October: *Stage Designs for Benjamin Britten's Opera 'The Rape of Lucretia'*, The Leicester Galleries.

1947
Scenery and costumes for *Albert Herring*, English Opera Group at Glyndebourne (Britten; produced by Frederick Ashton). First Performance 20 June.
September–October: painted at Montegufoni, near Florence, for Sir Osbert Sitwell.
Painted at Romney Marsh.

1948
Buildings and Prospects by John Piper (Architectural Press), collected articles.
February: *John Piper*, Buchholz Gallery (Curt Valentin), New York, 'Preface' by John Piper. Portland, church monuments and stage subjects.
Scenery and costumes for revival of *Job*, Sadlers Wells Ballet at Covent Garden (Vaughan Williams; produced by Ninette de Valois). First performance 20 May.
Scenery for *Simone Boccanegra*, with John Moody and Reginald Wooley, Sadlers Wells Opera (Verdi; produced by John Moody). First performance 27 October.
December: *New Paintings and Drawings by John Piper*, The Leicester Galleries. Painted in Portland, Snowdonia.

1949
Scenery and costumes for *Sea Change*, Sadlers Wells Theatre Ballet (Sibelius; choreography by John Cranko).
Murals for British Embassy, Rio de Janeiro.
Drawings of Snowdonia for wood engravings by Reynolds Stone.
Rented cottage Bodesi, above Llyn Ogwen, Snowdonia, and continued to visit throughout 1950s.

1950
Romney Marsh, illustrated and described by John Piper (King Penguin).
Commissioned to design for Festival of Britain mural for exterior of 'Houses and Gardens Pavilion' and, with Osbert Lancaster, decoration of 'Main Vista'.
Member of Oxford Diocesan Advisory Committee (to present).
October: *John Piper, Recent Work*, Buchholz Gallery (Curt Valentin), New York. Portland and North Wales subjects.
Painted in Isle of Wight.

1951
February: *John Piper, oils, gouaches, watercolours*, The Philadelphia Art Alliance, USA. Snowdonia Subjects. Scenery and costumes for *Combattimento di Tancredi e Clorinda*, English Opera Group at Lyric Theatre, Hammersmith (Monteverdi; choreography by Walter Gore). First performance 1 May.
May–September: Festival of Britain. Scenery and costumes for *Harlequin in April*, Sadlers Wells Theatre Ballet (Richard Arnell; choreography by John Cranko). First performance 8 May.
Scenery and costumes for *Don Giovanni*, Glyndebourne Festival Opera (Mozart; produced by Carl Ebert).
November: *Stones and Flowers, An Exhibition of New Pictures by John Piper*, The Leicester Galleries.
Scenery and costumes for *Billy Budd*, Royal Opera House (Britten; produced by Basil Coleman). First performance 1 December.
December: took lease of Kenton Theatre, Henley-on-Thames.

1952
Arranged programme at Kenton Theatre with John Cranko.
Scenery and costumes for *Dancing*, Kenton Theatre (George Shearing; choreography by John Cranko). First performance 21 July.
Illustrations for *First and Last Loves* by John Betjeman.
Scenery for *Umbrella*, Kenton Theatre (Lanchbery; choreography by John Cranko). First performance 21 July.

1953
Lithographs at Mourlot, Paris, for St George's Gallery.
'Winter Words', song cycle by Britten after poems by Hardy, dedicated to John and Myfanwy Piper. *John Piper, Retrospective Exhibition*, Arts Council Gallery, Cambridge, catalogue by John Commander.
Scenery and costumes for *The Shadow*, Sadlers Wells Ballet at Covent Garden (Dohnanyi; choreography by John Cranko). First performance 3 March.
May: asked by Grocers' Company to consider design of stained glass for Oundle

School Chapel, and subsequently introduced to Patrick Reyntiens as craftsmen.
Scenery and costumes for *Gloriana*, Royal Opera House (Britten; produced by Basil Coleman). First performance 8 June, in presence of the Queen.
Began series of 'Foliate Head' paintings, after heads on medieval roof bosses.

1954.
Scenery for *The Pearl Fishers*, Sadlers Wells Opera (Bizet; produced by Basil Coleman). First performance 17 March.
Scenery and costumes for *The Turn of the Screw*, English Opera Group at Teatro La Fenice, Venice (Britten; libretto by Myfanwy Piper; produced by Basil Coleman). First performance 14 September.
Painted variations of the figures on ancient Cretan seals. On return from Venice studied glass at Bourges and Chartres for Oundle School Chapel.

1955
Mural 'Man's Relation with Nature' for Mayo Clinic, Rochester, Minnesota, USA.
John Piper, Paintings, Drawings and Theatre Designs by S. John Woods (Faber & Faber). Reviewed by Douglas Cooper, Times Literary Supplement, 17 June.
February: *John Piper, Curt Valentin Gallery*, New York, introduction by S. John Woods. Shobdon, Portland, Foliate Heads subjects.
30 March: *John Piper*, documentary film by John Read, broadcast on BBC Television.
May: *Recent Work of John Piper*, The Leicester Galleries. With Reyntiens selected and catalogued exhibition *A Small Anthology of Modern Stained Glass*, Aldeburgh Festival, June. Included 'Two Heads', first glass made by Reyntiens from Piper's drawing. Painted in France (Dordogne and Charente).

1956
Invited to design stained glass at Eton College Chapel; St Andrew's Plymouth (restored by Frederick Etchells) and Llandaff Cathedral.
Scenery for *Cranks*, St Martin's Theatre, Cambridge Circus (John Addison; choreography by John Cranko). First performance 3 January at New Watergate Theatre Club.
January: Visited Coventry Cathedral to advise on stained glass for Baptistery.
Scenery and costumes (with Alix Stone) for *The Magic Flute*, Royal Opera House (Mozart; produced by Christopher West). First performance 19 January.
26 May: dedication of stained glass at Oundle School Chapel.

1957
Design for first window at St Andrew's Plymouth, exhibited in London; continued to work on six windows until 1968. Visited stained glass at Audincourt (Léger) and Ronchamp (Le Corbusier).
Scenery for *The Prince of the Pagodas*, Royal Ballet (Britten; costumes by Desmond Heeley; choreography by John Cranko). First performance 1 January.
February: *John Piper*, Durlacher Bros, New York.
Scenery for *Less Than Kind*, Arts Theatre Club (play by Derek Monsey; produced by Yvonne Mitchell). First performance 27 June.
November: Commissioned with Reyntiens to design stained glass for Baptistery, Coventry Cathedral. Converted barn at Fawley Bottom into studio to take full size drawings; work continued until 1961.

1958
Murals for Morley College and BBC New Televison Centre.
Scenery for *Reflection*, Edinburgh Ballet at Edinburgh Festival (John Gardner; choreography by John Cranko).
Scenery for *Secrets*, Edinburgh Ballet at Edinburgh Festival (Poulenc; choreography by John Cranko). First performance 25 August.
Scenery for *Il ballo delle Ingrate*, English Opera Group at Aldeburgh Festival. (Monteverdi; produced by John Cranko). First performance 13 June.
Painted in Venice (May) and France.

1959
Member of Royal Fine Art Commission.
First fabric design for Arthur Sanderson and Sons Ltd. Mosaic for St Paul's, Harlow.
February: first cartoon for Eton College Chapel finished.
September: new designs for *The Turn of the Screw* for Independent Television.
November: *John Piper, New Paintings and Gouaches*, The Leicester Galleries. Abstract landscapes and studies related to glass. Painted at Venice (April–May), Burgundy, Aix-en-Provence.

1960
Designed interior stained glass panel for Arthur Sanderson & Sons Ltd. Abstract murals for S.S. Orion. Mosaic for Chamber of Commerce, Edgbaston. Co-selector of *Modern Stained Glass* for Arts Council.
May: *Paintings and Watercolours of Venice by John Piper*, Arthur Jeffress Gallery.

Scenery and costumes, assisted by Carl Toms, for *A Midsummer Night's Dream*, English Opera Group at Aldeburgh Festival (Britten; produced by John Cranko). First performance 11 June. Redesigned for new production at Royal Opera House.
Scenery for *Abelard and Heloise*, Arts Theatre Club (play by Ronald Duncan; produced by Hugh Hunt). First performance 24 October.
Painted in Venice (March) and Brittany (August–September).

1961
Visited stained glass factory at Darmstadt.
May: *Brittany. New Paintings by John Piper*, Bear Lane Gallery, Oxford.
October: *John Piper*, Durlacher Bros, New York.
Painted at Rome (February–March) and Brittany (August).

1962
Murals for North Thames Gas Board (fibreglass) and Lower Market, Exeter. Designed vestments for Coventry Cathedral. Redesigned *Albert Herring* for new production at Aldeburgh. Acquired cottage 'Garn Fawr' near Strumble Head, Pembrokeshire, and continued to visit several times a year.
May: *Paintings and Watercolours of Rome by John Piper*, Arthur Jeffress Gallery.
25 May: consecration of Baptistery window, Coventry Cathedral.
Painted in Cornwall, Wales, Scotland.

1963
Completed designs of Eton College Chapel stained glass.
Commissioned to design stained glass for Liverpool Metropolitan Cathedral.
March: *Recent Work by John Piper*, Marlborough New London Gallery.
Painted in Italy (Montepulciano) April.

1964
Published suite of twenty four lithographs 'A Retrospect of Churches'. Commissioned to design tapestry for Chichester Cathedral. Drew designs for Liverpool Cathedral in Henley Town Hall.
March: *John Piper. Retrospective Exhibition*, Marlborough New London Gallery. Preface by Robert Melville.
June: *John Piper in Wales*, Welsh Committee of the Arts Council, Llandaff Cathedral and tour; introduction by Tom Cross.

1965
March: group exhibition *Axis, Circle, Unit One*, Marlborough Fine Art.

Mural in fibreglass, 1962, North Thames Gas Board

September 15: designed fireworks for Commonwealth Arts Festival, Hyde Park. Painted at Strasbourg and the Vosges.

1966
Made first screenprints, of 'Foliate Heads', with Chris Prater. Designed glass for St Andrew's, Wolverhampton.
February: design for Chichester tapestry sent to weavers at Felletin. Installed in Cathedral, September.
April: *Nolan. Piper. Richards*, Marlborough Fine Art. First exhibition of 'Eye and Camera' series.

1967
15 January: dedication of stained glass at St Margaret's, Westminster.
14 May: consecration of stained glass at Liverpool Cathedral.
March: *John Piper, Retrospective Exhibition*, Ulster Museum, Belfast and tour. Introduction by A. Reichardt.

1968
Stained Glass, Art or Anti-Art by John Piper (Studio Vista).
Tapestry for Civic Centre, Newcastle. Painted in France (Perigord, Burgundy, Ardennes).

1969
May: *John Piper, European Topography 1967–69*, Marlborough Fine Art (London) Ltd.
Painted in Ireland (October).

1970
Tapestry for Hall of Grocer's Company.
John Piper, Pieter Wenning Gallery, Johannesburg, first of several exhibitions in South Africa.
November: worked on recording of *Owen Wingrave* for BBC Television at Aldeburgh (broadcast 16 May 1971).

1971
Painted at Venice (worked on *Death in Venice* with Benjamin Britten) and Loire Valley (Chambord). Tapestries for Wartenweiler Library, Witwatersrand University, South Africa.

1972
Awarded Companion of Honour.
March: *John Piper*, Marlborough Fine Art (London) Ltd. Large paintings of Venice, French church façades and Chambord, gouaches of Romanesque architecture, first exhibition of ceramics (made with Geoffrey Eastop).

1973
Tapestry for Rothschild's International Bank. Designed set of five copes for St Paul's Cathedral.
Scenery, with Edward Piper, for *Owen Wingrave*, at Royal Opera House (Britten; libretto by Myfanwy Piper; produced by Colin Graham). First performance 10 May.
Scenery for *Death in Venice*, English Opera Group at Aldeburgh Festival (Britten; libretto by Myfanwy Piper; costumes by

Charles Knode; produced by Colin Graham).
First performance 16 June.

1974
August: group exhibition *Art Then. Eight English Artists: 1924–40*, Scottish Arts Council.

1975
Tapestries for Civic Centre, Reading and Sedgwick Forbes, London (Gates of the City of London).
September: *John Piper*, Marlborough Fine Art (London) Ltd.
Studies for *Death in Venice* and landscapes in France.

1976
Tapestry for British Embassy, Helsinki.

1977
John Piper. Victorian Dream Palaces and Other Buildings in Landscape, Marlborough Fine Art (London) Ltd.
Scenery and masks for *What the Old Man Does is Always Right*, Fishguard Festival (Hoddinot; produced by John Moody). First performance 27 July.

1978
Tapestry for Sussex University. Published 'Stones & Bones', series of screenprints.

1979
Stained glass for Robinson College Chapel, Cambridge.
Benjamin Britten Memorial Window, Aldeburgh Parish Church.
John Piper by Anthony West (Secker & Warburg).
May: *John Piper: 50 Years of Work*, Museum of Modern Art, Oxford, introduction by John Hoole.
24 May: designed firework display at opening of Tate Gallery extension.

1981
Tapestries for Hereford Cathedral.

1982
November: *John Piper, Ceramics*, Dan Klein Gallery.
December: *John Piper. Painting in Coloured Light*, Kettle's Yard Gallery, Cambridge, introduction by Martin Harrison.

1983
Piper's Places by Richard Ingrams (Chatto & Windus).
80th Anniversary Portfolio of lithographs and screenprints.
June: *John Piper. The Britten-Pears Collection. Ceramics*, Aldeburgh Festival.
November: *John Piper*, Tate Gallery.

Colour plates

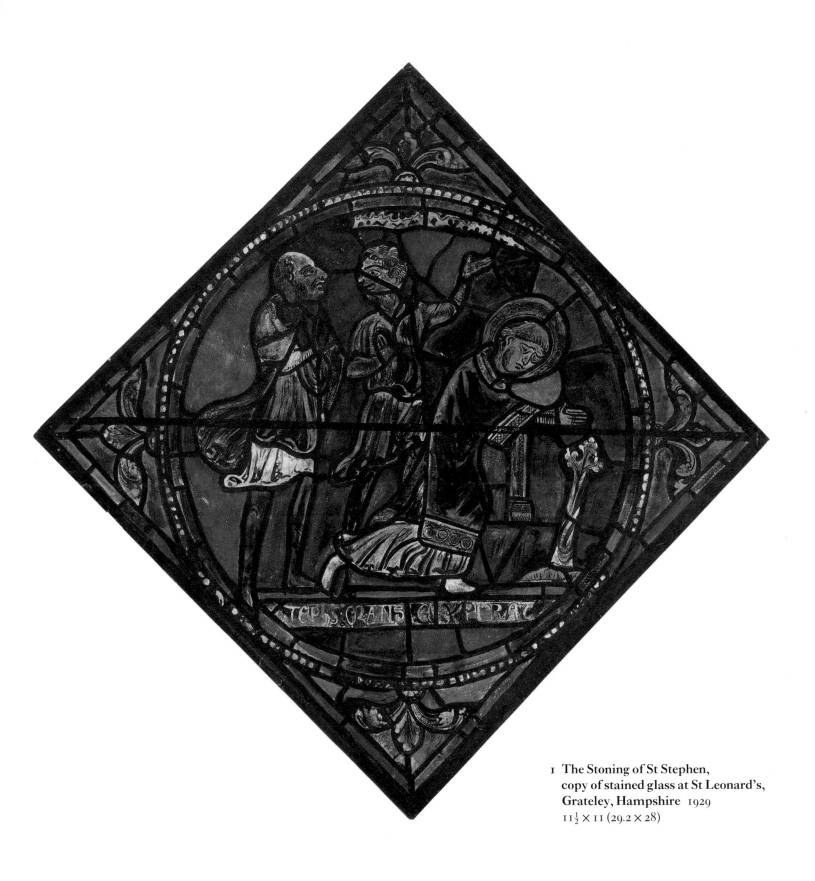

1 The Stoning of St Stephen,
copy of stained glass at St Leonard's,
Grateley, Hampshire 1929
$11\frac{1}{2} \times 11$ (29.2 × 28)

2 **Rose Cottage,
 Rye Harbour** 1931
 $14 \times 18\frac{1}{4}$ (35.5×46)

4 **Girls by the Sea** 1933
 $15 \times 18\frac{1}{4}$ (38×46)

17 Painting 1935
$46 \times 34\frac{1}{2}$ (116.8 × 87.6)

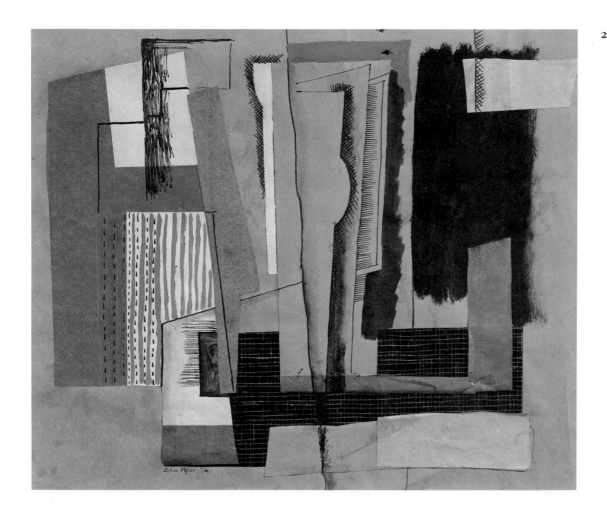

22 Abstract Composition
1936, $14\frac{1}{2} \times 17\frac{3}{4}$ (36.2 × 45.1)

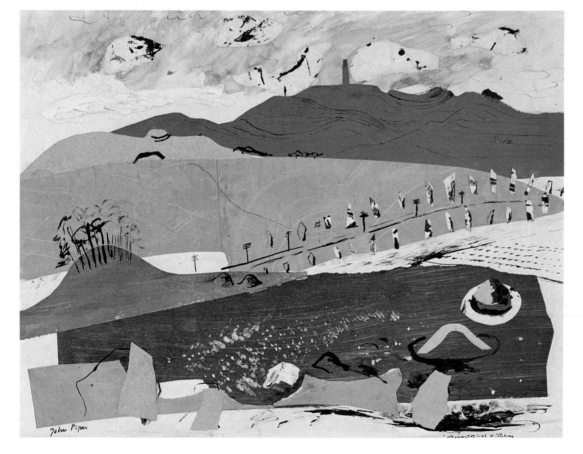

30 Avebury 1936
$15\frac{1}{2} \times 24$ (39.4 × 53.3)

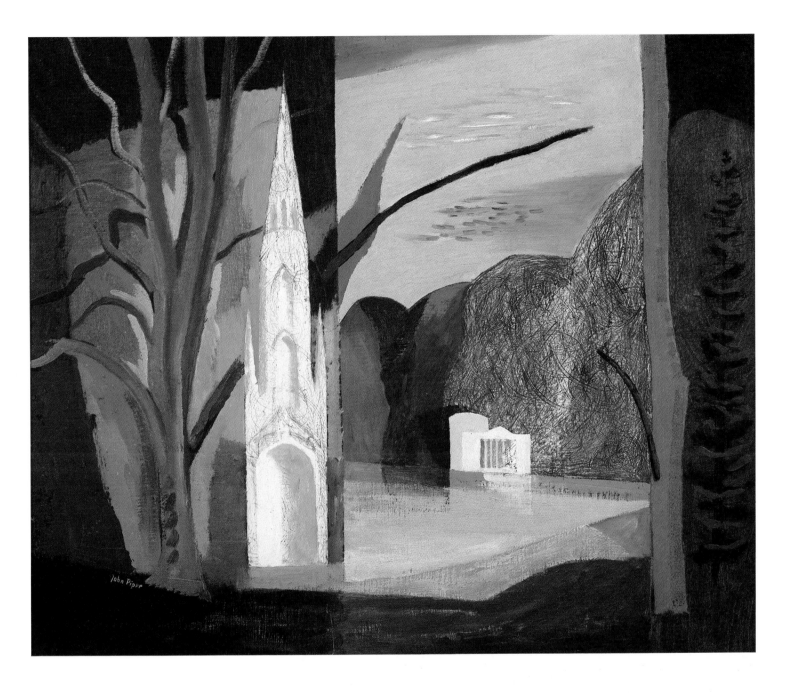

37 Autumn at Stourhead 1939
25 × 30 (63.5 × 76.2)

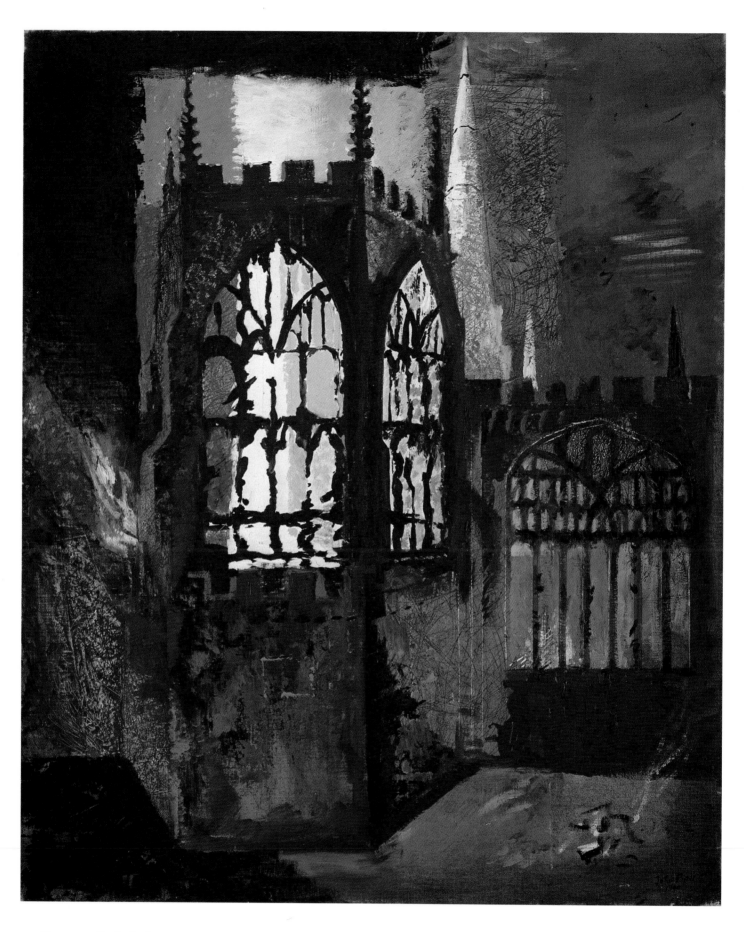

44 Coventry Cathedral,
November 15th, 1940 1940
30 × 25 (76.5 × 63.5)

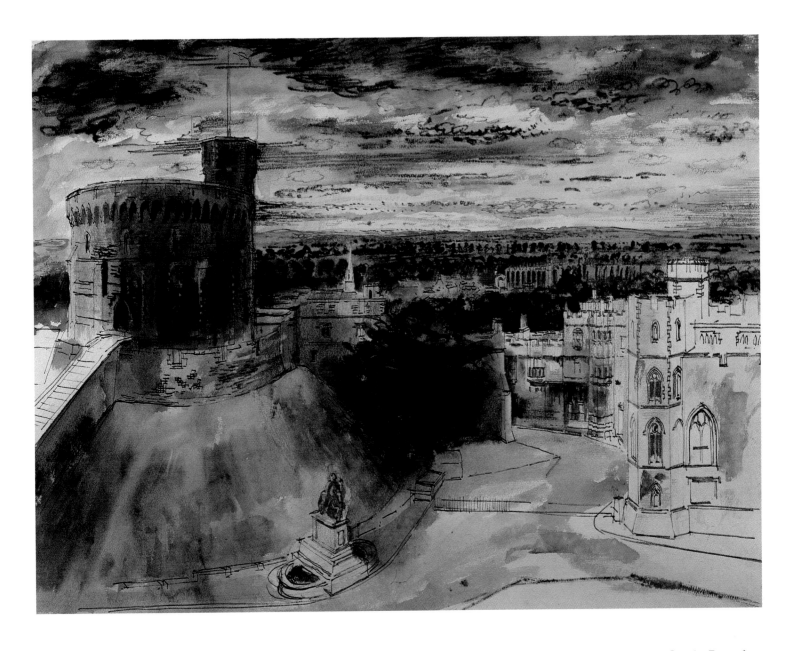

52 **Windsor Castle, Round
Tower and View over Eton**
1942, $15\frac{3}{4} \times 20\frac{3}{4}$ (38.1×52.7)

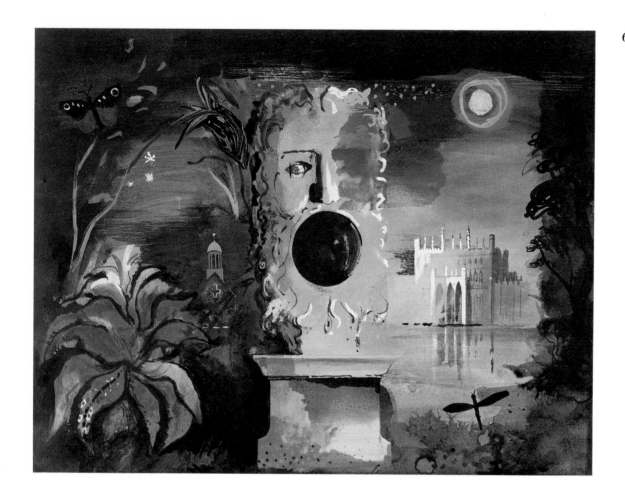

63 **Front Cloth** 1942
for *Facade*, $16\frac{1}{2} \times 21\frac{3}{4}$
(42.5×55.2)

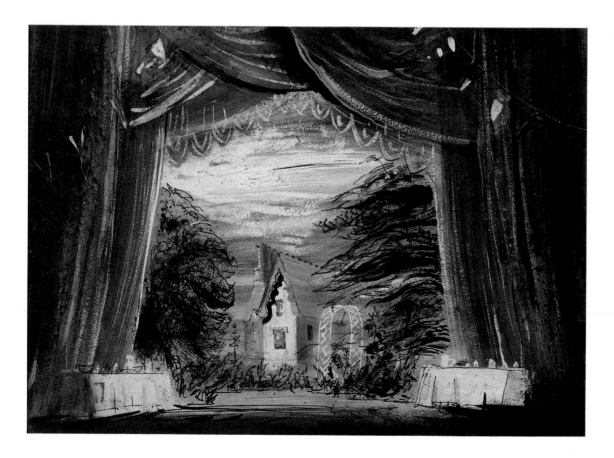

76 **Set Design,**
The Marquee at the
Vicarage 1947
for *Albert Herring*
$15 \times 21\frac{1}{4} (38.1 \times 54)$

78 Backcloth, Hell
 1948 for *Job, Being
 Blake's Vision of the
 Book of Job*, $16\frac{1}{4} \times 22\frac{1}{4}$
 (41.2×56.5)

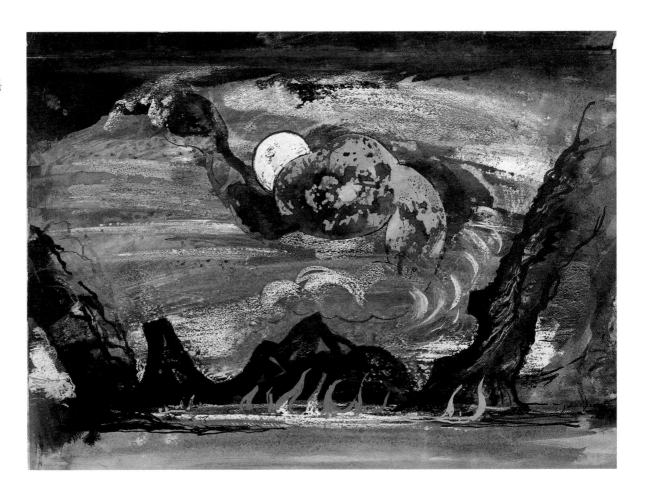

83 Backcloth 1951
 for *Don Giovanni*
 $11\frac{3}{4} \times 19\frac{3}{4}$ (30×50)

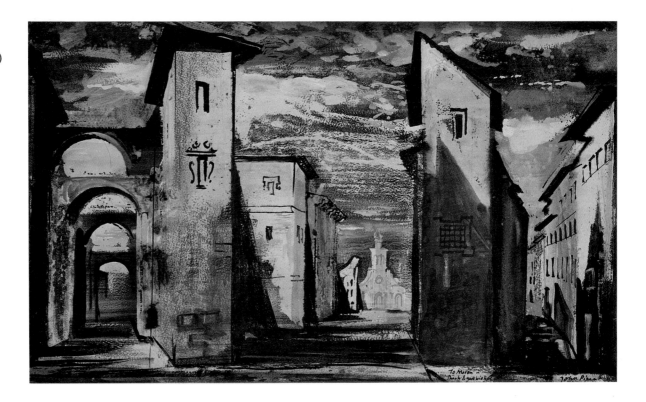

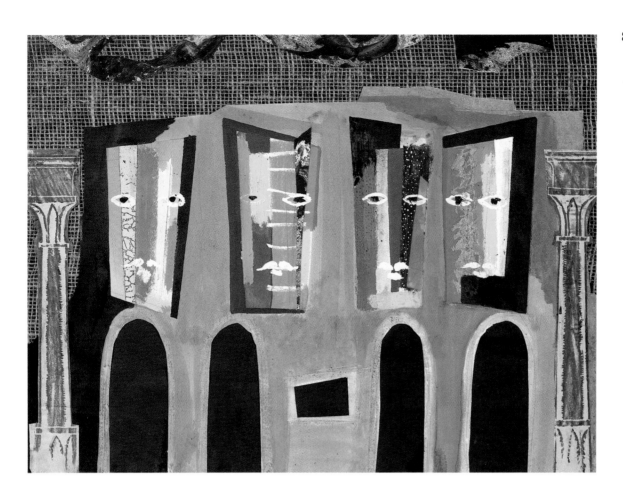

88 **Set Design** 1956
for *Cranks*, 18 × 24
(45.7 × 61)

95 **Cloth Design, The Arrival
at the Lido** 1974 for *Death
in Venice*, 20½ × 41¾ (52.1 × 106)

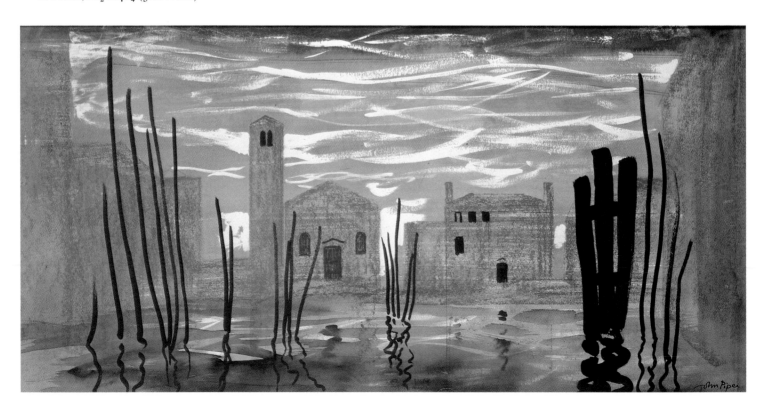

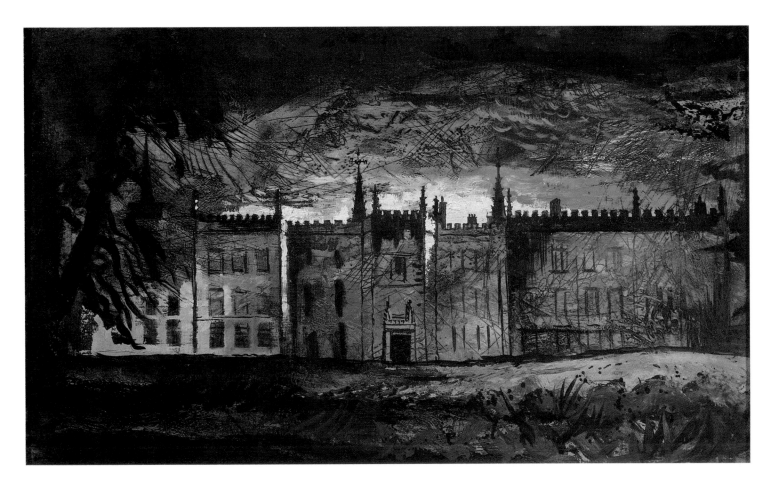

96 The North Front,
 Renishaw Hall 1942/3
 18 × 30 (45.7 × 76.2)

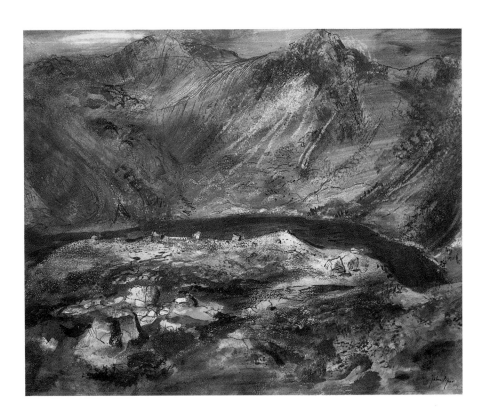

111 Ffynnon Llugwy 1949
 22 × 28 (56.2 × 71)

121 **The Nativity** 1982
73½ × 32 (186.6 × 81.3)

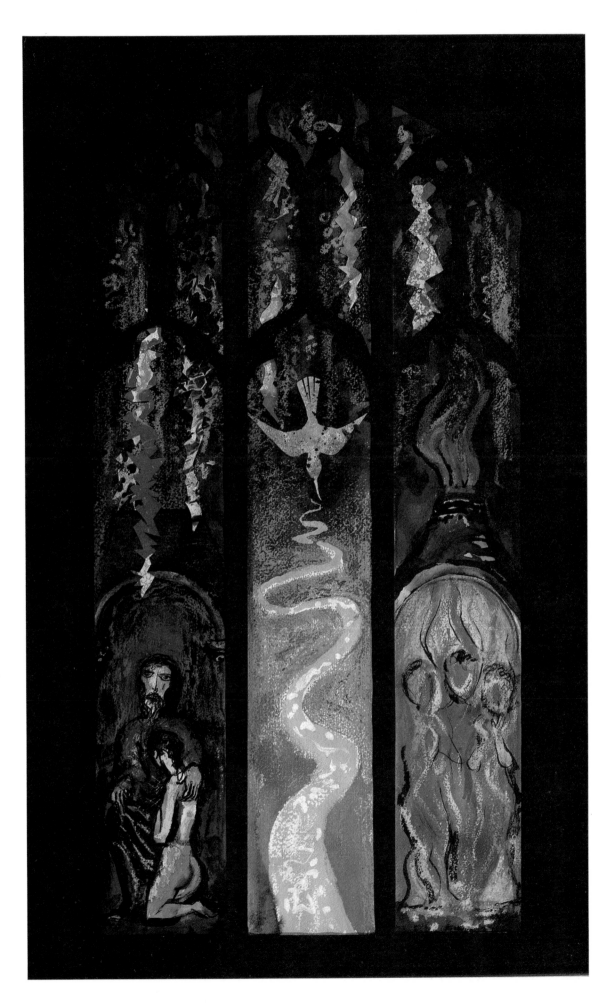

137 Clymping 1953
36 × 48 (91.4 × 122)

139 Rowlestone
Tympanum with a
Hanging Lamp 1951
$26\frac{3}{8} \times 38\frac{1}{4}$ (67 × 97.2)

145 **Palazzo Pesaro,**
Venice 1959–60
$14\frac{1}{4} \times 21$ (36.2 × 53.3)

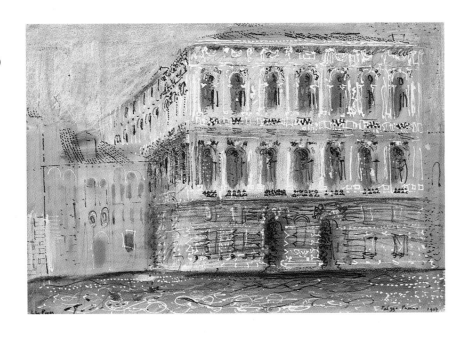

146 **The Salute, Venice** 1959
48 × 48 (121.9 × 121.9)

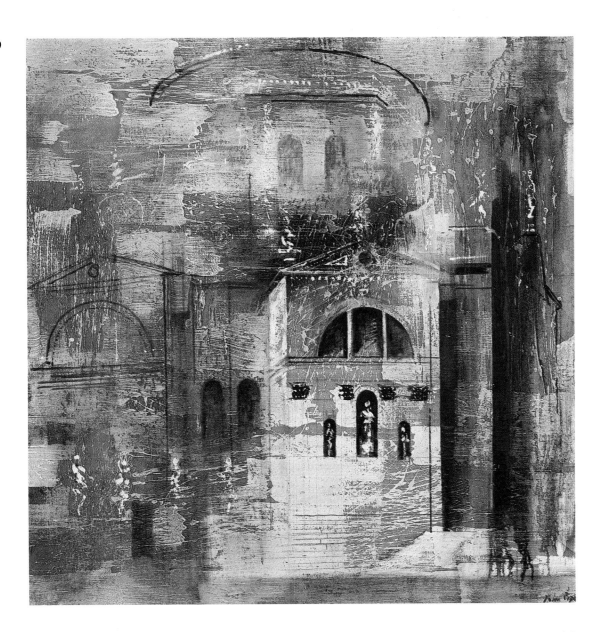

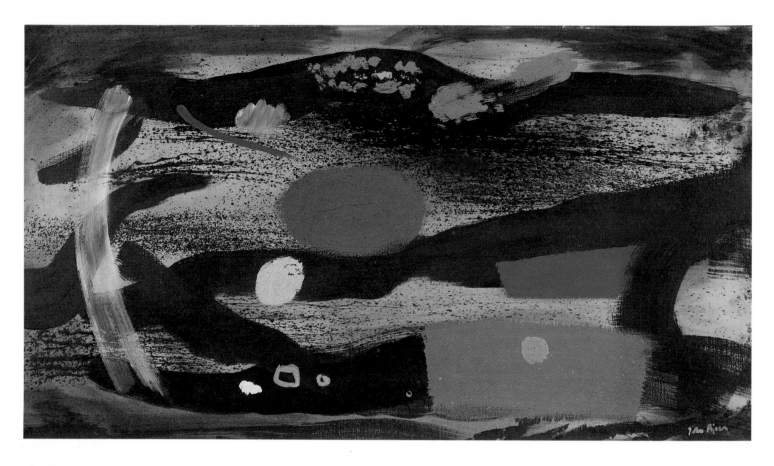

150 **Garn Fawr** 1962
 23 × 42 (58.4 × 106.7)

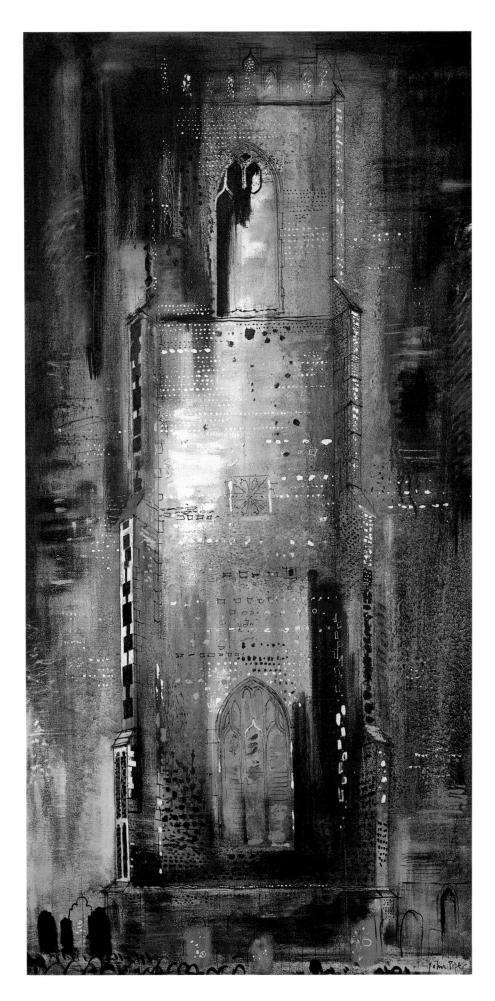

154 Corton, Suffolk 1968–9
79 × 39½ (195.6 × 100)

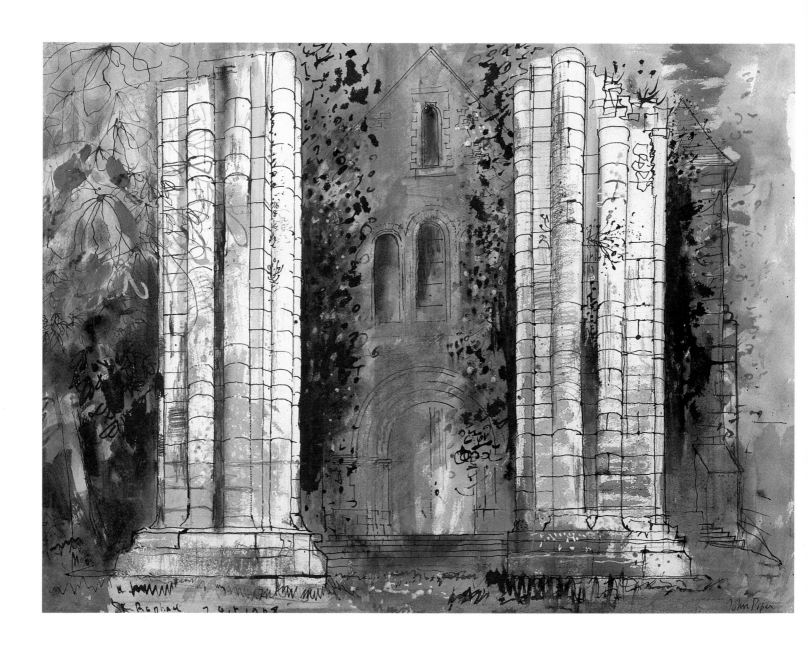

155 St. Raphael, Dordogne 1968
23 × 30 (58.4 × 76.2)

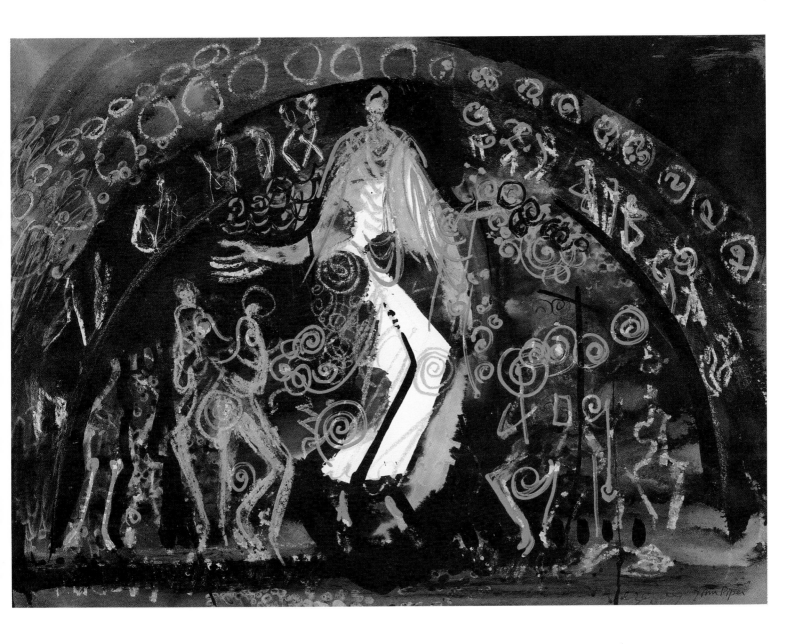

157 Vézelay Tympanum 1970
$22\frac{1}{2} \times 30\,(57.2 \times 76.2)$

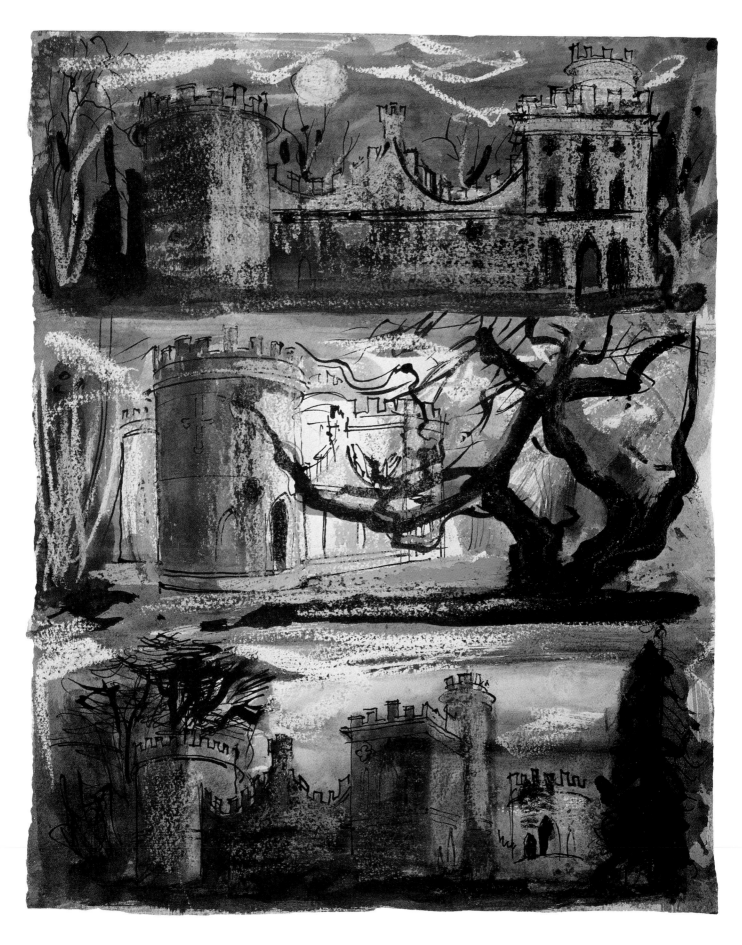

164 Clytha Folly 1975
$13\frac{3}{4} \times 11$ (34.9 × 28)

167 Girl and Flowers 1981
$22\frac{1}{4} \times 30\,(56.5 \times 76.2)$

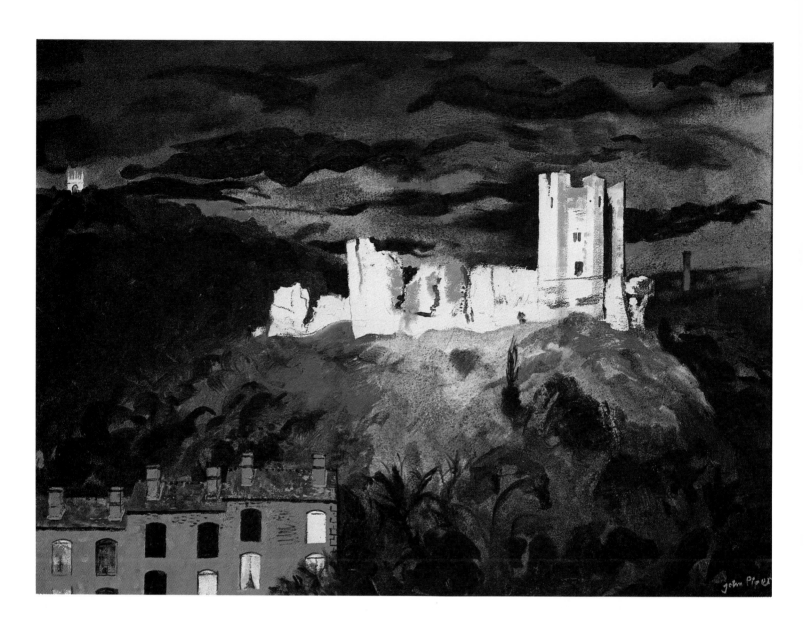

169 Conisborough Castle 1981
30 × 40 (176.2 × 101.6)

171 Newcastle Emlyn 1983
34 × 44 (86.4 × 110.7)

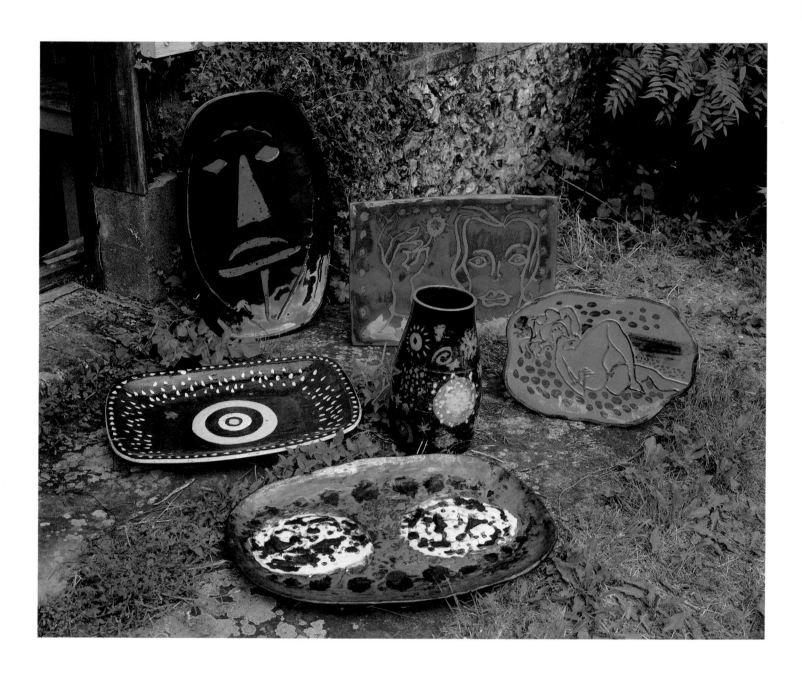

Ceramics 1972–82

Catalogue

Written and selected by David Fraser Jenkins.

In the catalogue entries dimensions are given in inches followed by centimetres in brackets; the height precedes the width.

Works illustrated in colour are marked *

1

Early Paintings and Drawings (1930s)
and 'The Lesser Arts'

1 **The Stoning of St Stephen, copy of stained glass at St Leonard's, Grateley, Hampshire*** 1929

Watercolour, $11\frac{1}{2} \times 11$ (29.2 × 28)
First exhibited: *John Piper: 50 Years of Work*, Museum of Modern Art, Oxford, May–June 1979 (1)
Reproduced: 'England's Climate', Geoffrey Grigson & John Piper, *AXIS* 7, Autumn 1936; *Stained Glass: Art or Anti-Art*, John Piper, 1968, p.18
Mrs John Piper

Grateley parish church preserves some of the medieval glass removed from Salisbury Cathedral, and was well known to Piper who, from the early 1920s, had made up notebooks of English architecture. The copy is full size, and is the earliest of many that he has, some of which were exhibited in 1943 in *The Artist and the Church*, a touring exhibition which Piper arranged for C.E.M.A. He reproduced this in his book on stained glass in 1968, remarking 'On the whole I learnt more about using colours doing this copy than I have ever learned before or since'.

2 **Rose Cottage, Rye Harbour*** 1931

Inscribed 'John Piper'
Watercolour, $14 \times 18\frac{1}{4}$ (35.5 × 46)
Mrs John Piper

Piper's first landscapes were the vignette wood-engravings which illustrated a volume of his own poetry published in 1924, and he exhibited wood-engravings, in a style resembling Paul Nash, in 1927. He painted watercolour landscapes, particularly at Gunwallow in Cornwall, while at the Royal College, and only in the early 1930s began to paint on the South Coast. His oils of this time, exhibited at the London Group from 1931, are of bathers and sea front buildings.

3 **Beach with Shells** 1932

Inscribed 'John Piper'
Pencil, ink, gouache, collaged paper doiley, $19\frac{1}{4} \times 15$ (48.8 × 38.1)
First exhibited: *John Piper*, Ulster Museum, Belfast, March–April 1967 (11, as '1933')
Victoria and Albert Museum

The window-sill still life was popular with English artists for a few years from 1930 for a surrealist effect, but Piper uses the shells, and the curtains represented by a doiley, as straightforward accessories of a seaside interior.

4 **Girls by the Sea*** 1933

Inscribed 'John Piper 1933'
Pencil, chalk, gouache and collage, $15 \times 18\frac{1}{4}$ (38 × 46)
Elisabeth Guinness

The deliberate naivety of painting and the pure colours were used in a comparable way by some members of the *7 & 5 Society* and by Victor Pasmore, who were discussed by Piper in two articles in *The Listener* in March 1933.

5 **Collage with Black Head and Flowers** 1933

Inscribed 'John Piper'
Watercolour and collage, 14×18 (35.6 × 45.7)
First exhibited: *3 British Artists. Henry Moore, John Piper, Graham Sutherland*, Temple Newsam, Leeds, July 1941 (54, as 'The Photograph Frame')
Private Collection

In 1933 Piper painted several still lifes, a subject he rarely touched again. His use of

3

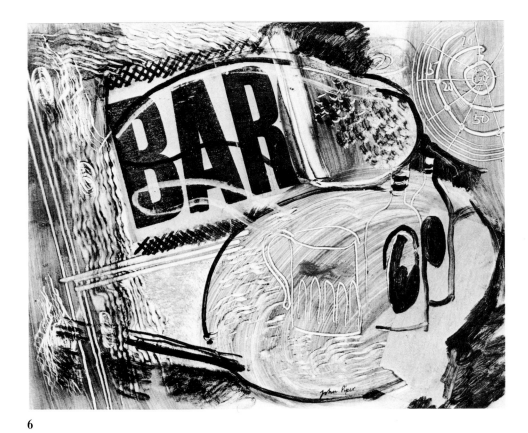

6

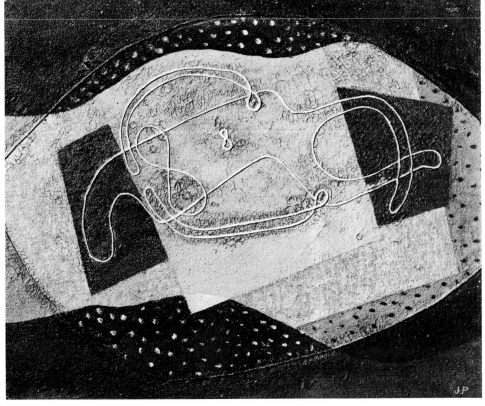

7

black here, and of the undulating lines that run through the whole composition, are indebted to contemporary work by Ben Nicholson.

6 Public Bar 1933

Inscribed 'John Piper'
Gouache and collage,
$14\frac{1}{2} \times 19$ (36.8 × 48.2)
First exhibited: *3 British Artists. Henry Moore, John Piper, Graham Sutherland*, Temple Newsam, Leeds, July 1941 (53)
Mrs John Piper

7 String Solo 1934

Inscribed 'String Figure. John Piper' on reverse
Oil and string on canvas,
18×22 (45.7 × 55.9)
First exhibited: *7 and 5 Society*, The Leicester Galleries, March 1934 (25)
Mrs John Piper

A double page from a sketchbook (reproduced in *John Piper*, Anthony West, 1979, p.15) is filled with similar outline drawings of a woman's figure, which is here imagined to be seen from above, lying on a beach.

8 Sketchbook 1934

Page size, 7×10 (17.8 × 25.4)
Miss M. Angus

The drawings in this sketchbook are of beach scenes and abstractions from them.

'The Lesser Arts'

The Lesser Arts have taken a major place in Piper's working life, and the ironic title from William Morris's essay of 1878 is appropriate, since his career is an example of the vitality that can follow from a close relation between 'The Fine' and 'The Decorative'. Piper's inventions go back always to drawing and colour, but in the actual expression he has often preferred to feel the pressure of the medium. This has extended, uniquely, to his ease in working with a craftsman, so that some of the exhibits are joint productions: glass made by Piper and Reyntiens, ceramics by Piper and Eastop, screenprints by Piper and Prater.

The central room of the exhibition, in addition to the earliest work contains textiles, photographs, posters and illustrations. Most have been lent by the artist, and only those on loan from elsewhere are listed individually.

Posters

a **Clergymen Prefer Shell** 1933/5

Gouache, 25 × 42 (63.5 × 106.7)
Shell U.K. Ltd

One of a group with similar titles commissioned from artists, but not in this case printed.

b **Pink String and Sealing Wax** 1945

30 × 40 (76.2 × 101.6)
National Film Archive, London

Piper made two posters for the Ealing Studios, whose art director was S. John Woods who later wrote the monograph for Faber & Faber, published in 1955. Woods had himself been an abstract painter in the 1930s, when his reviews in the periodical *Decoration* were a rare outlet of favourable criticism for the abstract movement.

c **Cranks** 1956

36 × 48 (91.5 × 122)
Private Collection

Fabric

d **Church Monuments, Exton** 1950s

The Hon. Alan Clark, M.P.

e **Blenheim Gates** 1950s

Dan Klein Ltd

Two fabrics printed for David Whitehead.

f **The Glyders** 1959

Arthur Sanderson & Sons Ltd

g **Stones of Bath** 1962

Arthur Sanderson & Sons Ltd

The fabrics for Sanderson's were reprinted from the original screens for the exhibition, and are two of four designs that he made for them.

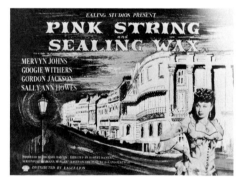

b

Photographs

Ivied Girl at Wootton

A selection from Piper's large collection of his own negatives was printed for the exhibition by Paul Joyce, and are displayed with some of the artist's own prints. The photographs date from the early 1930s, and cover very much the same range of subjects as his paintings. Many were taken specifically for articles in the *Architectural Review* – ruins for 'Pleasing Decay' (1947), for example – and other periodicals, or for the Shell county guides. The subjects before the war were often objects – ironwork, lettering, marine apparatus – but since then have been more usually of buildings in landscape. The primary purpose has always been to record topographical information, and series such as those of early British sculpture or of churches by G.E. Street are an historical record as well as a precocious revaluation.

The landscape photographs are very often to hand when Piper draws the same subject in the studio, along with sketches made at the place and any other available information, but they are not copied. Only in very rare cases – some of the mountain sides in North Wales in the later 1940s and of the Château of Chambord – were photographs squared and transferred to drawings. The quality of these photographs follows from the acuteness of eye of the landscape painter, who sees a subject or conditions of light of more than usual interest. Sometimes the site itself is an important one – a great house or church, or an ancient monument – but the texture of stone, or the fall of light and shade, or the change of scale with perspective, produces a memorable contrast. Sometimes the site is the reverse of important, but worthy of Constable in the appeal of its particularity – a wall, a cottage or a beach. There are not photographs of figures until the studies for 'Eye and Camera' in the 1960s, and in these, like the drawings, the face of the model is invariably concealed.

2

Abstract Works and Landscape Collages (1930s)

Piper began to make abstract relief constructions in the summer of 1934, and it is appropriate to start the exhibition with them, since although he was then aged thirty they are the first group that lead naturally into all his subsequent career. He remained exclusively an abstract artist for about two years, but exhibited abstract work alone for a longer period, from 1935 to 1938. These were also his first works to come to any sort of public attention and – very few – to be sold or commissioned, although the public concerned was hardly more numerous than those who read the art magazines and visited contemporary exhibitions.

Only three constructions still exist, all made in 1934, but there are photographs of another four of the same date and one rather different, free-standing 'Beach Object' of 1937. They were only displayed once, in January 1935, at the out of the way 'Experimental Theatre' in Finchley Road, an exhibition recorded in a review published in the first issue of the magazine *AXIS*. The surprise of their appearance is evident in the remarks:

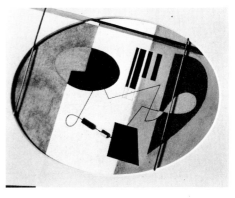

Construction 1934 (destroyed)
Reproduced in *AXIS* 4, November 1935, p.13

> More ingenious are Mr Piper's alarmingly precise and complex 'Constructions', assembled from hunks of cable, rods, drums, ribbed lavatory panes, strips of perforated bluebottle-metal etc., and painted in sober earth colours. They suggest Underground wiring diagrams, or nightmare relief maps such as a neat and gifted electrician might improvise in sleep
> (Hugh Gordon Porteus, *AXIS* 1, January 1935, p.27).

There are a number of preparatory drawings for these, mostly small, some partly made of cut out coloured papers.

The change from landscape to abstract construction was made quite suddenly during 1934, but Piper had previously been searching for a more geometrical and rhythmical style. The constructions are truly non-figurative, and do not depart from some disguised reference to an object, but the shapes, colours and materials are nevertheless related to his preceding drawings and paintings of figures on a beach. This subject disappears from his work after 1933, or rather it becomes absorbed into the abstract paintings. A sketchbook of this year shows this process (cat.no.8). Naturalistic life studies are put together to become a group of seated figures against the sea, and are then further stylised into a linear pattern, rather in the manner of Braque. The planes and textures of the landscape suffer a similar change, until there remains the repertoire of linear shapes, some in movement and some static, and contrasted textures that can be seen, in retrospect, to be near to the language of the abstract paintings. Such a development is described by Piper himself in writing of Edward Wadsworth's abstract paintings in *Apollo* in December 1933:

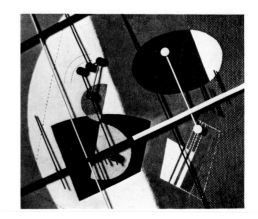

Construction 1934 (destroyed)

In his present work he is speaking a language of pure form ... The analytic outlook of his early work, with its foundations in the appearance of natural objects, has gradually given place to the attitude shown by his recent paintings, each of which, far from being analytic, is a synthesis with a complete life of its own ... The sea has played an important part ... Wadsworth now began to build up his formal structures through objects which were redolent of the sea ... these remarks might be made about his recent pictures, except that there is nothing of the sea about them.

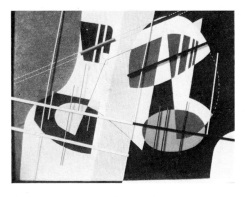

Construction 1934 (destroyed)
Reproduced in *John Piper* by J. John Woods, 1955, pl.14

The most advanced of Piper's transitional works was 'String Figure' (cat.no.7), the outline of a nude on the beach seen from above made with string, exhibited with the *7 & 5 Society* in March 1934, at the same time as Ben Nicholson's abstract 'Six Circles'. The painted constructions are abstract arrangements, the texture varied by using painted wooden rods and metal mesh in the place of prominent lines brought forward from the surface. The association with the beach could not be made by seeing these works alone, although it still lingers in the range of earth and sand colours and in the nautical feel – to be later defined by Piper's photographs for his article 'The Nautical Style' in the *Architectural Review* in January 1938 – of the rigid rods and their junctions.

The abstract paintings of 1935 and 1936 increasingly use a palette of clear reds, blues and whites against a background of black (often the shiny enamel Ripolin) and brown. The move from construction to painting followed also the change of studio from Betchworth in Surrey, where all the earlier constructions were made, to the new house near Henley in February 1935, but the continuity is evident, in the collaged studies and in the contrasted textures of the paintings, often cut through the canvas to the board beneath. The technical process of studying the arrangement in collage, then copying, altering and enlarging in gouache and oil, was established then and has persisted for many of Piper's more important works. Thus the abstract paintings exist in several versions of different sizes, with certain families of shapes. A record exists of about thirty-five of them from these two years, and there must have been more. They are difficult to identify from exhibition catalogues, except where there are photographs, since they were usually titled merely 'Painting', and furthermore there were no catalogue listings between the two *7 & 5 Society* exhibitions in March 1934 and October 1935. The more important works were illustrated and dated in *AXIS* with also, however, a gap over the summer of 1935.

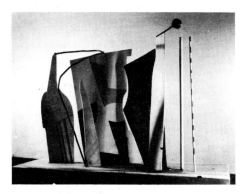

Beach Object 1937 (destroyed)
Reproduced in *The Painter's Object* edited by Myfanwy Evans, 1937, p.71

From 1936 Piper again made landscape collages in addition to the abstract oils, although they were not exhibited for a further two years. The subjects were mostly coastal, of Wales as well as of Sussex, with results more clearly structured than the collages of 1932–3; they were witty in the unexpected choice of printed papers and music for new subjects like Welsh chapels, and most were made out of doors on the spot from a stock of papers. Some landscape subjects led directly to the composition of the larger abstract paintings, and Piper has specified a connection between 'Newhaven' (1936, cat.no.28) and the painting (now at the Museum of Modern Art, Oxford) which is itself a study for 'Forms on Dark Blue' (1936, cat.no.23). The specific connection is now barely visible, but the decisions about balancing colour, shape and texture in the painting, which has evident depth, are comparable to those involved in matching observed landscape to the arrangement of coloured papers.

Piper did not publish before the war any direct statements of his own aims with the abstract paintings but has, since then, referred often to them as an 'exercise', as if dismissively or as if they were incomplete. He was, however, fully committed to the abstract movement in the mid 1930s, and showed repeatedly in its exhibitions. He was secretary of the *7 & 5 Society* at the time of the last, and exclusively abstract, exhibition, and he and Myfanwy, the editor, had from 1935-7 produced *AXIS*, then by far the most successful English language review of abstract art. He was necessarily slightly apart from Hampstead artists since his move out of London, but was personally close to Henry Moore and still frequented the Hampstead studios, although he never subscribed to the ambitious claims that led to the publication of the manifesto *Circle* in July 1937. His dissent from Hepworth and Nicholson's group followed from his belief that the individual quality of his work and others' was more important than the simple question of whether or not they were abstract. When he soon found that he could use these formal qualities within the subject of a landscape or a building he did so; and it is in this sense that the abstract paintings were a discipline. They were beautiful, but for his purposes the style as such became shallow.

The priority in practising abstract art in Britain belongs to Nicholson and Wadsworth, and more importantly to the former, since Wadsworth was personally isolated. Piper was effectively a generation younger than Nicholson as an artist (he had not been invited, for example, to join *Unit One*, which represented the advanced British artists, in 1933-4) and his work was never as refined as were Nicholson's white reliefs, made from late 1934. Piper's constructions, although individual, were made in the same year that not only Nicholson but Sutherland and Ceri Richards made reliefs, and his first wife, Eileen Holding, was making free-standing wooden constructions. It was, nevertheless, a bold step to renounce his earlier landscape oils, and however much it seems now that it was some of the best artists who did so, at the time the group had little support. The compelling example was knowledge of art in Paris, and he was a part of the short lived international style of abstract art. The Pipers were to become friends of Léger, Hélion and Calder, but it remained Picasso who was the greatest influence, both for individual examples and for the variety of the arts he practised. Piper compiled a book of Picasso illustrations from the late 1920s, copying from the originals and from magazines. It is Picasso's handling of collage that lies behind Piper's abstract paintings, and specific comparison could be made for such works as the 1936 collage (cat.no.22). One source unique to Piper was his interest in stained glass painting. His watercolour copy (cat. no.1) of a window at Grateley parish church was one of several made in 1929, and the restricted choice of clear colours in the glass, particularly blue and red, precedes his use of these colours in the abstract paintings, and it has also a kind of drawing – the leads – that is in places independent of the subject. Medieval glass and Romanesque sculpture, the primitive arts that Piper admired, were, typically, English, and both were of influence in his own work.

The new landscape collages were not seen until Piper's first one-man exhibition, held at the London Gallery (usually associated with the surrealists) in May 1938, but his pining at the restrictions of abstract art was apparent in his criticism from late 1936. In an article 'England's Early Sculptors' (*Architectural*

Review, October 1936) he still seemed to hope that abstract painting will become:

> Lucid and popular, not in the least "highbrow"

(an aim very different from that of Barbara Hepworth, for example), but in that autumn's issue of *AXIS* he wrote, jointly with Geoffrey Grigson, 'England's Climate', in which he explicitly states that abstract painting is necessarily limited in comparison to landscape, mentioning Constable, Blake and Turner. He became further involved with topography in the following year when starting work on his first *Shell Guide*, edited by John Betjeman, to his home county of Oxfordshire. He strengthened his friendship with Paul Nash, who had just written and illustrated the Dorset Shell Guide, and who was also returning to a landscape painting enriched by his experience of surrealism. A virtuoso account of feeling an abstract painting in the terms of objects in a room or on a beach is given by Piper in his essay 'Lost, A Valuable Object' in the anthology *The Painter's Object*, edited by Myfanwy Piper in 1937. In this he photographed a new free-standing construction of his and a similar abstract painting, as if at the close of his abstract period he was again, briefly, turning to sculpture as a way back to the real object of painting. The keynote of the anthology was Myfanwy's discussion of Picasso's 'Guernica', displayed in the Paris World's Fair that year, stressing its detached and abstract qualities in addition to its extreme emotion, and going on to appeal for an end to the judgement of value by style. *The Painter's Object*, as a collection of texts, did not mention Hepworth and Nicholson, who were not by habit authors. Equally, *Circle* was published without the knowledge of the Pipers, even though his work was illustrated in it, and these two volumes make clear the divide between these artists by 1937.

Piper's advance from abstraction was not a response to the war (or the phoney war) as is sometimes said, but took place shortly before. The landscape collages increased in number from 1936, but the larger event was that during 1937 he more or less ceased to make abstract oils (although there are a few from 1938, particularly the mural commissioned for Highpoint, the modern flats in Highgate, by Francis Skinner, one of the architects). In turning to landscape he incorporated the formal lessons and the imaginative power of the abstract paintings. His 1938 sets for Stephen Spender's anti-fascist play *Trial of a Judge* had put the actors in front of abstract designs, and his subsequent architectural and landscape paintings brought his fragmented subject also into association with them.

Constructions

9 Construction (Intersection) 1934

Oil on canvas, with painted dowelling, $19\frac{3}{4} \times 23\frac{3}{4}$ (50.2 × 60.3)
First exhibited: Group exhibition at Experimental Theatre, Finchley Road, January 1935 (no catalogue)
Mrs John Piper

In colour and in variation of texture and shape this is the closest of the constructions to the preceding drawings and collages of boats on a beach.

10 Abstract Construction 1934

Verso: Unfinished construction
Oil and sand on wood, with painted dowelling, $21 \times 24\frac{3}{4}$ (53.3 × 62.8)
First exhibited: Group exhibition at Experimental Theatre, Finchley Road, January 1935 (no catalogue, probably included)
Whitworth Art Gallery, University of Manchester

11 Construction 1934, repaired in 1967

Inscribed 'John Piper, Construction, 1934, reconstructed 1967' on reverse
Oil on wood, with perforated zinc, corrugated glass and painted dowelling, $39\frac{5}{8} \times 45\frac{5}{8}$ (100.5 × 116)
Reproduced: *John Piper*, S. John Woods, 1955, pl.13, in original state
First exhibited: Group exhibition at Experimental Theatre, Finchley Road, January 1935 (no catalogue)
Tate Gallery

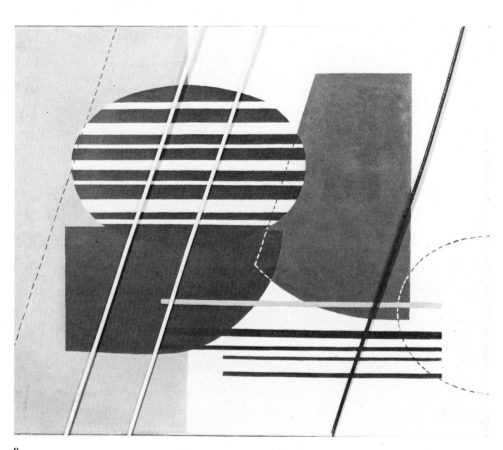

9

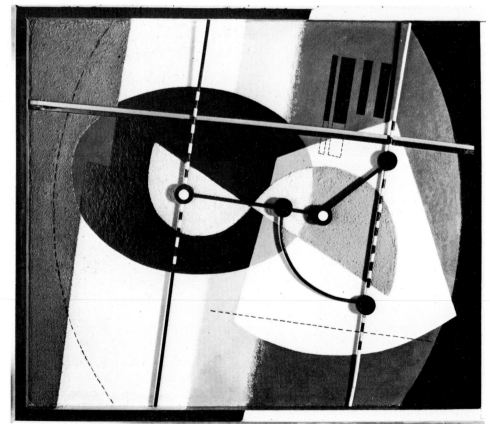

10

12

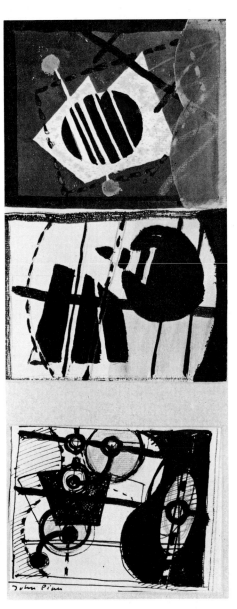

13

12 **Sketch for a Construction** 1934

Inscribed 'John Piper 1933'
Pencil and ink, $5\frac{1}{4} \times 6\frac{1}{2}$ (13.3 × 16.5)
First exhibited: *John Piper, Retrospective Exhibition*, Marlborough New
London Gallery, March 1964 (9, repr.)
Private Collection

This and a similar small collage were later
signed by the artist and dated 1933, but they
are studies for the Tate Gallery's construction of 1934

13 **Three Sketches for Constructions**
1934

Pencil, ink and gouache,
each $4 \times 5\frac{1}{2}$ (10.1 × 14)
First exhibited: *John Piper*, Ulster
Museum, Belfast March–April 1967
(20, repr.)
Private Collection

The top sheets have variations of a
construction related to 'Construction (Intersection)' (cat.no.9), and the lower sheet a
more rhythmic version of the Tate Gallery's
construction, comparable to one illustrated
in *AXIS*, 1, January 1935.

14 **Drawing for a Construction** 1934

Ink and collage, $14\frac{1}{2} \times 19$ (36.8 × 48.3)
First exhibited: *John Piper*, Ulster
Museum, Belfast, March–April 1967
(19, repr.)
Mrs John Piper

[83]

Abstract paintings and drawings

**15 A Few Forms Moving:
 Two Canvases in Relation** 1935

Inscribed 'A few forms moving. John
Piper. 1' on reverse of one, and '2' on
reverse of the other
Oil on canvas, each 10 × 12 (25.3 × 30.5)
First exhibited: *An Exhibition of Paint-
ings in Connection with a scheme to pro-
vide a permanent Gallery for the constant
display of works by Contemporary
Painters and Sculptors*, Thos Agnew &
Sons Ltd, January 1937 (18, as 'A Few
Forms Moving, 1935')
Mrs John Piper

These are the only paintings of Piper's that
are a pair in such a way, and they make use
visually of the collage of coloured papers
that preceded them to present the same
elements in a different combination.

16 Study for a Painting 1935

Inscribed 'Sketch for an abstract
painting 1937. Collage. John Piper' on
reverse, recently
Collage of painted papers,
4 × 4⅞ (10.2 × 12.4)
Mrs John Piper

17 Painting* 1935

Inscribed 'Painting 1935' on reverse,
recently
Oil on canvas over panel, partly cut,
46 × 34½ (116.8 × 87.6)
First exhibited: *7 & 5, Fourteenth
Exhibition*, Zwemmer Gallery, October
1935
Reproduced: *Decoration*, 7, November
1935 (review of *7 & 5* exhibition by
S. John Woods); *Behind Appearance*,
C.H. Waddington, 1969, p.56, col.pl.18
Private Collection

Piper's largest painting of this year, it
dominated his wall of the all-abstract
Zwemmer Gallery exhibition, where he
showed seven works all titled 'Painting 1935'
(except for one 'Drawing 1935'). At the same
exhibition Ben Nicholson showed seven
'Carved Reliefs' and two 'Paintings'.
 A small oil study for this painting is

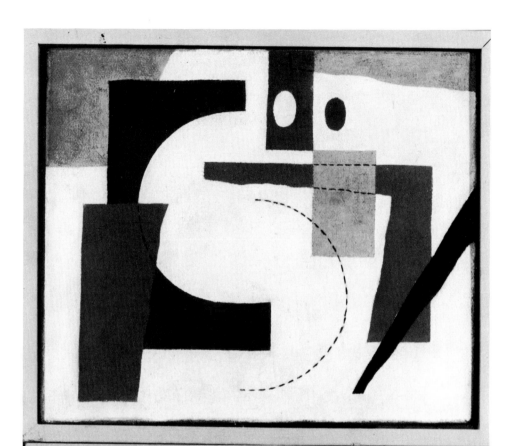
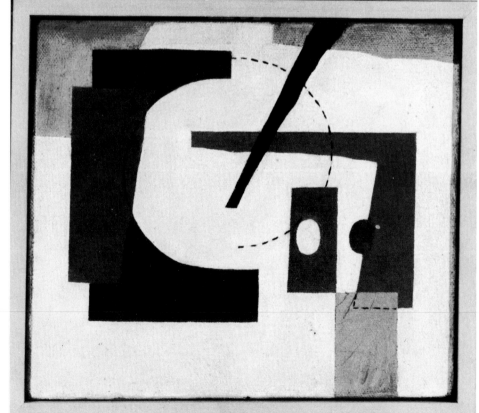

15

illustrated in *AXIS 5*, Spring 1936, and belongs to the National Museum of Wales, Cardiff (oil on panel, $15\frac{1}{2} \times 11\frac{1}{4}$ (39.4 × 28.6)).

18 Painting 1935

Inscribed 'Abstract Painting. John Piper 1935' on reverse
Oil on canvas over panel, partly cut,
$12\frac{1}{4} \times 16$ (31.2 × 40.6)
First exhibited: *7 & 5, Fourteenth Exhibition*, Zwemmer Gallery, October 1935 (repr. in catalogue sheet (10))
Reproduced: *AXIS 4*, November 1935 (colour, as 'Drawing for Painting (1935)'); *Decoration, 7, November 1935* (review of *7 & 5* exhibition by S. John Woods)
Rodney Capstick-Dale

19 Painting 1935

Inscribed 'John Piper. Painting 1935' and 'For Salon d'Automne' on reverse
Oil on canvas over panel, partly cut.
$19\frac{1}{4} \times 24\frac{1}{2}$ (48.9 × 62.2)
First exhibited: *L'Art Anglais, Salon d'Automne*, Palais de Chaillot, Paris, November–December 1938 (1919)
Private Collection

21

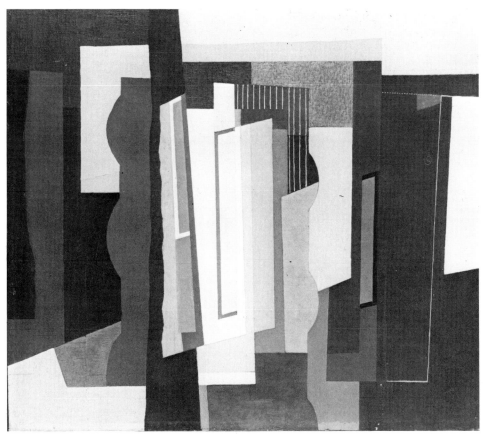

20 Abstract II 1935

Oil on canvas over panel, partly cut,
$11\frac{1}{2} \times 15\frac{1}{2}$ (29.5 × 39.7)
First exhibited: *Abstract and Concrete, an international exhibition of abstract painting and sculpture today*, Oxford, February 1936 and tour, including Alex. Reid & Lefevre, Ltd, April 1936 (5, as 'Painting, 1935')
Arts Council of Great Britain

A photograph of the 1936 exhibition at Lefevre identifies this, hanging beneath a construction by Domela (p.43).

21 Abstract I 1935

Inscribed 'John Piper. Painting 1935' on reverse
Oil on canvas over panel, with attached canvas and partly cut,
$36\frac{1}{4} \times 42$ (91.5 × 106.5)
First exhibited: *Abstract, Cubist, Formalist, Sur-Realist*, Redfern Gallery, April–May 1954 (376)
Reproduced: *Circle*, J.L. Martin, Ben Nicholson and Naum Gabo, eds, 1937, pl.25
Tate Gallery

A group of smaller paintings (not exhibited) show variations on these particular shapes, amongst which are:

a 'Painting 1935'
18×22 (45.7 × 55.8)
Reproduced: *AXIS 4*, November 1935; *John Piper*, S. John Woods, 1955, pl.19
S. John Woods

b 'Painting 1935'
$26 \times 30\frac{1}{4}$ (66 × 76.8)
Reproduced: *John Piper: 50 years of work*, Museum of Modern Art, Oxford, pl.16
Mrs John Piper

c 'Forms on Blue 1935'
22×27 (55.8 × 68.6)
Reproduced: *John Piper*, S. John Woods, 1955, pl.22 as 'Abstract Painting'
Private Collection

22 Abstract Composition* 1936

Inscribed 'John Piper '36'
Ink and collage of papers painted in watercolour, and scrim,
$14\frac{1}{4} \times 17\frac{3}{4}$ (36.2 × 45.1)
First exhibited: *John Piper,*

Retrospective Exhibition, Marlborough
New London Gallery, March 1964 (27)
Victoria and Albert Museum

A study for a painting, and midway between
the more rectilinear compositions of 1935,
all of which include a circle or half circle,
and the more open compositions of 1936
with smudged edges and inclined lines.

23 Forms on Dark Blue 1936

Inscribed 'Forms on Dark Blue 1936'
and 'Painting 1936' on reverse
Oil on canvas, 36 × 48 (91.4 × 121.9)
First exhibited: *Constructive Art*, The
London Gallery, July 1937 (37)
Mrs John Piper

Small studies for this are at the Museum and
Art Gallery, Reading and the Museum of
Modern Art, Oxford. The final version,
'Forms on Dark Blue', 62 × 76 (157 × 193)
was exhibited at *Abstract and Concrete* at the
Lefevre Gallery in 1936 and is reproduced on
the catalogue cover of the 1964 Marlborough
New London Gallery exhibition. This was
acquired by the architect Serge Chermayeff,
but has since been destroyed by fire.

24 Abstract Composition 1936

Watercolour and gouache,
$7\frac{1}{4} \times 9\frac{3}{4}$ (18.4 × 24.7)
Mrs John Piper

A study for a painting, and similar to but
probably later than the large 'Forms on a
Green Ground', 1936 (artist's collection)
which was reproduced in *Circle* and included
in the Artists' International Association
exhibition at 41 Grosvenor Square, April
1937.

25 Two Groups 1937 and 1964

Inscribed 'Two Groups 1937, oil and
ripolin' and 'repaired by JP 1964' on
reverse
Oil on canvas over panel, partly cut,
12 × 14 (30.5 × 35.6)
First exhibited: *John Piper*, The
London Gallery Ltd, May 1938 (11)
Mrs John Piper

The 1937 abstract paintings have a more
varied range of colours and quicker rhythms
than those of the previous two years, and in
some cases seem to have an association, like
this painting, with a still life subject.

26 Abstract Composition 1937

Gouache and white chalk,
$7\frac{1}{4} \times 9\frac{3}{4}$ (18.4 × 24.7)
First exhibited: *John Piper*, Ulster
Museum, Belfast, March–April 1967
and tour (31)
Mrs John Piper

A study for the large painting 'Screen for the
Sea' 1938 (Scottish National Gallery
of Modern Art, Edinburgh) which was
amongst those shown at the London Gallery
exhibition of that year and which had titles
ambiguously both abstract and marine.

27 Abstract Composition 1938

Inscribed 'John Piper'
Colour lithograph, 24 × 18 (71 × 46)
First exhibited: *Lithographs in Colour*,
The Leicester Galleries, September–
October 1938 (7)
Mrs John Piper

This print is a slightly less abstract and more
still life-like version of the drawing 'Inven-
tion in Colour', reproduced as a frontispiece
to the periodical *Signature*, 6, July 1937. It
was one of two prints – the other being the
extraordinarily long 'Nursery Frieze' –
which Piper made for Contemporary Litho-
graphs Ltd. This venture, directed by
Robert Wellington and largely organised by
Piper, intended 'to make original modern
pictures available to a wide public', and
advertised the 'Abstract Composition', for
example, at 25/–.

Landscape Collages

28 Newhaven 1936

Inscribed 'John Piper'
Ink, gouache, oil and collage of printed
texts, scrim and marbling,
15 × 20 (38 × 51)
First exhibited: John Piper, *Retrospective Exhibition*, Marlborough New
London Gallery, March 1964 (25,
repr.)
Private Collection

A comparison was made by the artist between this collage and an abstract painting
like 'Forms on Dark Blue' (cat.no.23):

'There is thus really no gap between my
topographical and abstract paintings.
The degree to which the one has been the
raw material for the other can be seen by
comparing the painting 'Newhaven' with
'Abstract No.21' . . . both dating from the
same year, 1936' (*Christian Science
Monitor*, 16 February 1966)

The cliff face is made from a torn page of
The New Statesman and Nation, 9 December
1933.

29 Newhaven 1936/38

Inscribed 'John Piper'
Ink, watercolour, gouache and collage,
$15\frac{1}{2}$ × 19 (39.4 × 48.2)
Mrs John Piper

30 Avebury* 1936

Inscribed 'John Piper' and 'Archaeological Wiltshire. Avebury 1936'
Ink, watercolour, gouache and collage,
with blotting paper,
$15\frac{1}{2}$ × 24 (39.4 × 53.3)
First exhibited: *John Piper*,
Retrospective Exhibition, Marlborough
New London Gallery, March 1964 (20)
*Scottish National Gallery of Modern Art,
Edinburgh*

Avebury had been the subject of a number of
Paul Nash's most important watercolours
and oil paintings since his first visit there in
1933, and this subject for Piper was a
hommage to Nash as much as to the place.
Piper's article 'Prehistory from the Air' was
published in the final volume of *AXIS*
('early winter', 1937), illustrated by aerial
photographs of Avebury and other sites, and
his ink drawing of this view was reproduced
in 'London to Bath . . . written and illustrated by John Piper' (*Architectural Review*,
June 1939, p.242)

31 Aberaeron 1936

Ink, collage of music and coloured
papers, 15 × 20 (38.1 × 50.8)
Mrs John Piper

Made on Piper's first working visit to West
Wales.

32 Aberaeron 1936

Inscribed 'John Piper' and, on the
reverse, 'Aberayron 1936'
Ink, chalk, watercolour and collage,
with printed papers,
16 × 19 (41.3 × 52.9)
First exhibited: *John Piper*, The
London Gallery Ltd, May 1938 (20,
probably this version)
Sheffield City Art Galleries

29

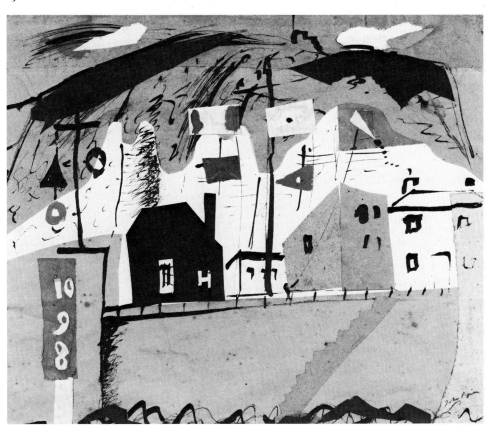

The printed papers used in this and other collages were collected from waste at the Curwen Press, and here include fragments of a print by Barnett Freedman which was later used on the slipcase for the periodical *Signature* in 1940. The same print was also used in one of the few dated collages 'Grongar Hill' of 1938 (National Museum of Wales, Cardiff)

33 Welsh Nonconformist Chapels

1937

Ink, watercolour and collage, with printed papers
Five drawings mounted together by the artist:

a 'Llanon, Cardiganshire'
 Inscribed with colour notes and 'Chapel at Llanon near Aberayron, Cardiganshire'
 15 × 12 (38.1 × 30.4)

b 'Tyrhos, near Cilgerran'
 Inscribed 'Tyrhos Near Cilgerran'
 11¾ × 11½ (29.7 × 29.2)

c 'Red Roses'
 Inscribed 'Red Roses 1812'
 11 × 10 (27.9 × 25.4)

d 'Rhydygwyn'
 Inscribed with notes to printer
 12 × 10½ (30.4 × 26.2)

e 'Emmaus'
 Inscribed 'EMMAVS'
 10 × 11 (25.4 × 27.9)

First exhibited: *John Piper*, The London Gallery Ltd, May 1938 (30, as 'Nonconformist Record')
National Museum of Wales, Cardiff

One of two such composite mounts of Welsh chapels, these drawings can be said to be the first in which Piper's architectural interests, already expressed in his notebooks and in the Oxfordshire *Shell Guide* (1937), are combined with the colours and techniques of the abstract collages.

32

33

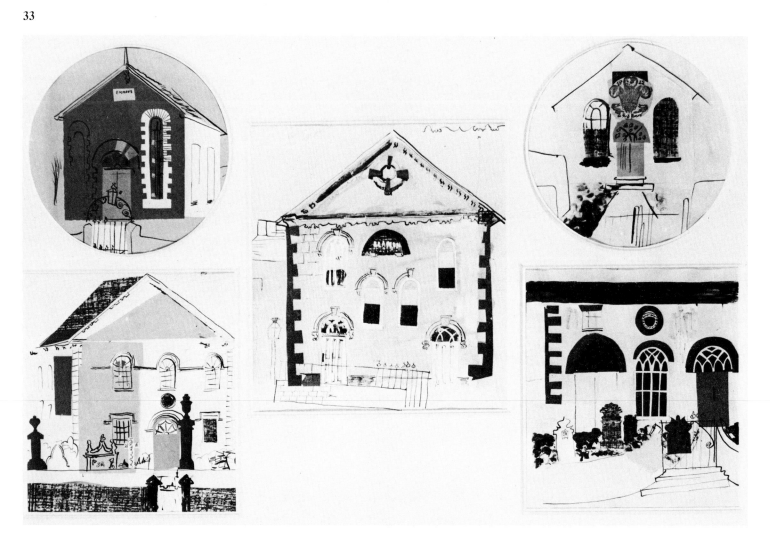

3

Picturesque Landscape and War Artist (1940s)

The January 1940 issue of *Signature* included an advertisement for:

<div align="center">

John Piper's

BRIGHTON AQUATINTS

</div>

This illustrated book was a startling revival of a style that had not been seen for about a century, and perhaps the choice of Lord Alfred Douglas as author of the text that came with it was also a gesture to the past. It was modelled on the English 'picturesque' travel books of the late eighteenth and early nineteenth centuries, which had themselves used aquatint as a medium, and had the format of a brief text on each plate, headed by an extravagant variety of typeface as a title page. Piper's illustrations were not, however, nostalgic, but sharply contemporary, for the emphasis was not on the Regency buildings but on the variety of styles existing in the town as it was in 1939, including a gothic revival church, the Pier, a house by Wells Coates and modern housing. The extravagance of Brighton allowed a technique that was almost a capriccio of different styles of building put together – as in Piper's 'Lithographic Panorama of Cheltenham', published in the same issue of *Signature* – and hence a collage-like method of composition. As with the abstract paintings, they seem to be assembled from a variety of flat pieces.

The pursuit of the picturesque style was deliberate and was cultivated by his collecting, with John Betjeman, the illustrated books of the period, such as Gilpin's *Tours* or Smith's *Hafod*. He sought out British watercolours of the time and visited the sites that had been popular. In October 1939, for example, with an interest revived by Kitson's recent book on the artist, he arranged to look at the collection of Cotman drawings belonging to Sir Michael Sadler (whose range of taste was similar, in that he also owned modern works including a Picasso papier collé), and in the following year borrowed one of them, of a Welsh subject, since in the meantime he had been there to paint the same view. The curious perspective of Cotman's watercolours, organised into parallel planes like stage flats, are comparable to Piper's oils of Hafod, Stourhead and Cheltenham of 1939–40, and there is a close connection in some of the watercolours of Hafod and those made for the 'Recording Britain' scheme organised by the Pilgrim Trust in 1939 (both groups are in the collection of the Victoria and Albert Museum). These oils were his first since the final abstracts of 1937–8, and the colours are similar, with the addition of a yellow that was to become more pronounced in the pictures of bomb damage.

The Contemporary Art Society bought 'Dead Resort, Kemp Town' (cat.no.34) from a group exhibition in the summer of 1939, his first sale to a public

institution. The following March, Piper held a one-man exhibition at the Leicester Galleries, at which pictures of Hafod, Brighton, Fonthill and such places sold well. It is arguable that such English subjects appealed for patriotic reasons in 1940, but Piper's treatment of them was by no means traditional – Betjeman correctly described them as 'abstract versions of English landscapes'. It is difficult to assess correctly the public significance of his style at the time. The mood of the editorial of the first issue of *Horizon* (January 1940, with a cover designed by Piper) was that now 'Our standards are aesthetic and our politics are in abeyance'. This is relevant in that Piper had appealed for such a situation in the practice of art from at least 1937, and the enforced truce in the battle of styles meant that intellectual taste and his own were now more in line, and it was also for that reason that his work appealed.

From April 1940 Piper was alternately working for the War Artists' Advisory Committee and privately for himself. He was not continually deferred military service, but given particular commissions from time to time. His first tasks, to paint the underground Air Raid Precaution control room at Bristol and transport subjects at York, were not inspiring, and he arranged with Sir Kenneth Clark, who chaired the Committee, in early November that he should paint destroyed churches. His subject caught up with him, and learning of the massive bombing raid on Coventry on 14 November while he happened to be nearby, he got there early the following morning, before the clearing up. He drew St Michael's Cathedral Church and St Mary's Hall as they were still smoking, and later elaborated two paintings, of the exterior and interior of St Michael's (cat.nos.44 and 45). The empty architecture of large walls matches his already spare treatment of buildings, and the details of rubble and roof timbers are ignored in preference to a clear, rectangular scheme. The fine canvas is glued to a panel and scratched away in places to the white ground, or into a rough surface. The disjunction of abstract and topographical allows a very evident sense of order, while the reference to the architecture is both minimal and dramatic. In December he completed paintings of four churches in Bristol, and began to work in London. These subjects he chose himself, with Clark's continuing approval. Paintings of underground factories requested by the Ministries of Information and of Aircraft Production although begun were not completed, but again he responded to the opportunity when the Houses of Parliament were bombed on 10 May 1941, and drew the interior of the Commons

It was following his first paintings of the blitz that Piper began a series of 'ruined cottages'. The first was painted in 1941 (cat.no.41), and is the closest to Samuel Palmer of all his paintings; he had already painted ruins, but not by moonlight or of such a rural building. It is remarkable that his long-standing interest in Palmer had not shown itself more forcefully earlier on, but it was strengthened now by his preparation of *British Romantic Art* (published 1942) and by his closeness to the Clarks, who were also enthusiasts. The series continued into 1943, and included a group of five ruins painted as a decoration for one of the publicly provided 'British Restaurants' (destroyed, but designs are in the Arts Council Collection).

At the same time Piper received two important commissions to paint houses, Renishaw for Sir Osbert Sitwell and Windsor Castle for the Queen. He was already, by choice, a painter of country houses, satisfying an historical interest

as well as cultivating an English tradition – although unlike their eighteenth century predecessors, the owners of the houses did not usually become the owners of the paintings, and furthermore he did not choose to paint contemporary buildings. The motive behind these views was the threat of their destruction, whether directly by bombing or indirectly by the upheaval of war. At Windsor the threat was felt to be real, and the Queen commissioned both a photographic record and the personal record of an artist. She was shown Piper's work in galleries by Clark, and asked for the set of drawings in August 1941. In so far as his military service was postponed for this time, the commission was an extension of his War Artists work. These watercolours are more linear and less insistently abstract than the earlier oils of churches. The example of Paul Sandby, who had drawn a similar series of Windsor for George III, was relevant to this graphic technique, and it was probably Clark's appreciation of Piper's style that led to the proposal for watercolours rather than paintings. The wartime spirit is evident: the contrast of grey sky and sunlit stonework gives the buildings a feeling of vulnerability – as if imagined to be seen through the sights of an enemy aeroplane.

The later work for the War Artists' Advisory Committee was also all in watercolour. In late April 1942 Piper was hurriedly sent to Bath, where a 'Baedecker raid' had destroyed churches and fine buildings. Seven watercolours were accepted by the Committee. The sense of the violation of these buildings was more savage than in the Coventry paintings, and they are his first paintings with a truly theatrical lighting effect, details spotlit against dark surroundings. Piper had already worked in two stage productions, and there was in addition a mutual influence between his and Sutherland's war work. In general their subjects were different and close to their strongest feelings – Piper with English architecture, Sutherland with distorted machinery or parts of buildings – but Sutherland's work in the East End of London in May 1941, exhibited along with the other War Artists in the National Gallery that October, had already used such dramatic lighting and acid colours, in part itself developed from Piper's earlier work.

Towards the end of the war Piper was briefly an 'Official War Artist', attached to the Ministry of Transport and asked to record railway yards and 'Coastwise shipping, loading of unusual cargoes, etc.' (letter of 18 July 1944). It was unfortunate that it was the shipping and not lighthouses that he had to paint, and these subjects were less successful than the trains, which he viewed from high ground in an extensive landscape.

The war work and paintings of houses and landscapes went together, as can readily be seen in the successive pages of a 1941 sketchbook (cat.no.51). The feeling that is implicit in these views was only overt in the scenery for Ashton's ballet 'The Quest', first performed on 6 April 1943. The narrative was adapted from Spenser's 'Faerie Queene' and by its nature was patriotic, including an allegorical figure of Britannia. The painted cloths (one repainted for this exhibition, (cat.no.69) in this context, even if their sources in Inigo Jones and Oxfordshire buildings were not recognised, must have been appreciated as a wartime style.

The Picturesque

34 Dead Resort, Kemptown 1939

Inscribed 'John Piper'
Oil on canvas over panel, partly cut,
18 × 22 (45.7 × 55.8)
First exhibited: *Artists of Fame and Promise*, The Leicester Galleries, Summer 1939 (134, as 'Dead Resort')
Leeds City Art Galleries

One of Piper's 'Preoccupations' listed by Myfanwy Piper (Marlborough Fine Art catalogue, March 1963) for the 1930s was 'An empty stage', which is particularly relevant to this small oil with its absence of people (it was painted in the winter) and flat geometry.

The subject was Arundel Terrace, Kemptown, but severely simplified.

35 Brighton Aquatints 1939

Text and twelve aquatints, introduction by Lord Alfred Douglas
Page size, 10 × 25$\frac{1}{2}$ (25.4 × 64.7)
Mrs John Piper

A series of prints bound together in the manner of volumes of illustrations of 'Picturesque' sites, such as country houses or interesting towns, which had been published in Britain from the late eighteenth century. Piper had worked with John Betjeman on the *Shell Guide* to Oxfordshire, and was preparing one for Shropshire, and the Brighton Aquatints reflect their broad architectural tastes. Anthony West has pointed out the appeal of the aquatint medium to Piper in necessitating a formal and planar description of the subject, comparable to the abstract paintings. The plates were printed at weekends at the Royal College of Art with the assistance of a Mr Malcolm of the staff of the Victoria and Albert Museum, and some sets were coloured by hand.

36 The Garden at Stourhead 1939

Inscribed 'John Piper'
Watercolour, ink and collage,
16 × 22 (40.7 × 55.9)
Mrs John Piper

A collage made out of doors at the place, recording as precisely as possible the outlines of the trees and buildings.

37 Autumn at Stourhead* 1939

Inscribed 'John Piper'
Oil on canvas over panel, 25 × 30
(63.5 × 76.2)
First exhibited: *John Piper*, The Leicester Galleries, March 1940 (29)
City of Manchester Art Galleries

The garden at Stourhead is the most thorough-going example of a landscape arranged as a picture, and hence of the 'Picturesque' style of late eighteenth century garden, and was attractive to Piper as he re-assessed the style at the moment when his own work was both landscape and artificial arrangement. The collage is an unusually exact study for a landscape painting.

38 Italian and Gothic, Hafod 1939

Inscribed 'John Piper Hafod 1939'
Watercolour and ink, 14$\frac{1}{4}$ × 20
(36.2 × 50.8)
First exhibited: *John Piper*, The Leicester Galleries, March 1940 (17)
Literature: 'Decrepit Glory: a Tour of Hafod', John Piper, *Architectural Review*, June 1940 (repr. p.209)
National Museum of Wales, Cardiff

Piper rediscovered Hafod, the ruined country house near Aberystwyth, which had once been the subject both of one of the finest books of illustrated tours (by J.E. Smith, 1810) and of an important watercolour, in part imaginary, by J.M.W. Turner. His article on the house and its grounds, published in the *Architectural Review*, gives a detailed history of its building and subsequent history, and when he visited it in 1939 it had only just been abandoned, the last owner dying the year before. He chose to stress the contrast of different styles of architecture, and selected here the maximum difference between two parallel facades of the building:

'In lively sunshine the round Italianate arches and balustrades of Salvin's addition throw sharp shadow on the recessed walls behind them. Grey weather and rain suit the delicate Gothic of the older wing. The contrast of Gothic and Italian, the stucco and granite, are contrasts of the sad,

ruminative imagination and the brisk life of their builders. Tragedy, on the whole, has triumphed at Hafod.'

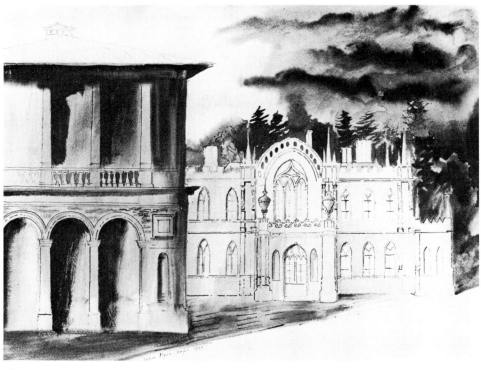

38

39 Lacock Abbey 1940

Inscribed 'John Piper'
Oil on canvas over panel,
23 × 48 (58.4 × 122)
First exhibited *British and French Paintings*, Lefevre Gallery, March 1942 (35)
Private Collection

Lacock Abbey in Wiltshire, notable as the home of the photographer Fox-Talbot, was drawn by Piper in the winter of 1940 while staying in Bristol to record the bombed churches.

40 Seaton Delaval 1941

Inscribed 'John Piper' and on reverse 'Seaton Delaval Northumberland. John Piper. 1941 oil 35 × 28'
Oil on panel, 28 × 34¾ (71 × 88.5)
First exhibited: *Contemporary British Painting*, British Council, Sweden 1947–8 (43)
Literature: 'Seaton Delaval', John Piper, *Orion*, 1945
Tate Gallery

The dramatic quality of Vanbrugh's architecture was particularly suited to Piper's treatment of light and shade. A companion painting of 'Castle Howard' (private collection), slightly smaller, was made the following year, and he later painted Blenheim Palace. His account of his visit to the ruined Seaton Delaval describes the character of the people who lived there and the emotional quality of the buildings, which he saw as a parallel to the destruction of British cities during the war:

> 'The centre block . . . ochre and flame-licked red, pock-marked and stained in purplish umber and black, the colour is extremely up to date: very much of-our-times . . .'

40

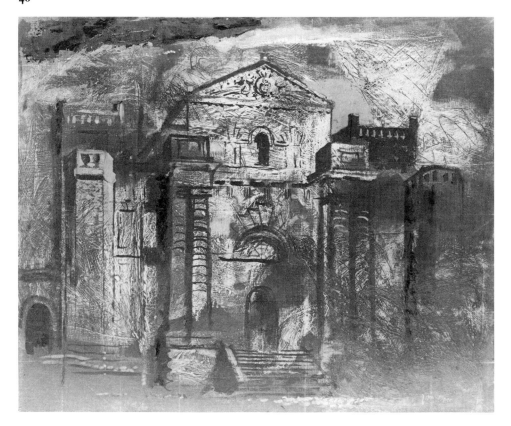

41 Derelict Cottage 1941
Inscribed 'John Piper'
Oil on canvas over panel,
25 × 30 (63.5 × 76.2)
First exhibited: *3 British Artists. Henry Moore, John Piper, Graham Sutherland,*

Temple Newsam, Leeds, July 1941 (46, dated 'March 1941')
J. Carter Brown

A cottage near the Roman Wall in Cumberland, visited shortly after Seaton Delaval. This is the finest of a series of ruined buildings, and it is also the closest to Samuel Palmer's watercolours of cottages in moonlight.

42 Two Nudes about 1942

Inscribed 'John Piper'
Ink, chalk, watercolour and gouache, $14\frac{1}{2} \times 21\frac{3}{4}$ (36.7 × 55.2)
Mrs John Piper

There are occasional life drawings throughout Piper's career, almost all of friends rather than models. The figures are invariably sketched quickly and with more attention to rhythm than accuracy, often with an extreme sensuousness, as is also the case with the much later 'Eye and Camera' series. Here the two figures are placed as if in a landscape, as were a number of nudes of 1933–4. The model lying on her back was taken from an earlier drawing of 1939, and added to a study of the same figure reclining.

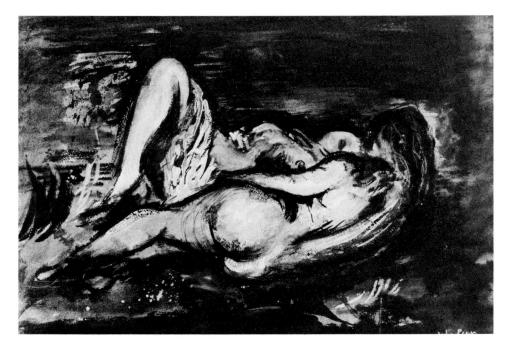

42

The War Artist 1940-1

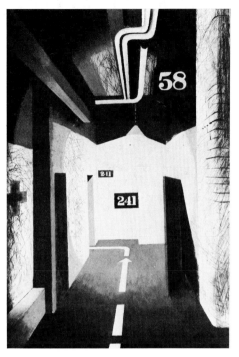

43

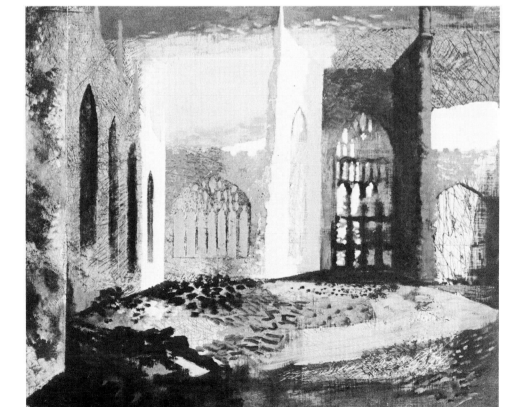

45

43 **The Passage to the Control Room at S.W. Regional Headquarters, Bristol** 1940

Oil on panel, 30 × 20 (76.2 × 50.8)
First exhibited: *British War Artists*, National Gallery, July 1940
Trustees of the Imperial War Museum

Two paintings of an Air Raid Precaution Control Room, painted in May 1940, were Piper's first official war work. He recalls his fascination in finding modern style typefaces in use with the army.

44 **Coventry Cathedral, November 15th, 1940*** 1940

Inscribed 'John Piper 1940'
Oil on canvas over panel, 30 × 25 (76.5 × 63.5)
First exhibited: *War Pictures at the National Gallery*, October 1941 (repr. in colour)
Reproduced: *Horizon*, III, 13, January 1941
City of Manchester Art Galleries

45 **Interior of Coventry Cathedral, November 15th, 1940** 1940

Inscribed on reverse 'Interior of the Cathedral, Coventry; Nov. 15 1940 John Piper'
Oil on canvas over panel, $19\frac{3}{4}$ × 24 (50.2 × 61)
First exhibited: *War Pictures at the National Gallery*, October 1941
Herbert Art Gallery, Coventry

A painting of Coventry Cathedral was sent by Piper to the War Artists' Advisory Committee on 24 November, ten days after the raid on the 14 November. This was his first painting of bomb damage, and was made from sketches made on the morning following the raid.

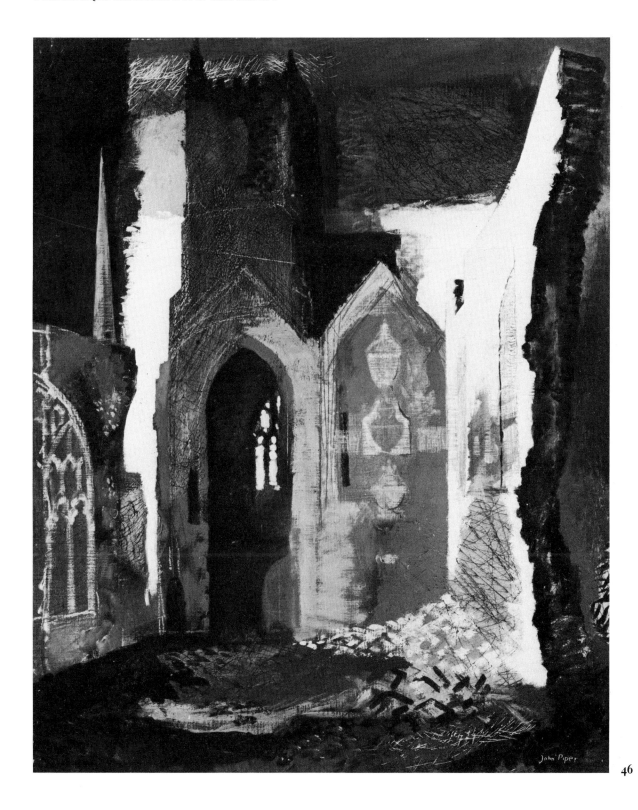

46

46 St Mary le Port, Bristol 1940

Inscribed 'John Piper'
Oil on canvas over panel,
30 × 25 (76.5 × 63.5)
First exhibited: *National War Pictures*,
National Gallery, 1942
Tate Gallery

This raid on Bristol took place on 24
November, and Piper's instructions were to
record damaged churches.

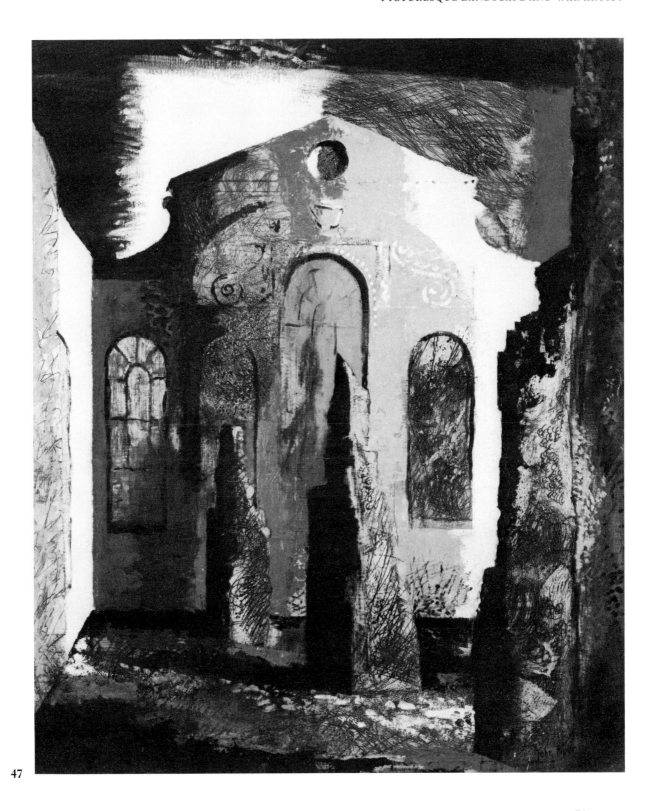

47

47 **Christ Church, Newgate Street,
after its Destruction in 1940** 1941

Inscribed 'John Piper' and on reverse
'Christ Church, Newgate Street, Jan
1st 1941'
Oil on canvas over panel,
$30\frac{1}{4} \times 20\frac{1}{4}$ (76.8 × 51.4)
First exhibited: *War Pictures at the
National Gallery*, October 1941
Museum of London

In December and January 1940–1 Piper
painted several London churches destroyed
in the Blitz. This Wren Church, with its tall
bases for columns, has been left unrestored
today as a memorial. A study of this painting
belongs to the British Council, and there is a
rough pencil sketch, probably done on the
spot, in the 1941 sketchbook (cat.no.51). It is
interesting that this shows Piper making
colour notes ('Naples', etc.) as he saw large
areas of colour in the ruins.

48 The House of Commons after Bombing 1941

Ink, watercolour and gouache,
$14\frac{1}{4} \times 18\frac{1}{2}$ (36.2 × 47)
First exhibited: *John Piper: 50 Years of Work,* Museum of Modern Art, Oxford, May–June 1979 (32)
Dudley Art Gallery

49 The Ruined Aye Lobby, House of Commons 1941

Ink, watercolour and gouache,
19×15 (48.3 × 38.1)
First exhibited: *John Piper: 50 Years of Work,* Museum of Modern Art, Oxford, May–June 1979 (33)
Dudley Art Gallery

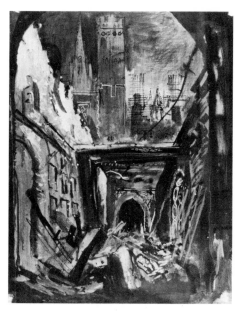

48 49

50 The Ruined House of Commons 1941

Inscribed 'John Piper' and on reverse 'Study for War Painting of Ruined Council Chamber, House of Commons, John Piper 1941'
Ink, watercolour and gouache,
$24\frac{3}{8} \times 29\frac{1}{2}$ (62 × 75)
First exhibited: *International Art Exhibition,* British Council, Cairo, 1947
Walker Art Gallery, Liverpool

The House of Commons was bombed on 1 May 1941. Piper completed two oil paintings, one of the interior of the Commons Chamber (now hanging in the Palace of Westminster), which is his largest war subject, 36×48 (91.4 × 121.9), the other of the interior of the Aye Division Lobby (National Gallery of Canada, Ottawa). The two watercolours at Dudley are early studies for these two subjects, and include more detail than either of the final versions. In the paintings, like those of Coventry, Bristol and London, the features and the colours are simplified and clarified. The watercolours were bought privately from the artist in 1948, and were not exhibited by him.

The watercolour at Liverpool is a final study for the painting of the Commons Chamber, and a different view from the sketch at Dudley.

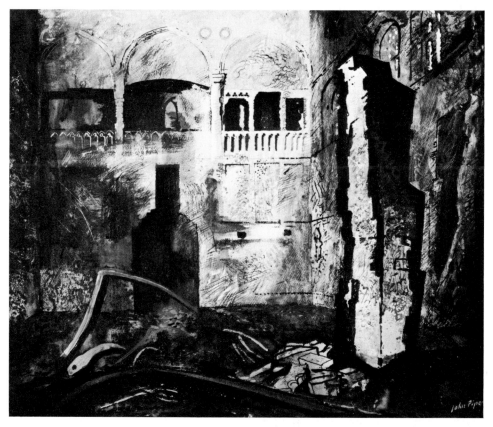

50

51 Sketchbook 1941

Page size, 8×6 (20.3 × 15.2)
Brinsley Ford

Acquired from the artist by the present owner in October 1941, this includes archi-

tectural studies (Kirby Hall, West Wycombe Park, Tretower, Llanthony Abbey), studies of bomb damage in London (St Bride's Fleet Street, the House of Commons) and illustrations for the cover and title page of Sir Thomas Browne's *Urne Buriall* (not published until 1946).

Windsor Castle

52 Round Tower and View over Eton* 1942

Inscribed 'John Piper'
Ink, watercolour and gouache, $15\frac{3}{4} \times 20\frac{3}{4}$ (38.1 × 52.7)
First exhibited: *John Piper: 50 Years of Work*, Museum of Modern Art, Oxford, May–June 1975 (38)
Her Majesty, Queen Elizabeth, The Queen Mother

53 Distant View of the Castle from the North 1942

Inscribed 'John Piper'
Ink, watercolour and gouache, $16 \times 20\frac{3}{4}$ (40.7 × 52.7)
First exhibited: *John Piper*, King's Lynn Festival, July 1983
Her Majesty, Queen Elizabeth, The Queen Mother

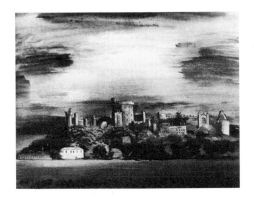

53

54 The Town Hall, Windsor, with the Castle 1942

Inscribed 'John Piper'
Ink, watercolour and gouache, $15\frac{1}{2} \times 21\frac{1}{2}$ (39.4 × 54.6)
First exhibited: *John Piper*, King's Lynn Festival, July 1983
Her Majesty, Queen Elizabeth, The Queen Mother

55

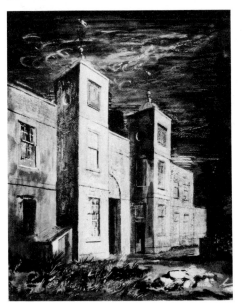

55 Entrance to Stable Block, Frogmore 1942

Inscribed 'John Piper'
Ink, watercolour and gouache, 21×16 (53.3 × 40.7)
First exhibited: *John Piper*, King's Lynn Festival, July 1983
Her Majesty, Queen Elizabeth, The Queen Mother

56 The Lower Ward seen from below the Round Tower 1942

Inscribed 'John Piper'
Ink, watercolour and gouache, $25\frac{1}{2} \times 30\frac{1}{2}$ (64.7 × 77.5)
First exhibited: *John Piper*, King's Lynn Festival, July 1983
Her Majesty, Queen Elizabeth, The Queen Mother

A series of twenty-six watercolours of Windsor was completed in 1941–2, all of which now hang in a single room at Clarence House. There is in addition a further completed watercolour in the collection of the National Museum of Wales, which was redrawn by the artist since it was made up of several pieces of paper. The initiative for the commission came from Sir Kenneth Clark, who:

'. . . is sending me to Windsor to do watercolours for the Queen . . . Took her round the Galleries to show her my works and has apparently got me deferred from H.M. Armed Forces indefinitely. I am to do 15 to start with and, if they are approved, 100 or so. Grottoes etc. at Frogmore, interiors and exteriors of Castle, etc. I am naturally excited . . . I follow unworthily in the footsteps of Paul Sandby, who did 200 water colours for George III which I am instructed to look at earnestly before starting' (Piper to Betjeman, 23 August 1941. Collection of University of Victoria, British Columbia).

Apart from the Castle exterior and roof, the series includes landscapes in Windsor Great Park, the ruins at Virginia Water, Frogmore and several outbuildings. It was implicit in the commission that a record was to be made because there was a danger that the Castle would be bombed.

The War Artist 1942-4

57 All Saints Chapel, Bath 1942

Inscribed 'John Piper'
Ink, chalk and watercolour,
$16\frac{3}{4} \times 22$ (42.5 × 56)
First exhibited: *War Pictures at the
National Gallery*, 1942
Tate Gallery

58 Somerset Place, Bath 1942

Inscribed 'John Piper'
Ink and watercolour, $19\frac{1}{4} \times 30$ (49 × 76)
First exhibited: *National War Pictures*,
National Gallery, October–November
1945 (223)
Tate Gallery

These two watercolours, of buildings opposite one another, are from a group of seven of Bath, from sketches drawn on 30 April. Unlike the 1940–1 paintings of churches these were all in watercolour, and included records of private houses in the town.

59 Train Ferry at Dover Harbour 1944

Inscribed 'John Piper'
Ink, watercolour and gouache,
$22\frac{3}{4} \times 28\frac{3}{4}$ (58.1 × 72.7)
National Maritime Museum, Greenwich

**60 American Locomotives Awaiting
Transhipment on the Foreshore at
Cardiff** 1944

Inscribed 'John Piper'
Ink, watercolour and gouache,
$22 \times 27\frac{1}{4}$ (55.8 × 69.2)
First exhibited: *National War Pictures*,
National Gallery, October–November
1945 (933)
*Ferens Art Gallery, City of Kingston upon
Hull Museums and Art Galleries*

During the brief period when he was an 'Official War Artist' – as opposed to receiving successive small commissions – Piper worked on railway yards and agricultural subjects.

61 Land Reclamation 1944

Ink, watercolour and gouache,
$15\frac{5}{8} \times 25\frac{3}{8}$ (39.7 × 64.4)
Birmingham Museum and Art Gallery

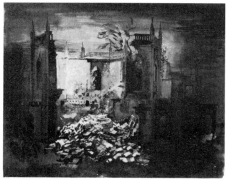

57

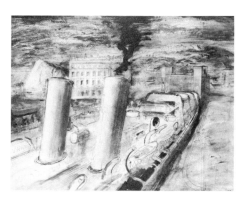

59

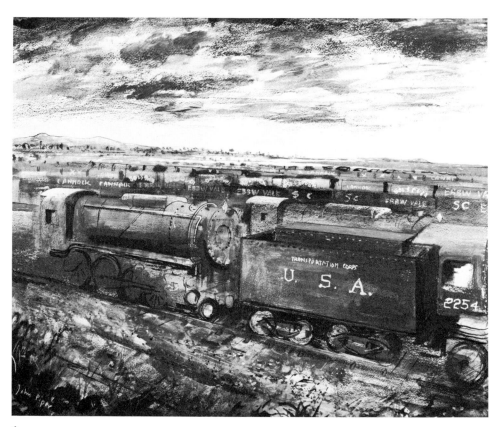

60

61

As part of the reclamation of land for sowing during the war the Fens were ploughed for the first time, and a number of fossilised trees were exposed. Since Piper was attached to the Ministry of Agriculture he was summoned to record this specimen near Swaffham Bulbeck before it was broken up.

4

Stage Designs

Details of Productions are given in the 'Summary Biography', page 41.

Trial of a Judge 1938

62 Two Set Designs

 a Act I, Scene I
 Inscribed 'Trial of a Judge. Act I,
 Sc.I. John Piper'
 Watercolour, $9 \times 12\frac{1}{2}$ (22.8×31.7)
 b Act II, Scene I
 Inscribed 'Trial of a Judge. Act 2,
 Sc.I. John Piper'
 Watercolour, $8\frac{1}{2} \times 12\frac{1}{2}$ (21.6×31.7)
 First exhibited: *Designs by Various
 Artists for Decoration in the Theatre,*
 C.E.M.A., 1943 (5)
 Hon. Alan Clark, M.P.

These are the watercolours used by Piper when himself painting the scenery, and a more stylised version of the Act II design (collection of Victoria and Albert Museum), with stencilled lettering, was intended for display.

Façade 1942

63 Front Cloth*

 Ink, watercolour, gouache and marbled
 papers, $16\frac{1}{2} \times 21\frac{3}{4}$ (42.5×55.2)
 Private Collection

The circle at the centre of the design was for the mouth of the megaphone, through which was spoken Edith Sitwell's verse.

The Quest 1943

**64 Backcloth, outside the House of
 Archimago**

 Watercolour and gouache,
 $10 \times 14\frac{1}{2}$ (25.4×36.8)
 First exhibited: *Exhibition of Ballet
 Design,* C.E.M.A., 1943–4 (123)
 The Royal Ballet Benevolent Fund

65 Backcloth, The Palace of Pride

 Watercolour and gouache,
 $9\frac{1}{2} \times 15$ (24.2×38.1)
 First exhibited: *Exhibition of Ballet
 Design,* C.E.M.A., 1943–4 (124 or 125)
 The Royal Ballet Benevolent Fund

66 Front Drop

 Watercolour and gouache,
 9×14 (22.8×35.6)
 The Hon. Alan Clark, M.P.

**67 Three Costume Designs, Sloth,
 Wrath and Lechery**

 a Inscribed 'Quest III Sloth. John
 Piper 1943'
 Ink, watercolour and gouache,
 $12\frac{1}{4} \times 9$ (31.7×22.8)
 b Inscribed 'Quest III Wrath. John
 Piper 1943'
 Ink, watercolour and gouache,
 $12\frac{1}{2} \times 9$ (31.7×22.8)
 c Inscribed 'Quest III Lechery. John
 Piper 1943'
 Ink, watercolour and gouache,
 $13\frac{1}{2} \times 8$ (34.2×20.3)
 First exhibited: *Exhibition of Ballet
 Design,* C.E.M.A., 1943–4 (126 a–c)
 The Royal Ballet Benevolent Fund

68 Backcloth, Scene V

 Inscribed 'for Myfanwy from JP April 6
 1943'
 Watercolour and gouache,
 $14\frac{1}{4} \times 21\frac{1}{4}$ (36.2×54)
 Mrs John Piper

For the final scene Piper partly used a design by Inigo Jones for Sir William Davenant's *Luminalia,* 1638 (reproduced in black and white in *The Walpole Society,* XII, 1923–4, p.308) and added on either side a gothic folly.

69 Backcloth, Scene V

 Tate Gallery

Painted from cat.no.68 for this exhibition by Mary Coxon, at The Paintshop at The Playhouse, Nottingham.

The Rape of Lucretia 1946

70 **Set Design, The Camp outside Rome**

Inscribed 'John Piper'
Ink and gouache, $14\frac{1}{4} \times 20\frac{1}{4}$ (36.2 × 51.4)
First exhibited: *Stage Designs by John Piper for Benjamin Britten's Opera 'The Rape of Lucretia'*, The Leicester Galleries, October 1946 (122)
Mrs John Piper

71 **Set Design, A Room in Lucretia's House in Rome**

Inscribed 'John Piper'
Ink, watercolour and gouache,
$15 \times 20\frac{3}{4}$ (38.1 × 52.7)
First exhibited: as cat.no.70 (19)
Victoria and Albert Museum

72 **Model, A Room in Lucretia's House in Rome**

$15\frac{1}{4} \times 20\frac{1}{4} \times 21\frac{1}{2}$ (38.7 × 51.4 × 54.6)
First exhibited: as cat.no.70 (22)
Theatre Museum, Victoria and Albert Museum

73 **Chorale Cloth**

Watercolour and gouache,
$20\frac{1}{4} \times 22$ (51.4 × 55.9)
First exhibited: as cat.no.70 (one of 11 to 16)
Birmingham Museum and Art Gallery

During the Interlude in Act II the Chorus sing a Christian hymn in front of this cloth. Piper recalled in a discussion of this that he turned to the colours and outlines of stained glass for this design.

Albert Herring 1947

74 **Set Design, Lady Billow's House**

Ink, watercolour, gouache and collage,
15×21 (38.1 × 53.3)
First exhibited: *John Piper*, Festival Gallery, Aldeburgh, June 1983 (2)
Sir Peter Pears

75 **Set Design, Mrs Herring's Shop**

Ink, watercolour, gouache and collage,
15×21 (38.1 × 53.3)
First exhibited: *John Piper*, Festival Gallery, Aldeburgh, June 1983 (3)
Sir Peter Pears

76 **Set Design, The Marquee at the Vicarage***

Ink, watercolour, gouache,
$15 \times 21\frac{1}{4}$ (38.1 × 54)
First exhibited: *John Piper*, Festival Gallery, Aldeburgh, June 1983 (4)
Sir Peter Pears

77 **Drop Curtain, Loxford**

Ink, watercolour, gouache and collage,
$15 \times 19\frac{1}{4}$ (38.1 × 48.9)
Private Collection

Job, Being Blake's Vision of the Book of Job 1948

78 **Backcloth, Hell***

Inscribed 'John Piper'
Ink and gouache, $16\frac{1}{4} \times 22\frac{1}{4}$ (41.2 × 56.5)
First exhibited: *Ballet Designs*, British Council, 1950
Theatre Museum, Victoria and Albert Museum

79 **Backcloth, The Earth**

Inscribed 'John Piper'
Ink and gouache, $15 \times 21\frac{3}{4}$ (38.1 × 55.2)
Theatre Museum, Victoria and Albert Museum

71

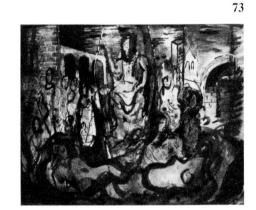

73

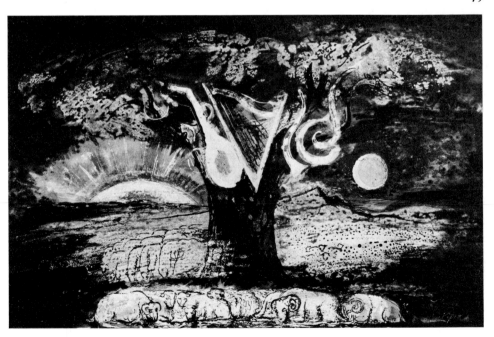

79

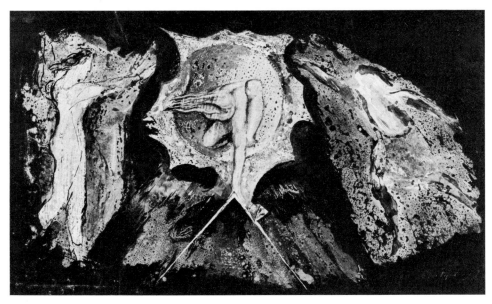

80

80 Backcloth, Heaven

Inscribed 'John Piper'
Ink and gouache, $13\frac{1}{4} \times 22\frac{1}{4}$ (33.7×56.5)
*Theatre Museum, Victoria and Albert
Museum*

These designs were based on William Blake's
engraved black and white illustrations to the
Book of Job.

81 Model for Scene 2, Satan Usurps the Throne

$17 \times 35\frac{1}{2} \times 24\frac{1}{2}$ ($43 \times 90 \times 62$)
*Theatre Museum, Victoria and Albert
Museum*

Built for the British Council by Ralph Dyer,
1949, and reconstructed 1965.

Combattimento di Tancredi e Clorinda 1951

82 Backcloth

Ink, chalk and gouache,
$13\frac{1}{2} \times 21\frac{1}{4}$ (34.3×53.9)
Victoria and Albert Museum

Don Giovanni 1951

83 Backcloth*

Inscribed 'To Moran; Thanks and
good wishes, John Piper'
Watercolour, $11\frac{3}{4} \times 19\frac{3}{4}$ (30×50)
Moran Caplat

The set was based in part on buildings at
Montepulciano in Umbria.

Billy Budd 1951

84 Model, Above Decks, H.M.S. Indomitable, 1797

85 Model, Below Decks, H.M.S. Indomitable, 1797

Each $24 \times 32 \times 19$ ($61 \times 81.3 \times 48.3$)
Tate Gallery

The models for both scenes were recon-
structed for the exhibition from the original
plans by Michael Northen, who had made
the first models from Piper's designs in
1951.

84

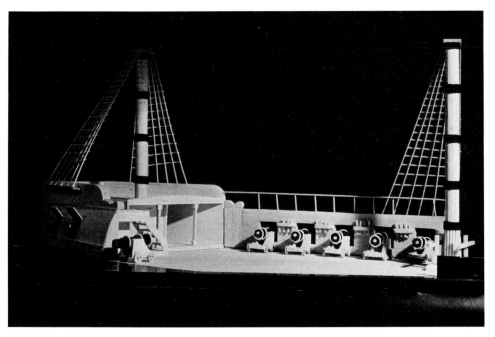

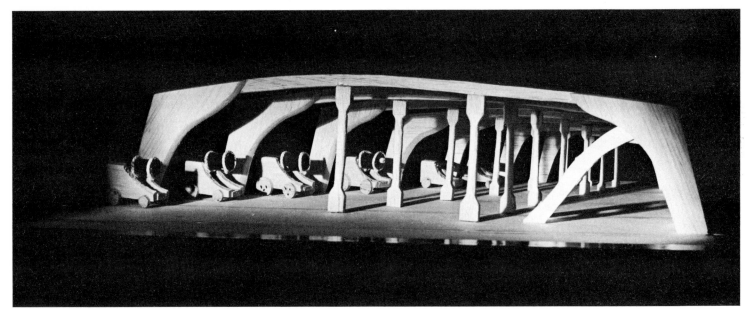

85

86 Costume Designs	*The Prince of the Pagodas* 1957

86 Costume Designs

Four watercolours, each $22 \times 14\frac{3}{4}$
(55.8×37.5)
Inscribed 'Donald...';
'The Novice...'; 'Two Midshipmen
(who sing)...'; 'Squeak and 6 other
corporals...'
Mrs John Piper

Dancing 1952

87 Set Design

Inscribed 'Sketch for "Dancing"
Ballet by John Cranko 1952, John
Piper'
Chalk and gouache,
$12\frac{1}{2} \times 18$ (31.7×45.7)
Mrs John Piper

Cranks 1956

88 Set Design*

Inscribed 'Scene design for "Cranks",
revue by John Cranko 1954' on reverse
(recently)
Watercolour and collage on hessian,
18×24 (45.7×61)
Mrs John Piper

The design resembles the 'Foliate Heads'
that Piper had begun to draw, after roof
bosses in churches, from 1953.

The Prince of the Pagodas 1957

89 Set Design, Act I

Watercolour construction,
$16\frac{5}{8} \times 30\frac{1}{4}$ (42.2×76.8)
First exhibited: *Ten British Stage
Designers*, British Council, Sao Paulo
Biennale 1959
*Theatre Museum, Victoria and Albert
Museum*

A Midsummer Night's Dream 1960

90 Model for Act 2, The Palace

Watercolour construction,
$19\frac{1}{2} \times 28\frac{3}{4} \times 4\frac{1}{2}$ ($49 \times 73 \times 11.5$)
Mrs John Piper

Owen Wingrave 1973

91 Model for The Hall at Paramore

$20\frac{1}{2} \times 36 \times 24$ ($52 \times 91.4 \times 61$)
Royal Opera House, Covent Garden

The model was made by Norman Darling
from Piper's designs, and the painted por-
traits were drawn by Edward Piper

94

Death in Venice 1973

92 Model

24 × 32 × 19 (61 × 81.3 × 48.3)
The Artist

Reconstructed for the exhibition with the assistance of Michael Northen, from drawings copied from the original designs.

93 Cloth design, The Interior of St Mark's 1974

Inscribed 'John Piper'
Ink and watercolour,
19 × 35 (48.2 × 88.9)
First exhibited: *John Piper*, Marlborough Fine Art, September–October 1975 (repr.)
Sir Peter Pears

94 Cloth Design, The Exterior of St Mark's 1974

Inscribed 'John Piper'
Ink and watercolour,
21 × 40½ (53.3 × 102.8)
First exhibited: *John Piper*, Marlborough Fine Art, September–October 1975 (45, repr.)
The Artist

95 Cloth Design, The Arrival at the Lido, 1974*

Inscribed 'John Piper'
Ink and watercolour,
20½ × 41¾ (52.1 × 106)
First exhibited: *John Piper*, Marlborough Fine Art, September–October 1975 (49)
Her Royal Highness The Princess Margaret

The three cloth designs were used in the revival of the opera at The Maltings, Snape and at the Royal Opera House, some projected and some painted onto screens.

5

The Landscape Painter:
Renishaw Hall and North Wales (1940s)

Piper's landscapes of the 1940s rediscovered the 'Sublime', a category of painting identified in the romantic period as an expression of anxiety, and found particularly in certain British landscapes. His war paintings, including the drawings of Windsor Castle, were all special cases either in subject or commission, but left to himself Piper looked most often to the landscape of Snowdonia. His work there followed a homage to the most sublime of all English landscapes, Gordale Scar in Yorkshire, which had been painted by James Ward during the Napoleonic Wars. Piper, in his by comparison tiny oil painting (cat.no.102), perfected a particular colouring and rough application that was to influence his work for the next ten years. It incorporates his loose drawing style so that there is on the surface a feeling of rapid handwriting, and the varied textures that had been contrasted schematically are bound into the geological structure. 'Gordale Scar' was however only a homage, and the later scenes of mountains are more personal and direct: it was a necessary preliminary, just as the picturesque views had come before his country house paintings. Throughout this period he was also engaged on his most extensive commission, a series of watercolours and oil paintings of Renishaw Hall and its grounds for its occupant Sir Osbert Sitwell, who is still referred to by the artist as 'my patron'. These are also treated in a manner so dramatic as to be sublime – appropriately enough for a house that contained Salvator Rosa's masterpiece 'Belisarius'. The association with this connoisseur and author was a unique benefit to Piper, and both men knowingly took up their roles as last patron and artist.

Renishaw Hall, in Derbyshire, not far from Sheffield, was not only the Sitwell's home but a vital part of Sir Osbert's autobiography, the first volume of which, *Left Hand, Right Hand*, was published in March 1945. A considerable part of the autobiography is in fact about his father, Sir George Sitwell, whose passion for garden design is evident at Renishaw and was recorded by Piper. The drawings were commissioned ostensibly for reproduction in the volumes, but equally, like those of Windsor Castle, they were to preserve a record of the association between the family and the house, garden and countryside that seemed to be threatened, although by different forces. So Sir Osbert wrote of these works, introducing the exhibition 'The Sitwell Country' at the Leicester Galleries in January 1945:

> At the very moment when the great English houses, the chief architectural expression of their country, are passing, being wrecked by happy and eager planners, or becoming the sterilized and scionless possessions of the National Trust, a painter has appeared, to hand them on to future ages, as Canaletto or Guardi handed on the dying Venice of their day, and with an equally

inimitable art. And so it was to this painter, Mr. John Piper, that I turned when I began to write my autobiography, for in that book I was trying to record a way of life, as well as my own adventures, in my own medium; and I asked Mr. Piper to record, in his, the setting.

The series was begun in July 1942, when Piper first stayed at Renishaw. He had met Sir Osbert early in 1940 over the latter's enthusiasm for the *Brighton Aquatints*, which he reviewed, and he had then worked with the Sitwells on a revival of the recital 'Façade' in 1942, and for which his stage cloth showed buildings reminiscent of Renishaw. The 1945 exhibition included thirty-eight views, selected from a larger number. They were of interiors and of the roofs (a subject to which he was to return twenty years later at Chambord) as well as the house and garden, and also of other great houses in the county: Hardwick, Bolsover and Sutton Scarsdale. The association continued when after the war Piper visited the Sitwell villa, Montegufoni, near Florence, and, finally, before Sir Osbert retired to Italy in the mid 1960s, he installed in the hall at Renishaw, fitted around the chimneypiece, three large paintings of Venice. The paintings and drawings remain at Renishaw crowded into halls, over staircases and in studies and bedrooms; the patron and the house still survive in them, as does Lord Egremont's Petworth in the Turner's of the 1820s.

For more than a generation there had been no significant paintings of the mountains of North Wales before Piper first went there in 1943. He visited with the commission to paint the underground quarry in Manod mountain, where the National Gallery paintings, and others, were being stored. Staying in Festiniog he toured by bicycle, and drew Wilson's waterfall 'Pistyll Cain', a ruined cottage in one of the passes and a distant view of the mountains from Tomen-y-Mur, chosen because it was an ancient site (cat.no.105). The mountains became for him the sublime at first hand, not mediated through historical association, for even such romantic drawings as Cornelius Varley's are quite different and lack the sense of geological structure which is so important. The series continued from about 1944 into the early 1950s. Piper rented two cottages, successively, high in the mountains where he stayed for a few weeks at a time, most often during the winter, so that a detailed knowledge of the geography guided his looking, as his knowledge of architecture had directed his paintings of buildings. His photographs of Snowdonia dwell on the texture of the rocks and cliff faces, and in the watercolours this is elaborated in close-up views in grisaille. Experiencing directly the toughness of the landscape he transferred this to the drawings, exploiting here as elsewhere in his work the so-called 'pathetic fallacy', the idea that the landscape has a human sensitivity. Kenneth Clark at the same time concluded his *Landscape into Art* with the belief that 'the best hope for a continuation of landscape painting consisted in an extension of the pathetic fallacy, and the use of landscape as a focus for our own emotions'. Piper's sketches drawn on the spot include comments on the weather, in which he clearly sees the landscape as something personal, as in this private note, written near the summit of the Glyders:

Mist blowing across all day: visibility about 15–20 yards only; curious sensation in presence of gigantic boulders, giant coffin slabs, pale trunk-

shaped rocks, disappearing into grey invisibility even at close range. The affectionate nature of the mountain not changed by the acute loneliness and closed-in feeling induced by the mist: but an atmosphere of an affectionate cemetery.

The landscapes of Snowdonia were displayed in London for the first time only at the Leicester Galleries in December 1948, for Piper's previous exhibition had been of the designs for Benjamin Britten's Opera 'The Rape of Lucretia'. Had it not been for this delay, his 1940s work might not have been promoted in quite the same way as it was as 'Neo-Romantic'. This plausible term was taken from Robin Ironside's book *Painting since 1939*, published by the British Council in 1947, although written two years earlier, which illustrated as its Piper 'Gordale Scar'. It was part of a series 'The Arts in Britain', and the author was obliged to look for the specifically British. The abstract arts (and Roger Fry's criticism) were discredited by Ironside, in place of subject matter and emotion. Thus under the heading *Emergence of the Neo-Romantic Spirit* he wrote:

> It is the broad truth that British painting since 1939 has accomplished, or almost accomplished, the revival of a liberal conception of the art as a creative instrument for the communication, not simply of those specialised emotions that the felicitous arrangement of forms and colours may arouse in us, but also for the communication by imagery, whether the imaginative vision be naturalistic or not, of any emotion whatever.

So style was again seen as an issue, emotion versus abstraction, as if the hatchet, buried during the war, was now disinterred and found to have the chopper at the other end. The subsequent reaction was bitter, and Piper's work would have been better understood by artists and critics if his work since 1943 had been known.

The term 'neo-romantic' was first borrowed from literary criticism by Raymond Mortimer in 1942 (New Statesman, 28 March, referred to by Robert Hewison in *Under Siege: Literary Life in London 1939–45*, 1977, p.149) when he was putting into categories modern works in a group exhibition at the London Museum, where Piper showed a country house view of 1941. Mortimer chose 'Euston Road', 'Surrealist', 'Constructivist' and 'Neo Romantic' (Hodgkins, Sutherland, Hitchens, Moore and Piper). In the same year was published Piper's *British Romantic Artists*. His own work was included by implication in this original and beautifully written study along with Hodgkins, Nash and Sutherland, who are actually mentioned. This selective history of British art was a thoroughly personal idea of the 'romantic', in which Piper stressed always that it was reality that was poetic, and fantasy and the imagination less so, and hence he included Constable, Pinwell and Sickert as well as Turner, Blake and Palmer. The origin of this idea can be seen in the unexpected inclusion of de Chirico's essay on Courbet in *The Painter's Object*, which discourses on the meaning of romantic: 'Every work of art embraces this sense of reality, and the deeper that sense is, the more poetic, the more romantic, will it be'.

The understanding of the 'neo-romantic style' in the years following the war stressed too much the association with Blake, Samuel Palmer, fantasy and

literature. Some artists exhibiting then for the first time after suffering a forced delay took up the palette of grey, mauve and yellow, the thorn shapes of Sutherland, the schematic colour planes of Piper of 1938–40 and the rural subjects, and even saw the outstanding Continental influence, Picasso, in the same terms. Just at this time an exact – but uncharacteristic – example of 'neo-romanticism' furthered the limited meaning of this term when the 'Masque for Dancing' by Geoffrey Keynes and Gwen Raverat, 'Job', was revived by Sadlers Wells Ballet in 1948. The subject was 'Blake's Vision of the Book of Job', and although Piper was the obvious choice as designer his sets and drop curtains were explicitly intended as derivations from Blake's drawings (cat.nos 78–81), and were not totally original works of his own.

Renishaw Hall

96 The North Front, Renishaw Hall*
1942/3

Oil on canvas, 18 × 30 (45.7 × 76.2)
First exhibited: *The Sitwell Country…
by John Piper*, The Leicester Galleries,
January 1945 (17)
Reproduced: *Cruel Month*, Sir Osbert
Sitwell, 1945
Private Collection

98 The Lake in Summer, Renishaw
1942/3

Inscribed 'John Piper'
Ink, watercolour and gouache,
15 × 20 (38.1 × 50.8)
First exhibited: *The Sitwell Country…
by John Piper*, The Leicester Galleries,
January 1945 (30 or 32)
Reproduced: *The Scarlet Tree*, Sir
Osbert Sitwell, 1946, opp. p.232
Private Collection

97 Derbyshire Domains 1942/3

Oil on canvas, 39¾ × 155 (98.4 × 392)
First exhibited: *The Sitwell Country…
by John Piper*, The Leicester Galleries,
January 1945 (47)
Private Collection

The houses are, from left to right: the ball-
room at Renishaw; Sutton Scarsdale; the
triumphal arch at Renishaw; Renishaw;
Barlborough; Hardwick Hall; Bolsover
Riding School. One of two paintings of this
format, made to hang at either side of the
entrance hall at Renishaw, over bookcases.
Its companion painting is a composition of
views of Renishaw roofs.

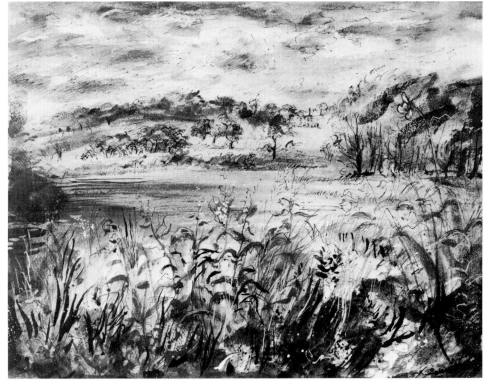

98

97

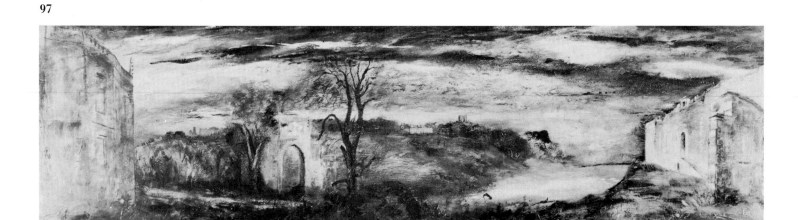

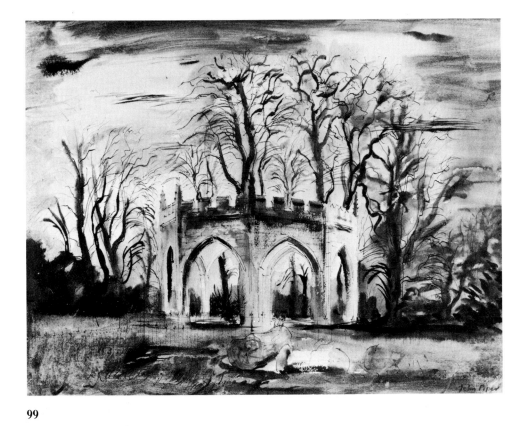

99

99 **The Gothic Temple, Renishaw**
1942/3

Inscribed 'John Piper'
Ink and wash $17\frac{1}{2} \times 22\frac{1}{2}$ (44.4 × 57.2)
First exhibited: *The Sitwell Country ...
by John Piper*, The Leicester Galleries,
January 1945 (20)
Reproduced: *The Scarlet Tree*, Sir
Osbert Sitwell, 1946, opp. p.137
Private Collection

100 **The Entrance to the Wilderness at
Renishaw** 1942

Inscribed 'John Piper'
Ink, watercolour and gouache,
21 × 17 (53.3 × 43.7)
Reproduced: *Cruel Month*, Sir Osbert
Sitwell, 1945, opp. p.233
Private Collection

101 **The Moon over the Lake, Renishaw**
1942/3

Inscribed 'John Piper'
Ink and watercolour,
15 × 20 (38.1 × 50.8)
Private Collection

These drawings and paintings (cat.nos 96–101)
are selected from at least fifty that Piper
made of Renishaw Hall and nearby country
houses, which were commissioned by Sir
Osbert Sitwell in 1942. Many were repro-
duced in his autobiography, published in five
volumes from 1945 to 1949. The majority
were watercolours, and most of these in
grisaille. The house was generally painted
in overcast weather, and the lake often by
moonlight. Sir Osbert, in his 'Preface' to the
1945 exhibtion at the Leicester Galleries,
defended them against the charge of being
'over sullen' by recounting his witness of
such a scene as it was drawn '... we were
treated to every form of tenebrific effect, of
celestial limelight, with, as it were, cloud
slides ...'

102 Gordale Scar 1943

Inscribed 'John Piper' and on reverse
'Gordale Scar. John Piper'
Oil on canvas, 30 × 25 (76.2 × 63.5)
First exhibited: *Quelques Contemporains
Anglais*, 28 Avenue des Champs Elysées,
Paris, 1945 (36)
Reproduced: *Painting Since 1939*,
Robin Ironside, 1947 (opp. p.61, colour)
Literature: 'Gordale Scar and the
Caves', John Piper, *The Geographical
Magazine*, December 1942
The Hon. Alan Clark, M.P.

Piper visited Gordale Scar in August 1942,
calling also at Easegill and Weathercote
Caves, to prepare his article for the *Geo-
graphical Magazine*. These sites had been
painted in the years around 1800 by J.M.W.
Turner, James Ward and other romantic
artists, and Piper's study is similar to Ward's
enormous oil painting in composition and
light and shade. He had reproduced this
Ward in his book *British Romantic Artists*,
1942, although giving it only slight mention
in the text, and this painted hommage is
important particularly as the precursor of
the paintings of Welsh mountains.

103 Talland 1943

Ink and gouache, 5 × 8¾ (12.7 × 22.2)
Brinsley Ford

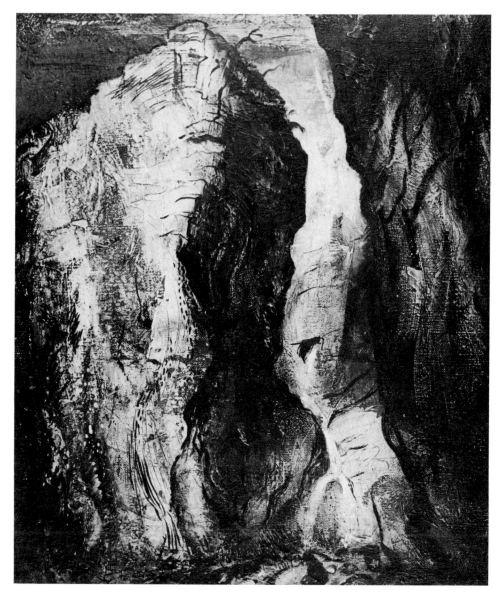

102

North Wales

104 Festiniog 1943

Ink and gouache, $5 \times 8\frac{3}{4}$ (12.7×22.2)
Brinsley Ford

105 Roman Amphitheatre and Tomen-y-Mur, near Festiniog 1943

Ink, chalk, watercolour and gouache,
$14\frac{3}{4} \times 19\frac{5}{8}$ (37.5×49.8)
First exhibited: *The Sitwell Country…
by John Piper*, The Leicester Galleries,
January 1945 (46)
Reproduced: *English, Scottish and Welsh
Landscape*, chosen by John Betjeman
and Geoffrey Taylor, 1944, opp. p.11
(lithograph)
*Birmingham Museum and Art
Gallery*

An oil painting of a 'Ruined Cottage at
Tomen-y-Mur' belongs to the City Art
Gallery, Manchester, and both were painted
on Piper's first working journey to North
Wales, in 1943.

106 Welsh Landscape, Cader Idris 1943

Oil on canvas over panel,
$5\frac{1}{2} \times 7\frac{1}{2}$ (14×19)
S. John Woods

A drawing of the same subject, slightly larger,
is dated 1943.

107 In Llanberis Pass about 1944

Inscribed 'John Piper'
Ink, chalk and watercolour,
$22\frac{3}{4} \times 27\frac{1}{2}$ (57.8×69.9)
Arts Council of Great Britain

108 Glaciated Rocks, Nant Ffrancon
about 1944

Inscribed 'John Piper'
Ink, watercolour and gouache,
$15\frac{1}{2} \times 20\frac{1}{4}$ (39.3×51.4)
First exhibited: *John Piper in Wales*,
Welsh Committee of the Arts Council,
1964 (24, repr.)
Private Collection

107

109 Nant Ffrancon Pass 1947

Inscribed 'John Piper'
Ink, watercolour and gouache,
$21 \times 26\frac{1}{2}$ (53.3×67.3)
First exhibited: *John Piper*, Buchholz
Gallery, New York, February 1948 (14,
repr.)
Mrs M.A. Hartley

110 Llyn du'r Arddu 1949

Ink, chalk and watercolour,
$20 \times 15\frac{1}{2}$ (50.3×39.3)
The Hon. Alan Clark, M.P.

The lake is to the north of Snowdon. A larger
version is illustrated in *John Piper*, S. John
Woods, pl.105, and the subject was much
later included in the portfolio of prints *Stones
and Bones* (1978)

111 Ffynnon Llugwy* 1949

Inscribed 'John Piper'
Ink, chalk and watercolour,
22×28 (56.2×71)
British Council

The source of the River Llugwy, under the
peaks of the Carneddi, was near the Piper's
second cottage in Snowdonia.

112 Three Views of Snowdon 1949

Inscribed on reverse 'Snowdon from
Capel Curig, John Piper', 'Snowdon
from Aberglaslyn, John Piper',
'Snowdon from the Glyders, John
Piper 1949'
Ink, watercolour and gouache, each
$3\frac{3}{4} \times 10$ (9.5×25.4)
First exhibited: *British Romantic Paint-
ing in the Twentieth Century*, Arts Council
of Great Britain Welsh Committee,
1953 (40)
Professor Moelwyn Merchant

Piper worked in Snowdonia from 1944 until
the early 1950s. In 1944 he rented the cottage
'Pentre' in the Nant Ffrancon valley, and in
April 1949 transferred to another one 'Bodesi',
at the highest point of the same valley. The
family stayed there for a period of a few
weeks, often during the winter.

Church Monuments and Landscape

113 Monument, Waldershare 1947

Inscribed 'John Piper' and on reverse
'Waldershare (Kent) Monument'
Oil on panel, 24 × 18 (61 × 45.7)
First exhibited: *John Piper*, Buchholz
Gallery, New York, February 1948 (37)
S. John Woods

The spectacular early eighteenth century
tomb of Sir Henry Furnese by Thomas
Green in Waldershare Church, Kent, is one
of a series of paintings of baroque monu-
ments painted during 1947–50. All are in
out of the way churches, rather than the
cathedrals, and are souvenirs of 'church
crawls' often undertaken with John Betjeman.
This was a pioneering rediscovery of English
sculpture, parallel to his interest in stained
glass, primitive sculpture and the architec-
ture of Methodist Chapels.

113

**114 Homage to Constable, Salisbury
Cathedral** about 1947

Ink and wash, 21 × 27 (53.3 × 68.6)
S. John Woods

115 Newchurch, Romney Marsh
about 1949

Ink and watercolour,
16 × 22 (40.6 × 55.8)
First exhibited: Castle Museum,
Norwich, 1957–8
Reproduced: *Romney Marsh*, John
Piper, 1950, p.30
Peter Meyer

Piper's King Penguin book on Romney
Marsh celebrated his return to work in the
South Coast, after the restricted access
during the war. It is also an example of how
thorough was his topographical knowledge,
both in historical detail and precise observa-
tion. The drawings exemplify the qualities
he had picked out in the text of *British
Romantic Artists* (1942): the commitment to
the particular, and to 'a sense of drama in
atmosphere'.

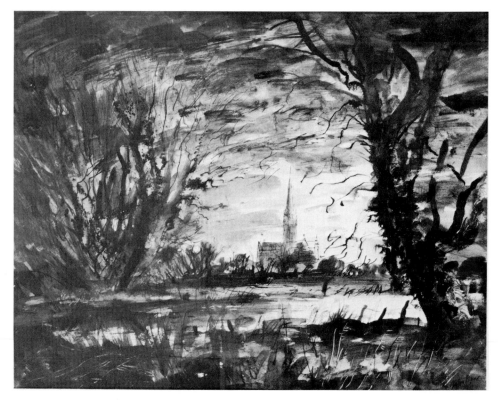

114

6

Stained Glass and Tapestry

116 Two Heads 1953–4
Stained glass panel,
$22\frac{1}{2} \times 28\frac{1}{2}$ (57.2 × 72.4)
Made by Patrick Reyntiens
First exhibited: *A Small Anthology of Modern Stained Glass*,
Aldeburgh Festival, June 1955 (15)
Mrs John Piper

The first piece of glass by Reyntiens from a drawing by Piper, made soon after they met, and in connection with the preliminary discussion of the Oundle School windows. The drawing was selected by Reyntiens and was not intended for stained glass, although made in an appropriate style. The technique of the glass is comparatively unrefined, with a variety of thicknesses.

117 Christ between St. Peter and St. Paul about 1958
Stained glass panel,
$32\frac{1}{2} \times 22$ (82.5 × 55.9)
Made by Patrick Reyntiens
First exhibited: *Mural Art Today*, Victoria and Albert Museum, 1960 (3, as 'Variation on a French Sculpture')
Victoria and Albert Museum

The larger of two pieces of glass made from the same subject (the other belongs to the artist), a gouache of 1955 after a Romanesque tympanum at Aulnay in France.

118 Model for the Window of the Baptistery, St. Michael's Cathedral, Coventry 1958–9
Assembly of stained glass panels, total size $144\frac{1}{4} \times 92$ (366 × 229)
Made by Patrick Reyntiens
First exhibited: *John Piper*, Baukunst, Cologne, September 1965
Victoria and Albert Museum

The commission to Piper and Reyntiens in 1957 for the Coventry Cathedral window came late in the history of Basil Spence's building, after the designs for the new nave windows had already been exhibited in January 1956 and after Sutherland's tapestry design had been completed and approved. The stone mullions had been placed as if for clear glass and occupied a large proportion of the space, which influenced Piper's decision to make an abstract rather than a figurative design. His painting at the time, seen at the Leicester Galleries in November 1957, was of landscape, but with a distinctly rectilinear appearance, as the watercolour of 'Ironbridge' (cat.no.144). Thus Piper's abstract painting of the late 1950s, his first since before the war, was encouraged by the Coventry commission but did not come solely from it, since this geometrical tendency was already apparent. In May 1957 he visited the glass designed by Le Corbusier in the Ronchamp Chapel (1950–3, abstract) and by Léger at Audincourt (1950, figurative).

This model is the only trial design made in glass for any of Piper's commissions. In order to be able to make the designs full size, rather than enlarged mechanically from smaller drawings, Reyntiens suggested that he make this model in glass from Piper's large drawing of the whole window. The model was then used by Piper in making the drawings for the separate panels, one at a time, as a guide to the colour. The leads in this model are placed at random and were not copied from the large drawing or used in the final designs.

The Baptistery window is bayed outwards, so that on entering the Cathedral and looking to the right the visitor sees as the centre of the design a point that is displaced slightly to the left, and here the middle point of the yellow in the model is also displaced to the left. The vertical row of circles at either side was a device copied from medieval glass in order to give a border to contain the whole area.

Cartoon for Tapestry

119 The Elect and the Damned 1959–60

Stained glass panel,
50¾ × 30½ (128.8 × 77.5)
Made by Patrick Reyntiens
First exhibited: *Modern Stained Glass*,
Arts Council of Great Britain,
Aldeburgh Festival, 1960–1 (13)
Mrs John Piper

Commissioned by the Arts Council for their
1960 exhibition, this is a comparable size
to the individual panels of the Coventry
Cathedral window, being made at the same
time.

120 Brittany Beach II 1965

Stained glass panel,
45¼ × 62¾ (115 × 159.5)
Made by Patrick Reyntiens
First exhibited; *John Piper: Painting in
Coloured Light*, Kettle's Yard Gallery,
Cambridge, December 1982 (6)
The Artist

One of three panels made from the gouache
and collage landscapes of Brittany and North
Wales of the early 1960s, one of which was
displayed in *The English Eye* group exhibition
at Marlborough Gerson Gallery, New York,
November 1965. All were commissioned by
Piper from Reyntiens, for exhibition.

121 The Nativity* 1982

Stained glass panel,
73½ × 32 (186.6 × 81.3)
Made by David Wasley
First exhibited: *Prophecy and Vision*,
Van Dyck Gallery, Bristol, September
1982 (SG26)
The Artist

Made for the Bristol exhibition of 1982, the
text taken from an Elizabethan wall painting
at Shulbede Priory, Sussex in which the
Latin imitates the animal sounds.

**122 The Trinity, with the Symbols of
the Evangelists and the Four
Elements** 1964–5

Gouache and marbled papers, cut
paper, with chalk marks added by the
weavers.
Seven pieces, total size approximately
167 × 264 (422 × 670)
The Artist

The full size cartoon for the tapestry which
hangs on a screen behind the high altar at
Chichester Cathedral. This was sent to the
weavers, Pinton Frères, at Felletin near
Aubusson in Central France, where the
tapestry was made between February and
July 1966.

The Chichester tapestry was commis-
sioned by the Dean, the Very Rev. Walter
Hussey who, almost twenty years earlier, had
commissioned Henry Moore and Graham
Sutherland to ornament his church of St
Matthew's, Northampton. At Chichester the
tapestry hangs in front of the Chancel Screen,
under a row of medieval wooden canopies,
which is in seven bays, the three central ones
wider than the two outside ones on each side.
This division influenced the choice of subject,
and it was also recognised that the altar
would hide the lower part of the three central
panels. The subject was not given to Piper,
but was suggested by a personal friend,
Professor Moelwyn Merchant, who had also
advised on the subjects for the Eton College
Chapel windows in 1958. He was anxious to
find a doctrinal subject that could be treated
in an abstract way, and sketched the repre-
sentation of the Trinity that was eventually
followed, after Piper had also considered a
different scheme of full length figures. The
design originally lacked the white oval shape
at the centre, and represented God the
Father by the triangle, supporting on his
right God the Son as the tau cross, and on his
left God the Holy Spirit as the flame. After
some reconsideration the 'eye' shape of
'white light' was added as God the Father,
and the triangle became the Trinity itself. At
the sides the elements are in the order, from
the left: Earth, Air, Fire and Water, over the
symbols of the Evangelists: St Matthew (a
winged man), St Mark (a winged lion), St
Luke (a winged bull) and St John (an eagle).
 When the cartoon was complete the section

with the lion of St Mark was cut off and
woven as a trial panel. This section was later
copied by Piper and attached to the remain-
ing portion to complete the cartoon again.
The cartoon has been stored in rolls since
1966, and was repaired for this exhibition at
the Paper Conservation Department of
Camberwell School of Art.

Small scale design for glass

123 Three Kings, for the South Window, Oundle School Chapel 1954

Inscribed 'John Piper. First sketch for South Window, Oundle Chapel'
Pencil, watercolour and gouache,
36 × 30 (91.5 × 76.2)
First exhibited: The Grocer's Hall, 1954 (privately)
Oundle School

The windows of Oundle School Chapel in Northamptonshire were the first stained glass commission given to Piper, and were the occasion of his introduction to Patrick Reyntiens as collaborator. The School wished to replace existing glass in the east window, and Piper was recommended to Major L.M.E. Dent, a trustee of the fund administered by the Grocers' Company that was to pay for the commission, and was approached in May 1953. The subject, a full length figure of Christ filling each of nine windows, each with a different symbolical attribute, was suggested by Rev. V.E.G. Kenna, a friend of Piper's. The designs were influenced by French Romanesque sculpture, both in the appearance of the heads and in the elongated proportions and tubular limbs. The figure on the right in the drawing was the first made into glass, as a trial panel, which was exhibited in the Grocers' Hall in 1954.

124 Design for Arthur Sanderson & Sons Ltd 1959

Inscribed 'John Piper'
Watercolour and collage of marbled papers, 22 × 31 (55.8 × 78.7)
Private Collection

A preliminary design for the interior glass at Sanderson's head office and showroom in Berners Street. This was commissioned when the building was already under construction, and occupies a 21 × 32 feet (640 × 975) area in the staircase hall, and is lit artificially.

Ivan Sanderson first asked Epstein for a carving for the hall of his new building, but he declined on grounds of age. He then considered an interior coloured glass, and approached Piper and Reyntiens, leaving the subject to Piper's choice. This was his first secular glass, although he was making abstract mosaics at the time, and the design is unique

in his work as a row of semi-abstract plants, appropriate to wallpaper designers. A second and larger collage was elaborated from this one, and in the glass itself the subjects are more contrasted in style.

125 Two Designs for Eton College Chapel: The Parable of the Wheat and Tares, The Miracle of the Raising of Lazarus 1958–9

Both inscribed 'John Piper'
Ink, watercolour and gouache,
38 × 14 (96.5 × 35.6)
Private Collection, Scotland

Piper's eight windows at Eton Chapel, four on each side of the nave, were designed to be seen between new glass which had already been installed to replace that destroyed in the war, armorial glass by Marion Forsyth (completed 1959) and, most notably, the 'Crucifixion and Last Supper' by Evie Hone in the east window (completed 1952). Like this latter, each of Piper's windows has a clear figurative content. The subjects were outlined in the commission, a parallel scheme of Christ's parables on one side of the building, each with a relevant miracle opposite it. Since each of the large windows was divided by its framework horizontally into two halves, Piper decided to use two images, putting the problem of the story below and its Christian solution above. The particular choice of subjects was adapted by Piper from the proposals of Professor Moelwyn Merchant.

The windows vary in style, and the two nearest to Evie Hone's glass are the strongest in colour, matching hers, and the most abstract. These drawings are part of a complete set, made as a demonstration for the College before the glass was started.

126 Design for St. Andrew's Wolverhampton 1967

Watercolour, $12\frac{1}{2} × 28$ (31.7 × 71.1)
First exhibited: *John Piper: Painting in Coloured Light*, Kettle's Yard Gallery, Cambridge, December 1982 (17)
The Artist

In the west window of this new church, built

1965–7, Piper used a single colour, blue, varied through the whole area, as a reference to the water associated with St Andrew the fisherman. The pattern of water currents decorates the surface and the whole design anticipates the very large window of Robinson College, Cambridge.

127 Design for the Benjamin Britten Memorial Window, Aldeburgh* 1979

Gouache and collage, marbled paper,
24 × 12 (61 × 30.5)
First exhibited: *John Piper*, Festival Gallery, Aldeburgh, June 1983 (29)
Sir Peter Pears

The subject is Britten's three church parables: *Curlew River, The Burning Fiery Furnace* and *The Prodigal Son*. Piper had not designed productions of these, and his designs refer directly to the subjects. The cartoon differed quite considerably from this drawing, since he replaced the two outside lights with adaptations of Rembrandt's 'Prodigal Son' and a sculpture by Giselbertus at Autun.

7

The Post-war Landscape:
Montegufoni, Portland and Churches (1950s)

It was following the end of the war that Piper's art at last became most of himself, for in spite of the quality of his work of the 1940s its origin was shared with the public occasion to which it owed subject and emotion. It is also this postwar period, in which his art took a new direction, that is now the least known at first hand, since many of the best paintings were sold in America, where he held several exhibitions, and interest has subsequently focused on the 1930s and 1940s, or else on the latest work as it was seen. At first he continued to study repeatedly certain subjects that had a special importance, as before – the south coast at Portland and English church furnishings – but by the later 1950s he began to respond to landscape and architecture widely spread in Britain, although his output was then for a time limited by massive commissions for stained glass, which both took time and encouraged a second period of abstract painting.

The new work was exhibited at the Leicester Galleries in November 1951, the whole collection titled 'Stones and Flowers'. In his previous exhibition there, in December 1948, he had shown drawings and paintings of North Wales and of Portland, both subjects in which there was from then a gradual change from the grisaille and earth colours to the startling mixed colours of 'Clymping' (1953, cat.no.137) and the later oils of Anglesey. The watercolours of Montegufoni, Sir Osbert Sitwell's villa in Italy, as a commission and a record follow the style of the earlier series of Windsor and Renishaw, although in a more relaxed and freely coloured way. They celebrate the end of the war and are his first works drawn abroad, but do not go beyond that. The 'Stones and Flowers' are in contrast much less exactly topographical, although fully about the church of their subject. They are also completely free of the point of view of any earlier Romantic artist, whether in the sense of the perspective composition or in the particular choice of the location. Shobdon and Rowlestone had never been drawn before, and Piper's views have none of the theatrical composition of flats and balanced masses in his pre-war 'Autumn at Stourhead' (cat.no.37) which had been painted at an equivalent moment in that it was just before the interruption of the war. The surprise of these new works is their colour, an idiosyncratic range of greens, pinks and pale blues, placed in an arrangement in part independent of the subject. This particular palette is unique to Piper and at once makes his work – equally in the decorative arts as in painting – identifiable and unlike any of his contemporaries. Unlike the war paintings or the Montegufoni drawings, the image is fragmented by the application of the colour and the swirling drawing and also, in the 'Stones and Flowers', by placing objects in the foreground, whether on site or in the studio. No doubt it was this that appealed

about the Shobdon Folly, in addition to the importance of its sculpture, that the architecture was already in fragments and re-assembled, and had both an eighteenth century and a Romanesque history before featuring in his contemporary view.

The subjects are in this way elusive, almost diffident, and hidden within the technique. There are no people in the landscapes (except by implication, because whether church or stone quarry it is the works of man that are featured) since Piper only drew what he knew well, and the figures of strangers were not essential – 'Nudes at Wroxeter' (cat.no.143), a repeated study of a single known model, proves the point. It is only in such a concealed way that Piper could approach what are in fact religious subjects, for the paintings of medieval sculpture are also paintings of the 'Christ in Majesty' of the particular tympanum. This applies to some extent also to the Portland landscapes, for the attraction of this were the heaps of cut blocks of stone which give such a distinctive character to the place. In part this was a technical matter of shape and colour, but they are also important symbolically, like Paul Nash's or his own pre-war views of ancient monuments; now man-made and recent, they imply the work that was the whole livelihood of the town, and also, by extension, the relation between man and nature, which is here exemplified by these sculpture-like blocks. The object in view, whether of nature or God, remains an inherited, historical particularity, transformed through the intense observation that can find in it emotional qualities of design and colour.

On several occasions in the 1950s, in interviews and catalogue introductions, Piper quotes Ruskin, especially his exhortation that 'you will never love art well till you love what she mirrors better'. This is significant during a period when Piper wrote little himself about his own work, and it is also more generally true that his ideals found support and inspiration in Ruskin. Ruskin's writings may be so large and diverse that they can be found to witness differing packets of ideas, but the fundamental beliefs implied by Piper's post-war career are there: these include the judgement of the abstract value and the significance of the subject of the painting both separately and in balance together; the detailed attention to nature, in the senses of both real existence and existence outside the modern town; the commitment to common sense rather than deliberately aesthetic taste; and the total appreciation of the work in moral and religious terms.

Montegufoni

128 The Baroque Façade 1947

Inscribed 'John Piper'
Ink, chalk, watercolour and gouache,
$20\frac{1}{4} \times 14\frac{1}{4}$ (51.5 × 36.2)
First exhibited: *John Piper, The Sitwell's
Montegufoni*, The Maclean Gallery,
January – February 1981 (1, repr.)
Reproduced: *Great Morning*, Sir Osbert
Sitwell, 1948 opp. p.152
Frederick R. Koch, New York

**129 The Great Courtyard, with
Entrance Wing and Belfry** 1947

Inscribed 'John Piper'
Ink, watercolour and gouache,
$15\frac{1}{4} \times 20\frac{3}{4}$ (38.7 × 52.7)
First exhibited: *John Piper, The Sitwell's
Montegufoni*, The Maclean Gallery,
January – February 1981 (3, repr.)
Frederick R. Koch, New York

129

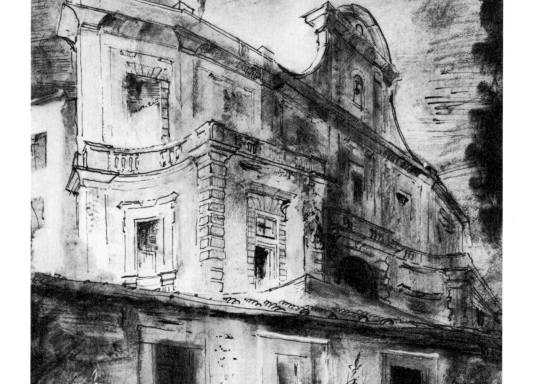

128

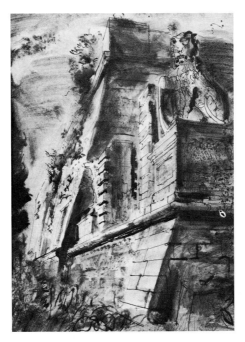

130

130 The Cardinal's Garden 1947

Inscribed 'John Piper'
Ink, chalk and watercolour,
$19\frac{3}{4} \times 14\frac{1}{4}$ (50.2 × 36.2)
First exhibited: *John Piper, The Sitwell's Montegufoni*, The Maclean Gallery, January – February 1981 (2, repr.)
Reproduced: *Great Morning*, Sir Osbert Sitwell, 1948, opp. p.281
Frederick R. Koch, New York

131 Detail of the Grotto 1947

Inscribed 'John Piper'
Pencil, ink, chalk and watercolour,
$14\frac{1}{4} \times 9\frac{3}{4}$ (36.2 × 24.7)
First exhibited: *John Piper, The Sitwell's Montegufoni*, The Maclean Gallery, January–February 1981 (14, repr.)
Reproduced: *Laughter in the Next Room*, Sir Osbert Sitwell, 1949, opp. p.281
Frederick R. Koch, New York

131

132 Latona and the Peasants, a Detail 1947

Inscribed 'John Piper'
Pencil, ink, chalk and watercolour,
$21\frac{3}{4} \times 16\frac{1}{2}$ (55.2 × 41.9)
First exhibited: *John Piper, The Sitwell's Montegufoni*, The Maclean Gallery, January–February 1981 (12, repr.)
Reproduced: *Laughter in the Next Room*, Sir Osbert Sitwell, 1949, opp. p.280
Frederick R. Koch, New York

Piper accompanied Sir Osbert Sitwell on his first visit after the war to his Tuscan Castle, Montegufoni, in September and October 1947. His watercolours continued the series begun at Renishaw, and some of the seventeen completed were used to illustrate the later volumes of the autobiography.

As illustrations the drawings were detailed and straightforward, as had also been the Windsor series, and as a group they emphasise the variety and contrast of parts of the building built at different times. Sir Osbert's account, and presumably his conversation at the time, dwells on the enthusiasm and extravagance of his father, who had bought the Castello but had recently died, and Piper's drawings convey a sense of both the wit of the original builders and of its evocation of earlier generations.

The South Coast

133 Dungeness 1947

> Inscribed on reverse 'Dungeness 1947'
> Oil on panel, 6 × 8 (15.2 × 20.3)
> First exhibited: *John Piper*, Arts Council
> of Great Britain, Cambridge, 1953 (10)
> *Mrs John Piper*

This tiny study in oils, painted directly from
a sketchbook page, is comparable to paintings
of North Wales and Cornwall made at the
same time, and served as a model for a larger
painting.

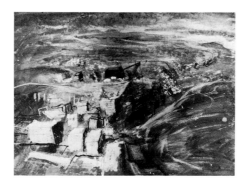

134

134 Portland, Cliff Derrick 1948

> Inscribed 'John Piper'
> Ink, watercolour and gouache,
> $15\frac{1}{4}$ × 21 (38.7 × 53.3)
> First exhibited: *New Paintings and
> Drawings by John Piper*, The Leicester
> Galleries, December 1948 (1)
> *Leicester Museums and Art Galleries*

135

135 Portland Foreshore 1948

> Inscribed 'John Piper'
> Oil on canvas over panel,
> 26 × 30 (66 × 76.2)
> First exhibited: *New Paintings and
> Drawings by John Piper*, The Leicester
> Galleries, December 1948 (21)
> *Southampton Art Gallery*

136 Two Landscapes at Portland 1948/50

> Both inscribed 'John Piper'
> Ink, watercolour and gouache, each
> $6\frac{1}{4}$ × $20\frac{1}{4}$ (15.8 × 51.4)
> *Brinsley Ford*

Although he had painted at Chesil Beach
before the war, Piper did not work on Portland
Bill until 1948, and then continued to exhibit
Portland subjects until 1955. John Read's
documentary film of 1955 shows him working
on a drawing and then a painting of Portland,
commenting on the need to rearrange the
landscape 'so as to make an elaborate symbol
of the place; not a view, but a history'.

137 Clymping* 1953

> Inscribed 'John Piper'
> Oil on canvas, 36 × 48 (91.4 × 122)
> First exhibited: *John Piper*, Festival
> Gallery, Aldeburgh, June 1983 (31)
> *Sir Peter Pears*

This is the only view by Piper of Clymping
Beach, near Littlehampton, but there is also
an elaborate watercolour study for this and a
lithograph after it. The composition was
later considerably extended at the left for a
large painted mural commissioned for the
Mayo Clinic, Rochester, Minnesota, under
the given title 'Man's Relation with Nature'.
The row of sea defences takes on a similar
geometrical role to the blocks of stone in the
Portland subjects, but the colouring is
stronger and more varied. This stark illust-
ration of the permanent alteration of the
landscape was intended as a final war painting.

Churches

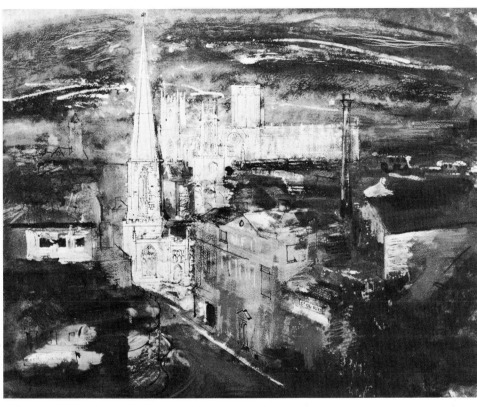

138

138 York from Clifford's Tower 1950

Inscribed 'John Piper'
Ink, chalk, watercolour and gouache,
$21\frac{1}{4} \times 26\frac{3}{4}$ (54×68)
York City Art Gallery

Commissioned in 1950 by Hans Hess, the
director of the Gallery.

**139 Rowlestone Tympanum with a
Hanging Lamp*** 1951

Inscribed 'John Piper'
Ink, watercolour, gouache and collage,
$26\frac{3}{8} \times 38\frac{1}{4}$ (67×97.2)
Private Collection

A study for the oil painting of the same size
at the National Gallery of Canada, Ottawa,
which was included in the 1951 'Stones and
Flowers' exhibition. Piper had already photo-
graphed the carving at Rowlestone in
Herefordshire before the war, and the paraffin
lamp was one that he used in the studio at the
time of this painting. Such a contrast of
foreground and background – more usually
flowers seen in front of carvings – was the
theme of this exhibition, and enabled Piper
to approach the style of the early abstract
paintings, separating colours into different
planes, coming forward from a black back-
ground.

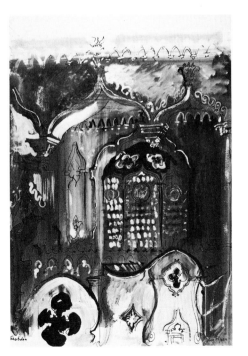

140

140 Shobdon Interior 1951

Inscribed on reverse (later) '1953'
Watercolour and gouache,
29×22 (73.7×55.8)
Trustees of the British Museum

**141 Shobdon Folly – Romanesque Frag-
ments** 1951 P56.14

Inscribed 'John Piper'
Oil on canvas, $44\frac{3}{4} \times 59\frac{3}{4}$ (113.5×152)
First exhibited: *'Stones and Flowers'.
An Exhibition of New Pictures by John
Piper*, The Leicester Galleries,
November 1951 (18)
*Museum of Fine Arts, Boston (Otis
Norcross Fund)*

The eighteenth century 'Shobdon Arches'
incorporates sculpture from the Romanesque

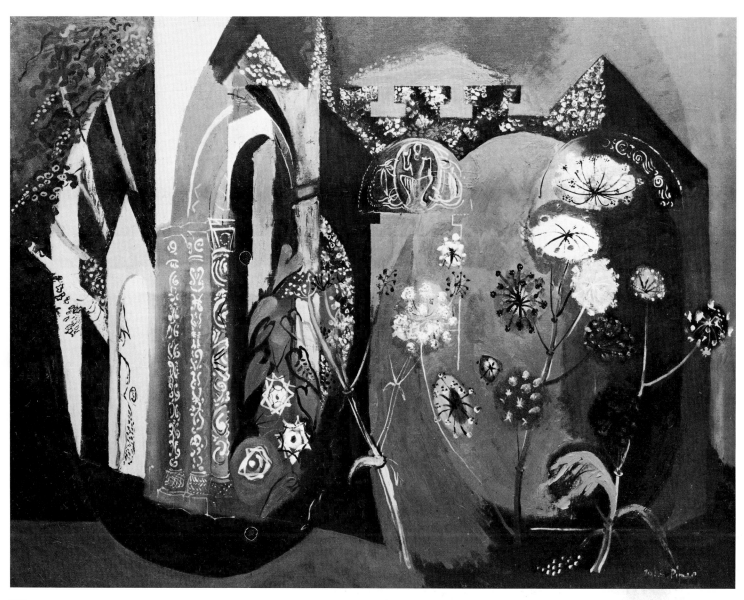

141

church, rebuilt as a garden ornament in the grounds of a country house in Herefordshire. The two tympana are similar to those in nearby Rowlestone.

The cow parsley in the foreground of the painting was in the artist's studio, seen in front of one of the studies that preceded this painting. Since the church was already a contrast of styles it was an ideal subject, and the intensity of colour and dislocation of perspective are both an extreme in this painting, which became the model for much of Piper's subsequent landscape.

142 Careby Cross with a Hollyhock
1951

Inscribed 'John Piper'
Ink, chalk, watercolour and gouache,
27 × 21 (68.6 × 53.3)
First exhibited: *'Stones and Flowers'.
An Exhibition of New Pictures by John
Piper*, The Leicester Galleries,
November 1951 (14)
*The Hugh Lane Municipal Gallery of
Modern Art, Dublin*

Drawn at Careby, near Stamford in Lincoln-shire.

142

143

143 Nudes at Wroxeter 1954-5

Ink, chalk and gouache,
$10\frac{1}{2} \times 19$ (26.7 × 48.2)
First exhibited: *Recent Work of John Piper*, The Leicester Galleries, May–June 1955 (31)
Reading Museum and Art Gallery

Piper has continually drawn from life, but only rarely elaborated such drawings into finished work to be displayed. These repeated studies of the same model are grouped together in the guise of an old master painting, or a sculpture in a ruined building, and set amongst the remains of the Roman Camp at Wroxeter.

144 Ironbridge 1957

Inscribed 'John Piper'
Ink, chalk, watercolour and gouache,
$22\frac{1}{2} \times 30$ (57 × 76)
First exhibited: *New Paintings and Watercolours by John Piper*, The Leicester Galleries, November 1957 (1)
Trustees of the Cecil Higgins Art Gallery, Bedford

A view from across the Severn, with the end of the bridge drawn, but not coloured, at the left. In the later 1950s Piper's work again became abstract and in this watercolour and others made in France in the same year the colours are beginning to be formed into rectangular patterns.

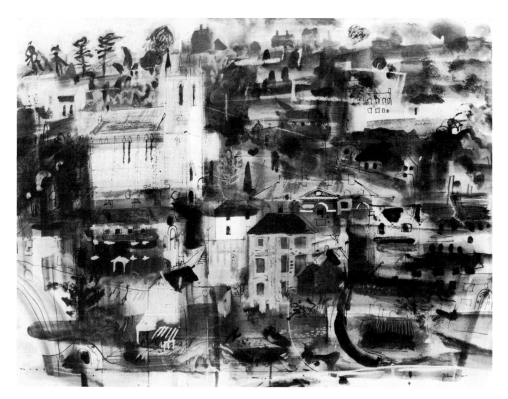

144

8

A Landscape Anthology (1960s and 70s)

The period from the early 1960s to the time of this exhibition is the furthest point in the evolution of Piper's art, continuous from the pre-war abstract paintings. It is evident that over the last twenty years he has felt freer to choose his subjects both from throughout Britain (as well as France) and of a varied type, panorama or detail, town centre or brambles in a field, as well as the historical buildings that remain his most frequent choice. One value of the recent work is cumulative, in the sense that it is an anthology of good places, and his work has a character that follows from this. Each landscape is not only an individual treatment but an addition to this store, for although his technique allows this freedom it is not every place that will serve. Most notably, architecture of his own lifetime is excluded, not solely on grounds of taste but as much because its appearance has not weathered into its surroundings.

Gradually during these years the selection of colours became finer and more extreme in variety. This period falls into two halves as there was a change in technique in the later 1960s, when Piper had completed a number of stained glass and tapestry commissions and was able to work longer on landscapes, and began also to make screenprints. At the start of the earlier half, he for a time concentrated on the landscape of the Continent rather than Britain. His approach to the painting of Venice, on his first working visit in 1958, was through Turner, who was a precedent for his own response to the startling colour of the subjects, particularly grey and pink. The following year he was able to return with a commission from Arthur Jeffress to prepare an exhibition, which was then repeated in 1962 for Rome. Similarly he was in Brittany in 1960, having only worked occasionally on his frequent visits to France earlier on, except that the figures in the windows of Oundle School Chapel, and the numerous drawings that preceded them, owe poses and features to French Romanesque sculpture. His handling of paint as if a violent, scratchy handwriting in the Venetian oils of 1959 led to a number of works of gestural character, with a network of lines of poured paint over their surface. This extended to the Japanese style of the painted gauzes for 'A Midsummer Night's Dream' (1960–1), which, although delicate, depend on the readily apparent touch of the artist's hand. In the collages of Brittany of the same years, the drawing and colour lie in the angular and circular shapes of the cut papers, which are more rhythmical than in the pre-war collages, but are similarly on the surface. The tapestry for Chichester Cathedral and the stained glass at the Sanderson & Co. headquarters both follow this style. It was extended further in abstract landscapes, that is abstract paintings taken from a landscape composition and so titled. These have remained one of the extremes of his style, but the application with separate black lines and colours, like 'Garn Fawr' (cat.no.150) was not continued beyond 1963.

More important than technique, and more apparent when looking at these paintings of the 1960s, is the choice of colour. Moving beyond the pathetic fallacy or the landscape of mood that had been the basis of the 1940s paintings, Piper looked, as he had at Shobdon (cat.no.141), for a harmony of colour that was complete yet only a parallel and not an equivalent to the subject. A comparison can be made to the Fauves, and particularly to the landscapes and still-lifes of Dufy, admired by Piper from the early 1930s. As with Dufy, in Piper's Venice, Brittany and Rome landscapes, and from then generally in his work, there is a remarkable contrast of a few high-keyed colours, and allied with this a feeling of vitality and pleasure. A spontaneity is given by the direct technique, but it is the particular choice of unusual colour, applied in a large area, that is the basis of the painting.

The comparison with Dufy is also relevant to the nature of these two artists' reputations; both are celebrated, yet in a particular way that is strangely free of official underpinning, for their popularity was a threat to post-war abstract art, the more severe as they had at one time been a part of modern movements, and had continued to be so in their own ways. Yet Piper is by no means conventional or popular in an easy sense, although it is evident that he is happier with the audience of his glass and mural commissions rather than that of international exhibitions. The modern landscape painter has appeared to some critics a self contradiction, and this has coincided with the fear that to be copious, versatile in different media and interested in a national tradition might each tell against the appeal to the specialist. This is relevant to Piper's practice from the later 1960s because the foundation of his work has been since then the gouache landscapes, which he has made in large numbers. Small, attractive and with prices kept by the artist lower than his gallery advises, these offend some preconceived notions and are furthermore influenced by the technique of screenprinting, for which in part they are made and which in part reproduce them. The large oil paintings, as well as the ceramics, opera designs and stained glass designs are all derived, in different ways, from such drawings. The one new subject from these years, which is also associated with the screenprints and which brings together several of his preoccupations, is the series of nudes called by the title 'Eye and Camera', since they originate from photographs and drawings of the same model placed side by side.

The 'Eye and Camera' series are in fact not literally nudes, as the model is dressed in provocative underclothes, but the effect of a pin-up is denied by the overlapping of colours and different views, made possible in the screenprinting, which bury the original photograph. Piper's figures in exhibited work are always seen at two removes by being already works of art – the tomb sculpture, or the Cretan seals, or the transcriptions of Cranach and Poussin – and these photographs in the same way follow the conventions of (somewhat dated) glamour magazines, or, sometimes, drawings by Klimt. The sexual appeal is not played down, but the sense of titillation is lost in the insistence on technique, forced to the attention by the parallel contrast of drawing and photography. It is as if the nudes on the beach that were incorporated into the abstract paintings of 1935 were now again allowed to exist within this more complex structure, even though without a setting. Piper has returned to this subject repeatedly since 1965, when the series was first exhibited. The importance of the nude even for

his landscapes was implied in an unexpected way in an interview in 1963:

> Topography at its best is the interpretation of the world as a vision of the place. The best topographical paintings have the spirit of the place in the time … Giorgione's 'La Tempesta' is the epitome of every virtue topographical art should have (Encounter, 20 May 1963, pp.59–60).

This Giorgione, which Piper had already copied in watercolour in 1951, is only topographical in a special sense of the word, but is the paradigm of an ideal landscape, in which there is a mysterious relation between the nude suckling a child in the foreground and the landscape which fills the rest of the painting, and Piper evidently recommended experiencing real landscape in such an imaginative way.

The locations of Piper's sketching tours in Britain and the Continent are charted in his exhibitions at Marlborough Fine Art over the last twenty years. In his 'European Topography' there in 1969 he showed some seventy gouaches, many of French Romanesque churches, some of farm buildings in landscapes. His 'Preface' stressed his wish to record his emotions associated with these particular places, and he referred to Paul Nash's talk of the *genius loci*. Many of the drawings were published as screenprints by Chris Prater at the same time, and the interaction between these two techniques was something like that between his designs and the stained glass made from them by Patrick Reyntiens, in that they were drawn with the potentialities of screenprinting in mind. Some features of his style were accentuated as a result, the restriction of the number of colours, often a contrast between a certain golden yellow and black, for example, and along with this the discovery of intense particular shades.

In 1970 and 1971, although he worked on a number of public commissions these were not, individually, works of a large area, and Piper was able to paint a group of big oils for exhibition the following year. These were all architectural, of Chambord, Venice and French gothic façades, chosen for their intricacy of decoration, which he depicted by lines incised into the surface, already granular from the coarse canvas used. These paintings are also a response to a different kind of patron, and were not for the most part bought for private houses but for companies, and many hang alongside large works by contemporaries in deliberately acquired collections in City board rooms and dining rooms, appropriate to their scale. Anthony West has pointed out the connection between these and the stained glass in Liverpool Metropolitan Cathedral, where the enormous cone over the roof is divided into bursts of pale colours, through which the light passes, between darker colours, just as in the paintings the white highlights shine over the façades.

The pattern of this relation between gouaches and oil paintings was followed in later exhibitions, adding to the collection of places and favouring the intricate and decorative, especially the country houses of Salvin. The colours are more intensely, sometimes riskily, luminous. This painterly quality has been apparent in recent glass and stage commissions, a clear instance of one of Piper's strongest beliefs, that it must be the vision of the painter that underlies all his work, in whatever technique. The designs for *Death in Venice* at the Royal Opera House in 1974, especially the drop curtains of St Mark's, are astonishingly

vibrant and free in application, depending on large areas of colour with contrasting touches over the surface. Similarly for the huge window at Robinson College, Cambridge, he exploited the step-shaped bay given by the architect, filling it with a single sunburst radiating through gradually deepening colours, overlaid with water and plant forms. As at St Andrew's, Wolverhampton, the design not only makes the culmination of the interior, it responds to a contemporary style by extending the capabilities of the medium, enlivening the whole area with a millefleurs related to his collage technique. In contrast, the small window in the antechapel at Robinson College corresponds to a gouache drawn after a French carved tympanum and is a virtuoso interpretation by Reyntiens. This figured style was used also for the Benjamin Britten memorial window at Aldeburgh parish church, made in the same year.

To see Piper's work assembled from over a period of more than fifty years is to be aware that at the centre there is always a painterly invention, in whatever medium the final product. The key to the range of his interests is his delight in always acting in response to the constraints of a new technique, whether in his own hands or in the complexities of a stained glass studio or a printer's workshop. The techniques seem to be chosen to make difficulties – direct representation with cut paper, watercolours that have to be reproduced on a lithographic stone or on screens, the coarsest of canvases, a scheme of pure colours – but these serve only to roughen the perceived subject before it is painted in oil or watercolour, although they may also become an intermediate stage on the way to a stained glass cartoon or a theatre model.

His long apprenticeship was similarly an introduction to the imagination of Diaghilev, Picasso, Miró and others, but his own style became so idiosyncratic that, although there are a few imitators, he has no real followers. This learning from his contemporaries has been continued with earlier works of art which are still often his sources:

> And as to the saying "Do not derive art from art" I would rather say "*Always* derive art from art", though it is just as useless as practical advice ('The Quest': Notes on the Decor, 1943).

He has responded particularly to sculpture, but the essentials of, say, his drawing after a Romanesque carving are entirely Piper. His own imagination does not invent unseen subjects, but works on an exterior stimulus to such an extent that it is revitalised. The landscape and architecture that he chooses to draw are transformed in the same way: selected and then incorporated into his style. The result, however startling, makes a graphic presentation of the subject, as had his first use of art in the guidebook illustrations of the early 1920s. His work has evolved into a fluent, seemingly casual, application and brighter and more contrasted colours, becoming always a more passionate representation of the subject. This intensity of feeling is equally present in the 'Eye and Camera' nudes as in the landscapes, and the two were paralleled by Piper in the title of the volume of prints 'Stones & Bones'. The combination of gouache and screenprint in the last fifteen years has been the culmination of his work, allowing a choice of topographical subjects, a popular appreciation and intense colouring. The fundamental strength is his detailed knowledge of British archi-

tecture and his commitment to the Church of England, although neither are openly displayed. Piper discreetly says that he would not have been able to paint churches so often if they had meant nothing to him, but the colouring and sheer accumulation of the work is in the end as eloquent as any Bernini.

The character of a contemporary artist can be defined by a cluster of associations. Some of these for Piper are negative – aspects of life in towns, or of technology, or of aesthetic taste – and many of the positive associations are related to his own living for a half a century in a flint and brick farmhouse in Oxfordshire. He stands for the belief that the work of art is a pleasure to the beholder, in the first place, as opposed to a cure, whether social or spiritual, or a protest, or a moment of art history in the making. It is also a belief in the modern relevance of an English tradition of architecture and painting. Most particular to him alone is the attempt to pick up, in practice as well as subject, a relation between contemporary artist and the church which might otherwise seem to have been irretrievably lost.

A Landscape Anthology

145 Palazzo Pesaro, Venice* 1959–60

Inscribed 'John Piper'
Ink and gouache, $14\frac{1}{4} \times 21$ (36.2 × 53.3)
First exhibited: *Paintings and
Watercolours of Venice by John Piper*,
The Arthur Jeffress Gallery, 1960 (22)
Mrs John Piper

146 The Salute, Venice* 1959

Inscribed 'John Piper'
Oil on canvas, 48 × 48 (121.9 × 121.9)
First exhibited: *Paintings and
Watercolours of Venice by John Piper*,
The Arthur Jeffress Gallery, 1960 (not
catalogued)
Her Royal Highness The Princess Margaret

**147 Venice, the Salute from the Grand
Canal below the Accademia
Bridge** 1959

Inscribed 'John Piper'
Oil on canvas, 30 × 25 (76.2 × 63.5)
First exhibited: *Paintings and*

Watercolours of Venice by John Piper,
The Arthur Jeffress Gallery, 1960
(6, repr.)
William Mitchell

Piper stayed in Venice in September 1954
for the staging of 'The Turn of the Screw',
but did not paint there until he returned in
1958. In 1959 he again returned for longer,
with the commission to prepare an exhibition
for Arthur Jeffress. This exhibition included
the largest paintings he had made since
before the war. In these the features of the
buildings are drawn across the surface with
rapid lines or pourings of paint, giving a
vibrant effect of reflected light.

148 Brittany Beach 1961

Inscribed 'John Piper'
Gouache and collage of marbled papers,
28 × 35 (71.2 × 88.8)
First exhibited: *Brittany. New Paintings
by John Piper*, Bear Lane Gallery,
Oxford, May 1961
Private Collection

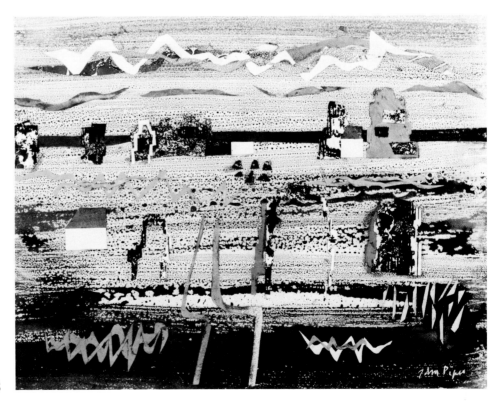

148

149 La Pointe du Château 1961

Inscribed 'John Piper'
Gouache and collage of marbled papers,
$22 \times 30\frac{1}{2}$ (55.9×77.5)
First exhibited: *Brittany. New Paintings
by John Piper*, Bear Lane Gallery,
Oxford, May 1961
Abbot Hall Art Gallery, Kendal, Cumbria

In the summer of 1960 Piper worked on the
coast of Brittany, and made these large
collages, and some oil paintings, on his
return. They are a distinct group in format
and technique, using the dispersed paint to
represent the horizontal lines of the open
landscape, and cut marbled papers to
represent the features.

149

151

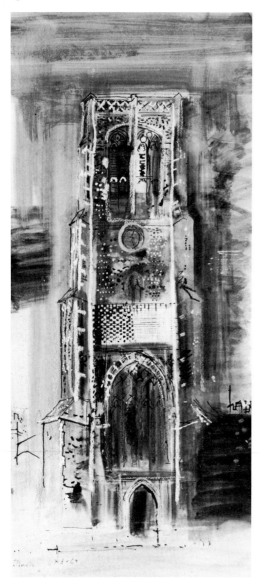 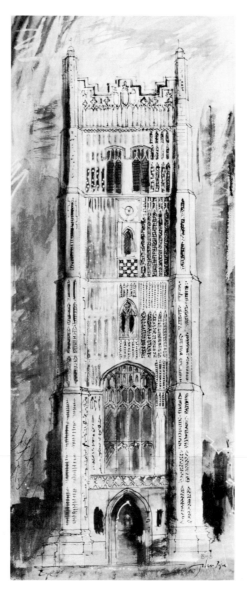 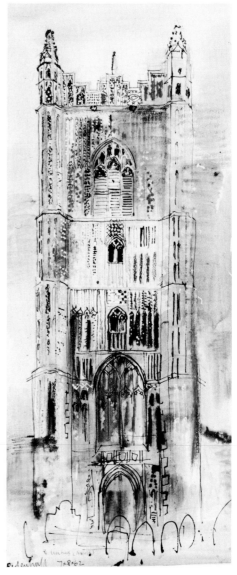

150 Garn Fawr* 1962

Inscribed 'John Piper'
Oil on canvas, 23 × 42 (58.4 × 106.7)
Professor Moelwyn Merchant

In the 1963 exhibition at Marlborough Fine Art, his first at this gallery, Piper showed mostly abstract landscapes, almost all of Brittany or Pembrokeshire. 'Garn Fawr' is the hill overlooking Piper's cottage near Strumble Head, and this oil is one of a number based on the view of it from across a low valley.

151 Three Suffolk Towers 1962 and 1963

Inscribed 'Southwold 6.8.63', 'Eye. John Piper', 'Redenhall (Norfolk) 7.8.62'
Ink, watercolour and gouache, $28\frac{1}{4} \times 13$ (71.2 × 33), $28\frac{1}{2} \times 12\frac{1}{2}$ (172.4 × 31.7), $28\frac{1}{2} \times 13$ (72.4 × 33)
First exhibited: *Suffolk Churches and Landscapes, John Piper*, Aldeburgh Festival, June 1966 (10)
National Museum of Wales, Cardiff

Piper first displayed an arrangement of buildings mounted together in the Welsh chapel façades of 1937. The church towers, of which there were many between 1958 and 1965, follow the format of the Oundle School Window designs as a group of three. In 1965 some of these were translated into partly abstract plaster reliefs.

152 Botolph Clayden 1964

Inscribed 'Botolph Clayden, John Piper 10 × 64'
Ink and gouache, 16 × 23 (40.6 × 58.4)
The Artist

153 Entrance Gate, Holkham 1967

Inscribed 'John Piper'
Watercolour and gouache, $22\frac{3}{4} \times 31$ (57.7 × 78.8)
First exhibited: *John Piper*, Marlborough Fine Art, September–October 1975 (20)
Private Collection

154 Corton, Suffolk* 1968–9

Inscribed 'John Piper'
Oil on canvas, $79 \times 39\frac{1}{2}$ (195.6 × 100)
First exhibited: *John Piper. European Topography 1967–69*, Marlborough Fine Art, May 1969 (1, repr. on cover)
Lord Rayne

155 St. Raphael, Dordogne* 1968

Inscribed 'John Piper. 7 Oct 1968'
Gouache, 23 × 30 (58.4 × 76.2)
First exhibited: *John Piper. European Topography 1967–69*, Marlborough Fine Art, May 1969 (10, col. repr.)
Lord Rayne

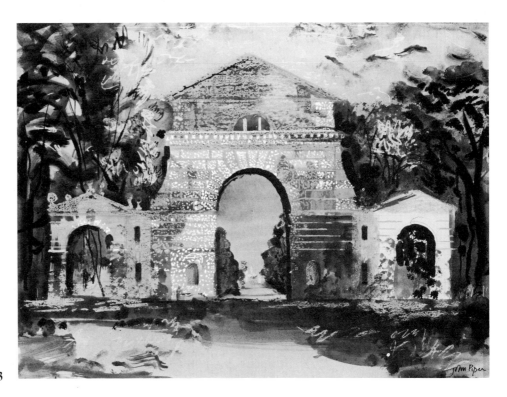

153

156 Ardmore (Eire) 1969

Inscribed 'John Piper. Ardmore. Oct
69'
Gouache, 22½ × 30 (57.2 × 76.2)
First exhibited: *John Piper*, Marlborough
Fine Art, March 1972 (19, col. repr.)
Private Collection

157 Vézelay Tympanum* 1970

Inscribed 'John Piper. Vezelay'
Chalk and gouache,
22½ × 30 (57.2 × 76.2)
The Artist

158 Riva degli Schiavoni, Venice 1971

Inscribed 'John Piper. 71'
Ink and gouache, 15 × 22 (38.1 × 55.9)
Doctor and Mrs David Lewis

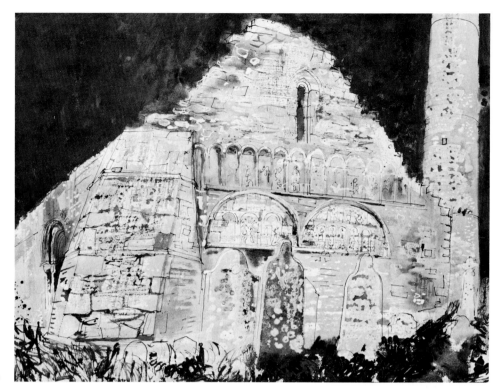

156

Eye and Camera

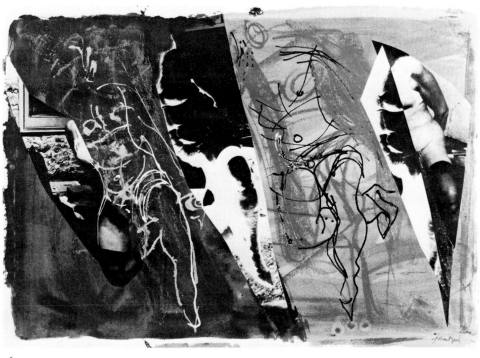

161

159 Eye and Camera 1971

Inscribed 'VI 71 FB – GF'
Ink, watercolour and applied photo-
graph, $18\frac{3}{4} \times 25\frac{1}{2}$ (47.6 × 64.8)
The Artist

160 Eye and Camera 1974

Inscribed '1974'
Ink, chalk, watercolour and applied
photograph, $15\frac{1}{2} \times 23$ (39.4 × 58.4)
The Artist

161 Eye and Camera about 1977
Inscribed 'John Piper'
Screenprint, $30 \times 43\frac{1}{2}$ (76.2 × 110.5)
Tate Gallery

The largest screenprint in this series, made
from a collage half the size.

The Eye and Camera collages, and the screen-
prints made from them, place side by side
photographs and drawings of the same model.
The photographs usually are made first and
are usually taken by Piper, and sometimes
the drawing is made from the photograph
and sometimes independently from the model.
The first were made in the mid 1960s and
they have been continued since then, and
many have been made into screenprints by
Chris Prater, often after an interval of some
years. The technique of collage and inde-
pendent colour, and the transfer from one
medium to another, are fundamental interests
of Piper, but the subject is a relaxation.

162 Château de Chambord, 2 1971

Inscribed 'John Piper'
Oil on canvas, 60 × 60 (152.5 × 152.5)
First exhibited: *John Piper* Marlborough
Fine Art, March 1972 (6, col. repr.)
Private Collection

163 Syleham, Suffolk 1971

Inscribed 'Syleham, Suffolk 1971' on
reverse
Watercolour and gouache,
22 × 29 (55.8 × 73.7)
Trustees of the British Museum

164 Clytha Folly* 1975

Watercolour and gouache,
13¾ × 11 (34.9 × 28)
The Artist

165 Elizabethan Tombs at Snarford
1976

Inscribed 'John Piper. 12 VIII 76'
Pencil, ink, watercolour and gouache,
20 × 26¾ (50.8 × 67.9)
The Artist

166 Four Figures for 'India Love Poems'
1977

Inscribed 'John Piper'
Gouache, 16 × 19 (40.7 × 48.2)
First exhibited: *John Piper*, Michael
Parkin Fine Art Ltd, August 1982 (no
catalogue)
The Artist

A study for illustrations for the poems by
Tambimuttu published in 1977, but not
used.

167 Girl and Flowers* 1981

Inscribed 'John Piper. 15 XII 1981'
Watercolour and gouache,
22¼ × 30 (56.5 × 76.2)
The Artist

168 Stokesay Castle I 1981

Inscribed 'John Piper'
Watercolour and gouache,
22½ × 31 (57.1 × 78.8)
First exhibited: *John Piper. Tudor Pic-
turesque, Other Buildings and Landscapes*,
Marlborough Fine Art, December
1981 – January 1982 (10, col. repr.)
Private Collection

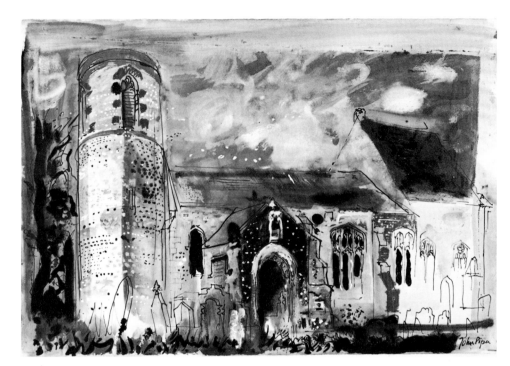

163

169 Conisborough Castle* 1981

Inscribed 'John Piper'
Oil on canvas, 30 × 40 (76.2 × 101.6)
*Institute of Chartered Accountants in
England and Wales*

One of three oil paintings (with 'Buckden'
and 'The Bishop's Palace and Cathedral, St.
Davids') commissioned for the new hall of
the Institute of Chartered Accountants,
which hang on a screen designed for them
and decorated with vertical strips of wood
panelling.

170 Covehithe Church 1983

Oil on canvas, 34 × 44 (86.4 × 110.7)
The Artist

171 Newcastle Emlyn* 1983

Inscribed 'John Piper'
Oil on canvas, 34 × 44 (86.4 × 110.7)
The Artist

Tapestry

It was not until the commission for Chichester Cathedral (1965–6) that Piper designed for tapestry, and this was then treated as a parallel to the stained glass work. In total he has had woven fourteen tapestries (some of them multiple), nearly all for unique commissions, either ecclesiastical or for public buildings. They have depended on suitable weavers. He first used Pinton Frères and then the Edinburgh Tapestry Company, but the recent tapestries were woven in Namibia. All are adapted in style and subject to their settings, and were sometimes part of a complete interior decoration. The design of three 'Trees' for Hereford Cathedral (1981) – 'The Fall of Man', 'The Deposition from the Cross' and 'The Fruits of Paradise' – is an outstanding recent work, close in style to a very linear drawing over a delicately coloured abstract background, and of an original Christian subject. A few tapestries, like this 'Foliate Head', have been made in editions for galleries.

172 Foliate Head 1978

> Inscribed 'John Piper'
> Tapestry, 60 × 84 (152.4 × 213.4)
> Made by Weberei Kraft, Dordabis, Namibia
> *The Artist (on loan to the President and Fellows of Wolfson College, Oxford)*

Ceramics

Pottery decorated by Piper was first seen publicly in Marlborough Fine Art in 1972, when a considerable number and variety of pieces was included in an exhibition of large paintings and gouaches. They are a collaboration between decorator and potter, and began when the opportunity arose for Piper to work with Geoffrey Eastop, who made earthenware to his design and taught him the techniques of moulding and glazing. These decorations were mostly heads or decorative abstract designs, but another large group made in 1982 in association with the Fulham Pottery included landscape variations after old masters, some of them on obelisks and candlesticks. The playful mood of the decorations recalls at times English slipware, Renaissance maiolica or Picasso's painted ceramics.

Bibliography

Beth Houghton assisted by Hilary Gresty

1 Books written or edited by the artist

2 Articles and sections of books by the artist, including those which he both wrote and illustrated, and some purely illustrative material

3 Books illustrated by the artist

4 Interviews with the artist

5 Broadcasts

6 One-man exhibitions

7 Group exhibitions (selected)

8 Books, and sections in books about the artist

9 Periodical and newspaper articles about the artist (selected)

All sections are arranged chronologically by date of publication, except section 8 which is arranged alphabetically by Author.

Sections 6 and 7 are lists of exhibitions for which a catalogue has been published unless stated otherwise in the entry. In view of the large number of group exhibitions in which Piper has participated, section 7 is highly selective, giving emphasis to earlier, and significant later exhibitions. The number of works given in brackets in this section refers to works exhibited by Piper.

All items have been seen by the compiler except those marked *

1 Books written or edited by the artist

1 *Wind in the trees*, Bristol: Horseshoe Publishing Co., 1921.
Illus. with line drawings by Piper.

2 *The gaudy saint, and other poems.* Bristol: Horseshoe Publishing Co., 1924.
6 vignettes: line drawings by Piper.

Oxfordshire . . . 1938.
see Shell guides (**12**)

3 *Brighton aquatints: twelve original aquatints of modern Brighton;* with short descriptions by the artist; and an introd. by Lord Alfred Douglas. London: Duckworth, 1939.
12 full-page black and white original aquatints.

Shropshire . . . 1939.
see Shell guides (**12**)

4 *British romantic artists.* London: Collins, 1942, (Britain in pictures series). Re-published in *Aspects of British art*, ed. by W.J. Turner. Collins, 1947.

5 *Buildings and prospects.* London: Architectural Press, 1948.
Illus. comprise 3 halftones of drawings, 4 halftones of paintings, 1 line drawing and dust wrapper.

6 [with John Betjeman, Eds.] *Murray's Buckinghamshire architectural guide.* London: J. Murray, 1948.
Dust wrapper designed by Piper.

[Editor of] *Studies in composition and tradition series* (M. Parrish). see Geoffrey Grigson. An English farmhouse . . . 1948 (**139**)

7 Foreword to *The drawings of Henry Fuseli.* by Paul Ganz. London: M. Parrish, 1949, pp.7–10.

8 [with John Betjeman, Eds.] *Murray's Berkshire architectural guide.* London: J. Murray, 1949.
Dust wrapper designed by Piper.

9 *Romney Marsh*, illustrated and described by John Piper. Harmondsworth: Penguin Books, 1950. (King Penguin Books, no.55).
1 line drawing, 16 halftones in colour, 16 in black and white.

10 *Stained glass: art or anti-art.* London: Studio Vista; New York: Reinhold, 1968.
[with J.H. Cheetham].

Wiltshire, 1968.
see Shell guides (**12**)

11 'Art or anti-art', in *Architectural stained glass;* ed. by B. Clarke. London: J. Murray, 1979, pp.53–57.
Piper's work with stained glass also covered.

12 *Shell guides*, London: Faber and Faber.
Since 1938 Piper has been associated with the Shell guides series – as an editor (initially with John Betjeman, later alone), as photographer and illustrator, and as the author of: *Oxfordshire, not including the city of Oxford*, Batsford, 1938, re-issued Faber and Faber, 1939. *Shropshire*, with John Betjeman, 1951. *Wiltshire*, with J.H. Cheetham, 1968.

2 Articles and sections of books by the artist,

including those which he both wrote and illustrated. In addition to the articles cited below, which are intended to include all those on painting, sculpture and graphic art, between the late 1920s and 1950s Piper contributed articles, reviews and illustrations to periodicals such as the Athenaeum, The New Statesman and Nation, The Spectator, Horizon, The Saturday Review, London Mercury, New Leader, House and Garden.

1931

13 Duncan Grant: [review of Cooling Galleries exhibition]. (Weekly notes on art). *The Listener*, 24 June 1931, pp.1058–9.

14 Flower, vase and larder in English art. (Weekly notes on art). *The Listener*, 16 Sept. 1931, pp.452–3.

1933

15 Younger English painters – I. *The Listener*, 22 Mar. 1933, pp.450–2.

16 Younger English painters – II. *The Listener*, 29 Mar. 1933, pp.490–2.

17 The Epstein exhibition. *The New Statesman and Nation*, 6 May 1933, pp.570–1.

18 Interpreting Ruskin: [book review of 'John Ruskin' by Wilenski]. *The New Statesman and Nation*, 17 June 1933, p.800.

19 Interviewing artists: [book review of 'Artists at work' by Casson]. *The New Statesman and Nation*, 15 July 1933, p.84.

20 Foreword to the catalogue of *New paintings by Ivon Hitchens*, London, Lefevre Gallery, Oct. 1933, p.[1].

21 Contemporary English drawing. (Art). *The Listener*, 11 Oct. 1933, pp.541–3.

22 December galleries. *The New Statesman and Nation*, 16 Dec. 1933, pp.809–10.

23 Recent paintings of Edward Wadsworth. *Apollo*, 18 Dec. 1933, pp.386–7.

1935

24 Picasso at the Tate. *AXIS*, no.1, Jan. 1935, pp.27–8.

25 Recent books: 'Plastic redirections in twentieth century painting' by J.J. Sweeney, and 'The modern movement in painting' by T.W. Earp. *AXIS*, no.2, Apr. 1935, pp.30–1.

1936

26 [with Geoffrey Grigson]. England's climate. *AXIS*, no.7, Autumn 1936, pp.5–9.

27 England's early sculptors; [text by John Piper; photos by John Piper and Myfanwy Evans]. *Architectural Review*, Oct. 1936, (vol.80), pp.157–62, plus 4 leaves of plates.

1937

28 'Lost: a valuable object', pp.69–73; and 'English early sculptors', pp.116–125. in *The painter's object*, ed. by Myfanwy Evans. London: Gerald Howe, 1937. (reprinted 1970 by Arno Press). Illus. of works by Piper pp.68, 71.

29 Lithographs by Eric Ravilious of shop fronts. *Signature*, no.5, Mar. 1937, p.48 plus 3 leaves of plates.

30 Died April 1st. 1837: John Constable. *Architectural Review*, Apr. 1937, (vol.81), pp.149–50, plus 1 plate.

31 Recent watercolours of Paul Nash. *Town Flats and Country Cottages*. May 1937.*

32 'Invention in colour': drawing by John Piper. *Signature*, no.6, July 1937, frontis.

33 Aspects of modern drawing. *Signature*, no.7, Nov. 1937, pp.33–41, plus 3 leaves of plates.

34 Pre-history from the air. *AXIS*, no.8, Early Winter 1937, pp.4–8.

1938

35 The nautical style. *Architectural Review*, Jan. 1938, (vol.83), pp.1–14, plus 1 plate, (photos by Piper and J.M. Richards).

36 English sea pictures. (Art). *The Listener*, 28 July 1938, pp.180–1.

37 Abstraction on the beach. *XXe Siècle*, Jul./Aug./Sept. 1938, (1ère année, no.3), p.41.

38 The art of the early crosses. *Country Life*, 28 Aug. 1938, pp.218–9.

39 Henry Fuseli, R.A. 1741–1825, *Signature*, no.10, Nov. 1938, pp.1–14, plus 4 leaves of plates.

40 Architectural deportment: [reviews of 'A miniature history of the English house', by J.M. Richards, and 'Pillar to post', by O. Lancaster]. *The New Statesman and Nation*, 10 Dec. 1938, p.1000, 1002.

41 Notes on wall objects old and new. *Decoration*, no.30, Winter 1938, pp.39–43.

1939

42 London: l'architecture londonienne depuis 1800. *Cahiers d'Art*, 1939, (vol.14, nos 1–4), pp.92–103.

43 *Curwen Press News-Letter*, no.16, 1939. 3 colour lithograph design by Piper on cover.

44 London to Bath: a topographical and critical survey of the Bath road; [written and illus. by Piper]. *Architectural Review*, May 1939, (vol.85), pp.229–46.

45 Barbarous Wales: [review of 'Welsh life in the eighteenth century', by Sir L. Twiston Davies and R. Edwards]. *The New Statesman and Nation*, 9 Dec. 1939, p.868, 870.

46 From 1 Dec. 1939 – 26 May 1944 John Piper wrote regularly for *The Spectator* as their art critic.

1940

47 Grey tower and panelled pew: John Piper looks at English country churches and makes drawings of them specially for The Listener. *The Listener*, 1 Feb. 1940, pp.216–8, (4 illus).

48 Fully licensed: [in praise of the ordinary public house]. *Architectural Review*, Mar. 1940, (vol.87), pp.87–100, (illus. incl. photos by Piper).

49 Decrepit glory: a tour of Hafod. *Architectural Review*, June 1940, (vol.87), pp.207–10, plus 1 plate, (6 illus. by Piper).

50 Round the art exhibitions. *The Listener*, 6 June 1940, p.1100.

51 The art of the stuccador. *The Listener*, 5 Sept. 1940, p.353.

52 Towers in the Fens. *Architectural Review*, Nov. 1940, pp.131–4, plus 2 plates, (illus. incl. 8 photos by Piper).

1941

53 John Piper at the A.A. : [extracts from a paper entitled 'Buildings in English art']. *Architect and Building News*, 9 May 1941, (vol.166), p.85, (2 illus. by Piper).

54 The Euston Road Group. *The Listener*, 29 May 1941, pp.771–2.

55 Victorian painting. *The Listener*, 20 Nov. 1941, p.698.

56 [2 illus. by Piper: 'Buckland House'; 'Towcester – screen to Racecourse']. *Architect and Building News*, 19 Dec. 1941, (vol.168), pp.170–1.

1942

57 S.H. Grimm: watercolour painter. (Art). *The Listener*, 12 Mar. 1942, p.341.

58 John Sell Cotman, 1782–1842. *Architectural Review*, July 1942, (vol.92), pp.9–12.

59 Notes from a Yorkshire journal. *The Geographical Magazine*, Dec. 1942 p.364–367.

1943

60 Foreword to the catalogue *The artist and the Church*, organised by C.E.M.A., London, 1943. pp.3–4. see also group exhibitions, (**353**)

61 Stanley Spencer. *Britain Today*, Jan. 1943, (no.81), p.24.

62 A Cubist folk art. *Architectural Review*, July 1943, (vol.94), pp.21–2, (5 drawings by Piper; photos incl. some by Piper).

63 Colour reproduction and the cheap book. (Art). *The Listener*, 22 July 1943, p.104.

64. The gratuitous semicircle. *Architectural Review*, Oct. 1943, (vol.94), pp.112–3, (illus. incl. 4 drawings by Piper).

65 Some old friends. (Colour in building series). *Architectural Review*, Nov. 1943, pp.139–41, (illus. incl. 7 drawings by Piper).

66 Colour and display. (Colour in building series). *Architectural Review*, Dec. 1943, (vol.94), pp.168–71, (illus. incl. 9 drawings by Piper).

1944

67 Colour and texture. (Colour in building series). *Architectural Review*, Feb. 1944, (vol.95), pp.30, 51–2.

68 Blandford Forum. (Colour in building series). *Architectural Review*, July 1944, (vol.96), pp.21–3, (illus. incl. 11 drawings by Piper).

69 Warmth in the west. *Architectural Review*, Sept. 1944, (vol.96), pp.89–91, (illus. incl. 8 drawings by Piper).

70 Topographical letter from Norwich (illustrated with notes for painting). *The Cornhill Magazine*, Jan. 1944, (vol.161, no.961), pp.9–18 plus [4]p. of plates, 8 line drawings, 4 pen and wash.

71 Flint. *Architectural Review*, Nov. 1944, (vol.96), pp.149–51, (illus. incl. 7 illus. by Piper).

72 Topographical letter from Devizes. *The Cornhill Magazine*, Nov. 1944, (vol.161, no.963), pp.190–5 plus [4]p of plates, 4 line drawings in text, 4 col. lithos.

1945

73 Seaton Delaval. *Orion: a miscellany*, no.1, 1945, pp.43–47.*

74 The English tradition of draughtsmanship. *The Listener*, 8 Feb. 1945.

75 Shops. *Architectural Review*, Mar. 1945, (vol.97), pp.89–91, (3 illus. by Piper).

76 Colour in the picturesque village. *Architectural Review*, May 1945, (vol.97), pp.130, 149–50, (6 illus. by Piper).

77 Renaissance Britain. (Art). *The Listener*, 26 July 1945, p.104.

78 St. Marie's Grange: first home of A.W.N. Pugin. *Architectural Review*, Oct. 1945, (vol.98), pp.90–3, (2 illus. by Piper).

79 Introduction to Middlesbrough, *Cornhill Magazine*, Dec. 1945, (vol.161, no.966), pp.430–3 plus [4]p. of plates, (1 illus. from a watercolour by Piper).

80 Coloured pictures. *The Listener*, 6 Dec. 1945, pp.663–4.

1946

81 A wool country: colour in the Cotswolds. *The Ambassador*, 1946, (no.5), pp.61–72, (10 illus. by Piper, plus cover design).

82 Georgian London. (Art). *The Listener*, 28 Mar. 1946, p.408.

83 Exeter replanned: [review of 'Exeter phoenix', by T. Sharp]. *The New Statesman and Nation*, 20 Apr. 1946, pp.288–9.

84 The market square. (Colour in building series). *Architectural Review*, May 1946, (vol.99), pp.153–5, (4 illus. by Piper).

85 The artist and the Church. *Cymry'r Groes: a Quarterly Magazine*, July 1946, (vol.2, no.1), pp.25–32.*

86 Religion inspires a modern artist: [on Graham Sutherland's 'Crucifixion' in the Church of St Matthew, Northampton]. *Picture Post*, 21 Dec. 1946, pp.13–15.

1947

87 Post-Reformation sculpture: [review of 'English church monuments', 1510–1840, by K.A. Esdaile]. *The New Statesman and Nation*. 8 Mar. 1947, p.160.

88 Pleasing decay. *Architectural Review*, Sept. 1947, (vol.102), pp.85–94.

89 Sickert: painter-critic. *The Listener*, 4 Sept. 1947, p.396.

90 English painting at the Tate: [exhibition review]. *Burlington Magazine*, Oct. 1947, (vol.89), p.285.

91 A new Bath guide. *The Listener*, 27 Nov. 1947, p.946.

1948

92 'Designs of Lucretia', p.67 *in The Rape of Lucretia: a symposium*; ed. by Ronald F.H. Duncan; with texts by Benjamin Britten, Ronald Duncan, John Piper *et al.* London: Bodley Head, 1948. Also contains 8 colour lithographs from the original designs by Piper, most full page. 3 fold out to 15″ wide. 1 reprod. on the front wrapper.

93 Design for 'The Quest'. *Britain Today*, Apr. 1948, (no.144), 1 illus. facing p.39.

94 Pattern and colour from English slate engravings; collected, coloured and described by John Piper. *The Ambassador*, 1948, (no.9), pp.67–80, (50 illus.).

95 Bath, Edinburgh, and art historians. (Art). *The Listener*, 1 July 1948, p.28.

96 Job: a masque for dancing – set designs. *Britain Today*, Oct. 1948, (no.148), 2 illus. facing p.37.

1949

97 Foreword to *The drawings of Henry Fuseli*, by Paul Ganz. London: M. Parrish, 1949, pp.7–10.

98 Book illustration and the painter – artist. *Penrose Annual*, vol.43, 1949, pp.52–4, plus 4p. of tipped-in lithographs from illus. by Piper, (6 illus.).

99 S. John Woods. (Portrait of the artist, no.12). *Art News and Review*, 16 July 1949, (vol.1., no.12), p.1.

100 Stonehenge. (Reassessment, 5) *Architectural Review*, Sept. 1949, (vol.106). pp.177–82, (illus. incl. 7 photos by Piper).

1950

101 Picturesque travel illustrated. *Signature*, no.11 (new series), 1950, pp.3–19 plus 4 leaves of plates.

1951

102 Advertising films intelligently. *The Penrose Annual*, vol.45, 1951, pp.33–4.

1952

103 Aquatint and lithography: [book review of] 'Scenery of Great Britain and Ireland in aquatint and lithography, 1770–1860, from the Library of J.R. Abbey'. *Signature*, no.16 new series, 1952, pp.50–1.

1953

104 What they stand for. *The Ambassador*, 1953, Special Coronation Edition, pp.40–52.

1954

105 Portland stone – Portland colours: textures and shades of the island and its treasure. *The Ambassador*, 1954, (no.6), pp.80–94. (16 illus. by Piper plus cover design).

1955

[Introduction to the 1955 exhibition] A small anthology of modern stained glass.
see Group Exhibitions (**363**)

106 The world of Paul Nash: [review of 'Paul Nash: the portrait of an artist' by A. Bertram]. *The New Statesman and Nation*, 8 Oct. 1955, pp.434, 436.

1956

107 Master of all arts: [review of 'In search of Diaghilev', by R. Buckle]. *The New Statesman and Nation*, 11 Feb. 1956, pp.158–9.

108 The card and the charmer: [review of 'William Nicholson' by L. Browse]. *The New Statesman and Nation*, 4 Aug. 1956, p.138.

1957

109 Abstraction to creation, *in A tribute to Evie Hone and Mainie Jellett*, ed. by Stella Frost. Dublin: Browne and Nolan, 1957, pp.43–45.

110 Good to steal from: [review of 'Index to the story of my days' by Edward Gordon Craig]. *The New Statesman and Nation*, 5 Oct. 1957, p.436.

1961

111 Serenissima. *Architectural Review*, May 1961, (vol.129), pp.301–3, (1 illus. by Piper).

1962

112 The eyes have it. (Pleasure in reading). *The Times*, 1 Feb. 1962, p.13.

1966

113 The artist and his work. *Christian Science Monitor*, 16 Feb. 1966.

1967

114 The Liverpool lantern. *Studio International*, June 1967, (vol.173, no.890), pp.294–5.

1973

115 Obituary: Adrian Stokes. *Architectural Review*, (vol.153), March 1973, pp.209–210.

116 Paul Nash – photographer: [review of Tate Gallery exhibition] *Architectural Review*, Jul. 1973, (vol.154), pp.62–3.

1975

117 [with others]. Completion of Queen's Gate – the results . . . article by the assessors. *Building Design*, 1 Aug. 1975, (no.261), pp.9–12.

1976

118 Colouring light: [review of] 'Stained glass' by Lawrence Lee, George Seddon and Francis Stephens . . . *The Guardian*, 28 Oct. 1976, p.15.

1977

119 Herefordshire – 3. *Vole*, no.1, 1977, pp.38–9, (5 photos by Piper).

120 Place of the month: the Fens. *Vole*, no.3, 1977, pp.43–52, (4 photos by Piper).

1978

121 [with W. M[oelwyn] M[erchant]]. Rev. Dr Victor Kenna: [obituary]. *The Times*, 16 Aug. 1978, p.14.

1980

122 *Master weavers: tapestries from the Dovecot Studios 1912–80:* [catalogue for exhibition held Royal Scottish Academy, Edinburgh Aug.–Sept. 1980]. Edinburgh: Canongate, 1980. Foreword by John Piper. John Piper's tapestries listed but not exhibited.

3 Books, articles and pamphlets illustrated by Piper

John Piper. *Wind in the trees*, 1921
see Books by ... (1)

John Piper. *The gaudy saint*, 1924
see Books by ... (2)

123 Charles Alfred Piper. *Sixty-three: not out: a book of recollections ...*; with decorations by J. Piper. Plaistow: Curwen Press, 1925.
Privately printed. 19 vignettes from ink drawings.

John Piper. *Oxfordshire*. 1938.
see Books by ... (12)

John Piper. *Brighton aquatints, 1939*.
see Books by ... (3)

John Piper. *Shropshire*. 1939.
see Books by ... (12)

124 John Betjeman. The seeing eye, or How to like everything; illus. by John Piper. *Architectural Review*, Nov.1939, (vol.86), pp.201–4, (8 illus.).

125 *Horizon*, Jan. 1940, (vol.1, no.1) Cover design by Piper.

126 C. Day Lewis. *Poems in wartime*. London: J. Cape, 1940. Illus. on the cover and title page reprod. from drawings by Piper.

127 John Betjeman and Geoffrey Taylor. *English, Scottish and Welsh landscape, 1700–c.1860;* chosen by John Betjeman and Geoffrey Taylor; with original lithographs by John Piper. London: F. Muller, 1944.
12 Full-page colour autolithographs, and front and back cover lithograph.

128 Rev. Francis Kilvert. *Kilvert's diary, 1870–1879: selections from the diary of the Rev. Francis Kilvert;* chosen, ed. and introd. by William Plomer. London: Readers Union, J. Cape, 1944.
Frontis. and decoration on title page from drawings by Piper.

129 Palinurus. *The unquiet grave: a word cycle ...* Rev. ed. London: H. Hamilton, 1945.
Front dust wrapper designed by Piper, printed from collage original at the Curwen Press.

130 Sir Osbert Sitwell. *Left hand, right hand:* [an autobiography in 5 volumes]. London: Macmillan, 1945–50. vol.1: Cruel month (1945); vol.2: The Scarlet tree (1946); vol.3: Great Morning (1948); vol.4: Laughter in the next room (1949); vol.5: Noble essences (1950). Illus. with reprod. of Piper's paintings and drawings.

131 Sir Thomas Browne. *The last chapter of Urne buriall;* [ed. by John Carter]. Cambridge: Will Carter at the Rampant Lions Press, 1946.
Ltd ed. of 175 copies. Cover and title page designs by Piper.

132 Walter de la Mare. *The traveller;* with drawings by John Piper. London: Faber and Faber, 1946.
6 colour drawings by Piper, lithographed by T.E. Griffits at the Baynard Press.

133 Myfanwy Evans (ed.) *The pavilion: a contemporary collection of British art and architecture*. London: I.T. Publications, 1946.
2 copies of medieval stained glass windows by Piper, lithographed by T. Griffits. pp.15–17.

134 James M. Richards. *The castles on the ground;* illus. by John Piper. London: Architectural Press, 1946.
8 full-page two-colour autolithographs incl. frontis. Dust wrapper design three-colour lithograph.
see also 2nd ed., 1973. (180)

135 Norman Hancock. *An innocent grows up*. London: J.M. Dent, 1947.
Colour lithographed dust wrapper and frontis. from same collage original.

136 Michael Sadleir. *Forlorn sunset*. London: Constable, 1947.
2-colour lithographed front dust wrapper and frontis. from same original.

137 Evelyn Waugh. *Scott-Kings modern Europe*. London: Chapman and Hall, 1947.
Dust wrapper design by Piper.

138 John Betjeman *and* John Piper (Eds). *Murray's Buckinghamshire architectural guide*. 1948.
see Books by ... (6)

139 Geoffrey Grigson. *An English farmhouse and its neighbourhood*. London: M. Parrish, 1948. (Studies in composition and tradition series, ed. by John Piper).
Double-spread cover design by Piper.

John Piper. *Buildings and prospects*. 1948.
see Books by ... (5)

140 William Sansom. *South: aspects and images from Corsica, Italy and Southern France*. London: Hodder & Stoughton, 1948.
Front dust wrapper designed by Piper.

141 Sir George R. Sitwell. *On the making of gardens;* with an introduction by Sir Osbert Sitwell; and decorations by John Piper. London: Dropmore Press, 1949.
Ltd ed. of 1,000 copies.
6 colour line illus.: 3 full-page; 3 double spreads.

John Betjeman *and* John Piper (Eds). *Murray's Berkshire architectural guide*. 1949.
see Books by ... (8)

142 Elisabeth Inglis-Jones. *Peacocks in paradise: the story of a house – its owners and the Elysium they established there, in the mountains of Wales, in the 18th century*. London: Faber and Faber, 1950.
Front dust wrapper illustration by Piper.

143 T.D. Kendrick. *British antiquity*. London: Methuen, 1950.
Front dust wrapper design by Piper.

John Piper. *Romney Marsh*. 1950.
see Books by ... (9)

144 Edith Sitwell, *Façade and other poems, 1920–1935;* with an introductory essay by Jack Lindsay. London: Gerald Duckworth, 1950.
Dust wrapper carries reprod. of curtain designed by John Piper for the concert performance of Façade.

145 *Fortune*, May 1950. Cover for the article 'Britain's Road Back', Colour halftone from pen and wash drawing.

146 William Wordsworth. *A Guide through the district of the Lakes in the North of England ...;* by William Wordsworth; with illus. by John Piper; and an introd. by W.M. Merchant. London: Rupert Hart-Davis, 1951. 10 line blocks from pen and collage drawings, 2 reprod. on the cover.

147 John Betjeman. *First and last loves*. London: J. Murray, 1952.
24 illus. in line and half-tone from drawings and collage. Dust wrapper designed by Piper.

148 Arthur Raistrick. *Dynasty of iron founders: the Darbys and Coalbrookdale*. London: Longmans, Green, 1953.
Front dust wrapper design by Piper; colour reprod. of painting by Piper as frontis.

149 John Piper and John Betjeman. Glories of English craftsmanship – electricity and old churches; specially drawn by John Piper from authentic examples in Buckinghamshire. *Time and Tide*, 5 Dec. 1953, (vol.34, no.49), pp.1582–3, (8 line drawings by Piper).

150 John Betjeman. *Poems in the porch*. London: S.P.C.K., 1954.
7 line drawings in text and one on front cover.

151 Edwin Muir. *Prometheus: aerial poem*. London: Faber and Faber, 1954.
3 illus.*

152 Janet Stone (comp.). *Edward Sydney Woods, 94th Bishop of Lichfield: some appreciations*. London: Victor Gollancz, 1954.
2 illus. by Piper, one engraved on wood by Reynolds Stone.

153 Drawings illustrating how not to do it, *in The installation of electricity in churches*. London: Central Council for the Care of Churches, 1955, p.4–6.

154 Julian Duguid. *The blue triangle*. London: Hodder and Stoughton, 1955.
Dust wrapper design by Piper, incorporating line drawing on front cover.

155 John Hadfield (Ed.). *Elizabethan love songs*; with lithographs by John Piper. Barham Manor (Suffolk): Cupid Press, [1955].
Ltd ed. of 660 numbered copies signed by Piper. 8 4-colour lithographs drawn on plastocowell film by Piper and printed by W.S. Cowell, Ipswich.

156 Colin Graham. The English Opera Group, 1946–1956.
[s.l.]: [s.n.], 1956.
Cover design by Piper.

157 John Betjeman (Ed.). *Collins' guide to English parish churches, including the Isle of Man*. London: Collins, 1958.
Line drawings in text, plus 12 photographs. *See also* 2nd ed., 1968; 3rd ed., 1980. (171, 188)

158 Basil F.L. Clarke. *Anglican cathedrals outside the British Isles;* with a foreword by John Betjeman. London: S.P.C.K., 1958.
Front dust wrapper design by Piper.

159 Yvonne Mitchell. *The bed-sitter*. London: A. Barker, 1959.
Front dust wrapper design by Piper.

160 Bertrand Russell. *The wisdom of the West*; ed. by Paul Foulkes; designer Edward Wright; with ten compositions by John Piper. London: Macdonald, 1959.
10 full-colour illus. from originals in collage and paint.

161 Ronald F.H. Duncan. *Judas;* illustrated by John Piper. London: Anthony Blond, 1960.
Ltd ed. of 500 numbered and signed copies plus ordinary ed. 8 full-page black and white collotypes from collage originals, printed at the Chiswick Press.

162 Ivan Sanderson and Sacheverell Sitwell. *A century of Sanderson, 1860–1960*. London: [Arthur Sanderson & Sons Ltd], 1960.
Cover design by Piper.

163 Robin Fedden. *The enchanted mountains: a quest in the Pyrenees*. London: John Murray, 1962.
3-colour lithograph frontis.

164 Gilbert White. *The natural history of Selbourne ...;* ed. with an introd. and notes by W.S. Scott; drawings by John Piper. London: Folio Society, 1962.
12 full-page drawings, incl. frontis. Double-spread design, in black and white, on boards.

165 Joyce and Kenneth Lindley. *Urns and angels: an anthology of epitaphs*. Swindon: Pointing Finger Press, 1965.
Ed. of 22 copies, utilising the same wood engravings from Piper drawings as 'Of graves and epitaphs', 1965.

166 Kenneth Lindley. *Of graves and epitaphs;* frontis. and endpapers [from drawings] by John Piper. London: Hutchinson, 1965.
Black and white wood engravings.

167 James Morris. *Oxford*. London: Faber and Faber, 1965.
2-colour lithographed frontis.

168 Adrian Stokes. *Venice ...,* illus. by John Piper. London: Lion and Unicorn Press, 1965.
26 4-colour lithographs, some full-page, some double-spreads.
Another ed. was published in the same year by Duckworth with an additional lithograph, and end-papers and dust wrapper by Piper.

169 Edward Blunden. *The Great Church of the Holy Trinity, Long Melford*. [s.l.]: [s.n.], 1966.
Double-spread cover, lithograph commissioned from Piper.

170 Chichester Cathedral. *Flower in praise, 2, 3, 4 September 1966*. [s.l.]: [s.n.], 1966.
Flower decoration, 2-colour halftone designed by Piper, used on cover and throughout the text.

171 John Betjeman (Ed.). *Collins pocket guide to English parish churches*. 2nd ed. 2 vol. London: Collins, 1968.
10 line drawings in the Introduction, and 8 photographs in the texts. Drawing by Piper reprod. in colour on front of dust wrapper.
see also 1st ed., 1958; 3rd ed., 1980. (**157, 188**)

172 Basil F.L. Clarke. Street's Yorkshire churches and contemporary criticism; notes on contemporary criticism by Basil F.L. Clarke; with [9 black and white] photographs by John Piper.
in Summerson, John. *Concerning architecture: essays on architectural writers and writing presented to Nikolaus Pevsner*. London: Allen Lane, 1968. pp.209–225.

173 Ronald S. Thomas. *The mountains…*; illus. with ten drawings by John Piper, engraved on the wood by Reynolds Stone; with a descriptive note by John Piper. New York: The Chilmark Press, [1968 or 9].
Printed by Will and Sebastian Carter at the Rampant Lion Press, in an edition of 350 numbered copies. 110 signed copies with special binding and an extra set of the wood engravings.

174 Arnold J. Taylor. *Castell Caernarfon…*; with three lithographs by John Piper. Cardiff: HMSO, 1969.
3 detachable illus. reprod. from lithographs. Published on the occasion of the Investiture of the Prince of Wales.

175 *Oxfordshire historic churches appeal*. Printed: Luton: Leagrave Press Ltd for the appeal by Robert Maxwell MC, … Pergamon Press, Oxford, [s.d. 197–?].
Line drawing reprod. on cover.

176 Alan Hoddinott. *The tree of life*. London: Oxford University Press, 1971.
Cover design by Piper.

177 Wilhelmine Harrod (Ed.). *Norfolk country churches and the future*. [s.l.]: The Norfolk Society. [1972].
Front cover: full colour half-tone from a drawing specially commissioned from Piper.

178 Anne Ridler. *The Jesse tree*; with drawings by John Piper. London: Lyrebird Press, 1972.
Ed. of 100 numbered and signed copies. Colour lithograph frontis. 9 black and white illus. in text, and one on cover.
Another ed. was published by the same publisher in the same year, in smaller, paperback format, no.3 in the series, PL: Editions poetry London, and lacking the coloured frontis.

179 James Morris. *Heaven's command: an imperial progress*. London: Faber and Faber, 1973.
Double-spread frontis. illus., reprod. of drawing by Piper. Repeated on double-spread dust wrapper.

180 James M. Richards. *The castles on the ground: the anatomy of suburbia*; illus. by John Piper. 2nd ed. London: John Murray, 1973.
4 of the illus. from the 1st ed. re-drawn, and 4 new subjects added, printed by off-set lithography in black only. One of the original images plus another by Piper are used in the jacket design.
see also 1st ed. 1946. (**134**)

181 *Chichester 900*; preface by Walter Hussey. Chichester: Chichester Cathedral, *c.*1975.
Double-spread colour cover from a drawing by Piper.

182 Llanddewibrefi Arts Festival, 1975. *Festival programme*.
2-colour lithograph cover from drawing by Piper.

183 Llanddewibrefi Arts Festival, 1976. *Festival programme*.

Cover: black and white half-tone from a painting by Piper who was also a consultant to the Festival.

184 Henry Thorold (Ed.). *Lincolnshire churches: their past and their future;* illus. by John Piper CH, Felix Kelly and John Sutcliffe. [s.l.]: [Lincolnshire Old Churches Trust], *c.*1976.
5 half-tone illus. from paintings (1 in col. on cover); 14 photographs.

185 *India love poems*; translated by Tambimuttu; illustrated by John Piper. London; New York: Paradine/London: PL. Edns. Poetry London No.4, 1977.
18 single-sided colour lithographs, printed by Will and Sebastian Carter of the Rampant Lion Press. Ed. of 200 signed and numbered copies, 40 accompanied by an original illus.

186 English village and French village: Weston Zoyland and Essoyes: [two line drawings]. *Architype: Bristol University Student Architecture Magazine*, no.3, 1977.

187 Roger Pringle and Christopher Hampton (Eds). *A selection from Poems for Shakespeare, vols.1 to 6*; with original drawings. London: Globe Playhouse Publications, 1978.
Ltd ed. of 500 copies.
Line drawings on endpapers (same image back and front), and title page decoration.

188 John Betjeman (Ed.). *Collins guide to parish churches of England and Wales, including the Isle of Man.* 3rd ed. London: Collins, 1980.
10 line drawings in the Introduction and 11 photographs in the text. *see also* 1st ed., 1958; 2nd ed., 1968. (**157, 171**)

189 Jean Corke, John Blatchly, John Fitch (Eds). *Suffolk churches.* 3rd ed. Lavenham, Sudbury: Suffolk Historic Churches Trust, 1980.
Originally publd 1976; 2nd ed., 1977.
Frontis.: black and white half-tone of drawing by Piper.

190 John Betjeman. *Church poems*; illus. by John Piper. London: J. Murray, 1981.
18 line drawings in text, one repeated on front of dust wrapper. Two ed., ordinary ed. with dust wrapper; limited ed. of 100 copies bound in watered silk and buckram signed by the author.

191 Ronald Blythe (Ed.). *Places: an anthology of Britain*. Oxford: Oxford University Press, 1981.
Illus. include 7 Piper drawings reproduced in black and white as double-page spreads, end papers, title page and dust wrapper illus.

192 Eric Mottram. *A book of Herne, 1975–1981*. Colne (Lancs): Arrowspire Press, 1981.
Front dust wrapper design 'Spring' from a suite of Piper's etchings called 'The Seasons' published by Christie's Contemporary Art, 1981.

193 John Dyer. *Grongar Hill*. London: Stourton Press, 1982.
Illus. and with a foreword by John Piper.

194 *Poetry London/Apple Magazine*, no.2, 1982. Cover by John Piper, also fold out half tone full colour reprod. of a collage/painting by John Piper inserted between p.48 and 49, illus. a poem 'Hands' by Bryan Guinness.

195 *Quarto*, no.25, Jan/Feb. 1982. Line cover from black and white drawing drawn for the issue, of Little Moreton Hall, Cheshire.

196 John Piper and Mark Girouard. *John Piper's Stowe*; with a foreword by John Piper and a commentary by Mark Girouard. Westerham: Hurtwood Press in association with the Tate Gallery, *forthcoming* 1983.*
Ltd ed. of 300 signed and numbered copies, containing an original print by Piper. ca. 60 illustrations printed in four or more colours working direct from the original drawings.

4 Interviews with the artist

197 B. Myerscough-Walker. Modern art explained by modern artists: B. Myerscough-Walker interviews John Piper who explains his views and general outlook on art. (Part III). *The Artist*, May 1944, (vol.27, no.3), pp.65–7.

198 Predicament, *London Magazine*, July 1961. Statement by Piper in reply to a questionnaire, pp.81–82.

199 Stephen Spender. A talk with John Piper. *Encounter*, May 1963, (vol.20, no.5), pp.59–61.

200 Noel Barber. *Conversations with painters*. London: Collins, 1964, pp.57–68.

201 Mary Banham *and* Bevis Hillier. *A Tonic to the nation*. London: Thames and Hudson, 1976.
A painter's funfair: interview with John Piper: artist; designer with Osbert Lancaster, of the Grand Vista, Battersea Pleasure Gardens, pp.123–5.

202 Martina Margetts (interviewer). A Piper portfolio. *Crafts*, Jan./Feb. 1979, pp.34–9.

203 Gary Power, Richard Swift, and Emma Cunningham. John Piper, interviewed, 18 Nov. 1978. *Composition:* [*University of Reading Fine Art Department*], Spring 1979, pp.[31–46] plus illus. on front cover.

204 John Higgins. 'The Dream' goes to Glyndebourne: John Higgins talks to John Piper, first designer of Britten's Opera. *The Times Preview*, 19–25 June 1981, p.v.

205 Angela Levin. John Piper; interviewed by Angela Levin; photographed by Brian Moody. (A Room of my own). *Observer Magazine*, 21 Feb. 1982, pp.30–1.

206 Graham Hughes. John Piper, interviewed. *Arts Review Year Book*, 1983, pp.42–3.

5 Broadcasts

1935

207 22 Jan. To unemployed listeners, by John Hilton and John Piper. Radio broadcast, B.B.C.

1936

208 7 Nov. The Autumn galleries, by John Piper. Television broadcast, B.B.C.

209 18 Nov. Some further exhibits . . . described by Mr Piper. Television broadcast, B.B.C.

1937

210 13 Jan. London Galleries. Television broadcast, B.B.C.

211 27 Jan. Art and modern architecture: a discussion between John Piper and Serge Chermayeff. Television broadcast, B.B.C.

212 10 Feb. London galleries. Television broadcast, B.B.C.

213 24 Feb. Modern art and stage design: John Piper and Robert Medley. Television broadcast, B.B.C.

214 10 March. John Piper and W. Staite Murray. Television broadcast, B.B.C.

215 24 March. John Piper and a group of young artists. Television broadcast, B.B.C.

1938

216 10 Jan. A trip to the seaside by Myfanwy Evans and John Piper. Television broadcast, B.B.C.

1955

217 30 March. John Piper: documentary, by John Read. Television broadcast, B.B.C.

1962

218 24 May. Women's hour: John Piper interviewed by Cecilia Ococks, discussing Coventry Cathedral's stained glass. Radio broadcast, B.B.C.

1965

219 25 Nov. British art in the thirties. Radio broadcast, B.B.C.

1983

220 27 Feb. Time with Betjeman. Television broadcast, B.B.C.2.

221 Oct. South Bank Show. Television broadcast, London Weekend Television.

6 One-man exhibitions

ca.1933

222 London, Zwemmer. No catalogue.*

1938

223 May. London, London Gallery. *John Piper: paintings, collages and drawings.* (31 works). in *London Gallery Bulletin,* no.2, 1938, pp.9–[12]. Introd. by Paul Nash.

1940

224 March. London, Leicester Galleries. *Paintings and watercolours by John Piper.* (35 works). 8p.

1945

225 Jan. London, Leicester Galleries. *The Sitwell country: Derbyshire domains, backgrounds to an autobiography . . .* (47 works). pp.18–20. Preface by Sir Osbert Sitwell, Bart.

1946

226 Oct.–Nov. London, Leicester Galleries. *John Piper: stage designs for Benjamin Britten's opera 'The Rape of Lucretia'.* (23 works). [4]p.

1948

227 Feb. New York, Buchholz Gallery. *John Piper.* (43 works). Introd. by John Piper. [8]p.

228 Dec. London, Leicester Galleries. *New paintings and drawings by John Piper.* (39 works). 19p.

1949

229 Nov.–Dec. London, Victoria and Albert Museum. *Special exhibition of paintings by John Piper commissioned for the British Embassy in Rio de Janeiro.* (5 works). [no catalogue traced].*

1950

230 Oct.–Nov. New York, Buchholz Gallery, *John Piper: recent work.* (34 works). Introd. by John Carter. [8]p.

1951

231 Feb.–Mar. Philadelphia, The Philadelphia Art Alliance. *John Piper: oils, gouaches, watercolours.* (22 works). [4]p.

232 Nov. London, Leicester Galleries. *New pictures by John Piper entitled stones and flowers.* (31 works). [8]p.

1953

233 Jan.–Feb. Cambridge, Arts Council Gallery. *Catalogue of an exhibition of paintings and drawings in various media and produced between the years 1935 and 1952 together with a group of photographs of topographical subjects by John Piper.* (29 works). 8p. Introd. by John Commander. Travelled to the Cecil Higgins Museum, Bedford.

1955

234 Feb.–Mar. New York, Curt Valentin Gallery. *John Piper.* (33 works). Introd. by S. John Woods. [12]p.

235 May–June. London, Leicester Galleries. *The recent work of John Piper.* (39 works). 15p.

1956

236 Oct.–Nov. Amsterdam, Kunstzaal Magdalene Sothmann. *Werken van John Piper.* (33 works). [7]p.

1957

237 Feb.–Mar. New York, Durlacher Bros. *John Piper.* (23 works). [2]p.

238 Nov. London, Leicester Galleries. *New paintings and watercolours by John Piper.* (31 works). 11p.

1959

239 Nov. London, Leicester Galleries. *New paintings and gouaches by John Piper.* (34 works). 11p.

1960

240 May–June. London, Arthur Jeffress Gallery. *Paintings and watercolours of Venice by John Piper.* (48 works). [11]p.

1961

241 May–June. Oxford, Bear Lane Gallery. *Brittany: new paintings by John Piper.* (21 works). [3]p.

242 Oct.–Nov. New York, Durlacher Bros. *John Piper.* (32 works). [2]p.

1962

243 May. London, Arthur Jeffress Gallery. *Paintings and watercolours of Rome by John Piper.* (45 works). [11]p.

244 Dec. New York, Landry Gallery. *[John Piper: 6 preparatory sketches for Coventry Cathedral Baptistery window].* [no catalogue traced].*

1963

245 Mar.–Apr. London, Marlborough Fine Art. *John Piper: recent work.* (63 works). 15p.

1964

246 Mar. London, Marlborough New London Gallery. *Retrospective exhibition: John Piper.* (137 works). 38p. Pref. by Robert Melville.

247 June–Nov. Cardiff, Arts Council (Welsh Committee). *John Piper in Wales: [a travelling exhibition organised in conjunction with Llandaff Festival Committee opened at Prebendal House of Llandaff Cathedral].* (36 works). Introd. by Tom Cross. [21]p.

248 June–July. Cardiff, Howard Roberts Gallery. *John Piper.* (38 works). [4]p.

249 Autumn. London, Marlborough Fine Arts. *A retrospect of Churches: exhibited on the occasion of the publication of a suite of lithographs by Marlborough.* (24 works). Introd. by J. Betjeman. [4]p.

1965

250 Sept.–Nov. Cologne, Baukunst. *John Piper: Olbilder, Aquarelle, Gouachen, Collagen, Kirchenfensterentwürfe.* (124 works). Introd. by Myfanwy Piper. [18]p.

1966

251 June. Aldeburgh, Aldeburgh Festival. *John Piper: Suffolk churches and landscapes.* (30 works). [5]p.

1967

252 March–April. Belfast, Ulster Museum. *John Piper Retrospective.* (121 works). [20]p. Travelling to Marlborough Fine Arts, London and Richard Demarco Gallery, Edinburgh. Introd. by A. Reichardt.

253 May–June. Nottingham, University Art Gallery. *John Piper: designs for the Chichester Cathedral tapestry.* (22 works). Introd. by John Piper. [4]p.

254 Oct.–Nov. London, Brook St. Gallery. *John Piper: studies from sketchbooks, 1940–60.* (100+ works). [32]p.

1968

255 Sept.–Oct. Bedford, Cecil Higgins Art Gallery. *John Piper: [paintings and drawings]* (47 works). [7]p. dupl. typescript.

256 Nov.–Dec. Blandford Forum, Hambledon Gallery. *John Piper: life drawings.* (31 works). [3]p.

1969

257 Feb.–Mar. London, Hamet Gallery. *John Piper: gouaches and watercolours.* (39 works). [4]p. folded card.

258 Apr.–May. Manchester, Cathedral Arts Festival. *John Piper: [paintings, drawings and prints].* (52 works). [10]p.

259 May–June. London, Marlborough New London. *John Piper: European topography, 1967–69, oil paintings and gouaches.* (76 works). [24]p.

260 June–July. Oxford, Bear Lane Gallery. *John Piper.* (28 works). [4]p.

1970

261 Johannesburg, Pieter Wenning Gallery. *John Piper.* (53 works). Introd. by John Piper. [9]p.

262 Oct.–Nov. Blandford Forum, Hambledon Gallery. *Landscapes and churches: [watercolours and gouaches; prints].* (33 works). [1]p. dupl. typescript.

263 Oct.–Nov. Folkestone, The Arts Centre, New Metropole. *John Piper retrospective exhibition.* (111 works). Introd. by J. Eveleigh. [16]p.

1971

264 June. London, William Weston Gallery. *Lithographs by John Piper.* (16 works). [16]p.

1972

265 Jan. King's Lynn. Fermoy Art Gallery. *Exhibition of gouaches and graphics by John Piper.* (47 works). [4]p.

266 Mar.–Apr. London, Marlborough Fine Art. *John Piper: oil paintings, gouaches and ceramics.* (73 works. 30p.

267 May–Sept. Lincoln, Cathedral. *An exhibition of works by John Piper:* [on the occasion of the Lincoln Cathedral 9th centenary Festival]. (52 works). [15]p.

268 Aug. Kidderminster, Kidderminster Art Gallery. *John Piper: paintings and graphics.* (47 works) [9]p.

269 Autumn. Oundle, Oundle School. *John Piper.* [no catalogue traced].*

1973

270 [Jan.–Feb.]. London, Marjorie Parr Gallery. *John Piper.* [no catalogue traced].*

271 Apr.–May. Leicester, Gadsby Gallery. *John Piper: an exhibition.* (52 works). Introd. by Rigby Graham. 130p. Ltd ed. of 450 copies

272 May. Birmingham, Compendium Galleries. *John Piper.* [no catalogue traced].*

273 May. Johannesburg, Pieter Wenning Gallery. *John Piper.* (37 works). [7]p.

274 [July–Aug.]. Harlow, Playhouse Gallery. *John Piper.* (37 works). [15]p. dupl. typescript.

275 July–Aug. Leigh (Lancs.), Turnpike Gallery. *John Piper: oil paintings, drawings, gouaches, watercolours and ceramics.* (48 works). [8]p. Travelling to Burnley, Sept.–Oct.

276 Nov.–Dec. Reading, Fine Art Gallery. The Gallery Upstairs. *Exhibition of originals and graphics by John Piper.* [no catalogue traced].*

277 Cardiff, Arts Council (Welsh Committee). *John Piper: photographs of Wales:* [plus some prints, drawings and collages]. (112 works). Introd. by Eric de Mare. [14]p and [16]p. fold. cards.

278 London, Barry Cronan Fine Art. *John Piper: foliate heads.* (1 work). [2]p.

279 [Apr.]. Norwich, Buxton Mill Galleries. *John Piper.* (54 works). [6]p.

1975

280 Nov. Henley-on-Thames, Bohun Gallery. [*John Piper, eye and camera*]. [no catalogue traced].*

281 Sept.–Oct. London, Marlborough Fine Art. *John Piper.* (49 works). 16p.

1976

282 May–June. London, Marjorie Parr Gallery. *John Piper.* (32 works). 2p. carbon copy of typescript.

283 July. Osaka, Gallery Kasahara. *John Piper.* (15 works). 16p.

1977

284 Feb. Aberystwyth, Arts Centre Gallery, University College of Wales. *John Piper.* (43 works). Introd. by Rev. W.M. Merchant. [4]p.

285 June–July. Blandford Forum, Hambledon Gallery. *John Piper.* (20 works). [1]p. dupl. typescript.

286 June–Aug. Kendal, Abbot Hall Gallery. (30 works). *John Piper.* [no catalogue].

287 Oct.–Nov. London, Marlborough Fine Art. *John Piper: Victorian dream palaces, and other buildings in landscape.* (45 works). 16p.

1978

288 Feb.–Mar. Cardiff, University Main College, Central Hall. *John Piper: early and recent pictures.* (72 works). Introd. by Peter Pears. [15]p.

289 June. Aldeburgh, New Gallery, Snape Maltings. *John Piper exhibition . . . : recent pictures and a few*

early ones. (28 works). [1]p. dupl. typescript.

290 Oct.–Nov. Swansea, Glynn Vivian Art Gallery and Museum. *John Piper: Swansea Festival.* (81 works). Introd. by J.S. Bunt [24]p.

291 Nov. Henley-on-Thames. Bohun Gallery. *John Piper.* [no catalogue traced].*

292 Nov.–Dec. Cwmbran, Llantarnan Grange Art Centre. *Paintings by John Piper.* [no catalogue traced].*

1979

293 May–June. Oxford, Museum of Modern Art. *John Piper: 50 years of his work: paintings, drawings and photographs, 1929–1979.* (90 works). Texts by J. Hoole, S. Mason, J. Betjeman, H.G. Porteous, J. Piper. 48p. Arts Council exhibition, travelling to Colchester, The Minories. June–July.

1980

294 July. Ollerton (Notts.), Rufford Craft Centre. *An exhibition of work by John Piper to mark the opening . . . of the Gallery at Rufford Craft Centre.* (72 works). [12]. leaves dupl. typescript.

295 Nov.–Dec. Henley-on-Thames, Bohun Gallery. *John Piper.* (35 works). [1]p. dupl. typescript.

296 Nov.–Dec. Manchester, Manchester Cathedral, Regimental Chapel. [*John Piper: paintings, drawings, graphics.* [no catalogue traced].*

1981

297 Jan.–Feb. London, Maclean Gallery. *John Piper: the Sitwells' Montegufoni.* (14 works). Introd. by Elisabeth Cayzer. [19]p.

298 June–July. Dorchester, Dorchester Abbey. *Paintings and graphics by John Piper.* (33 works). [4]p.

299 Dec.–Jan. 1982. London, Marlborough Fine Art. *John Piper: Tudor picturesque, other buildings and landscapes.* (41 works). 12p

1982

300 Jan.–Feb. Dublin, Solomon Gallery. *Paintings by John Piper.* (33 works). [12]p.

301 Feb.–Mar. London, Blackman Harvey Ltd. *John Piper:* [prints]. (40 works). [i], 4p.

302 Aug.–Sept. Newlyn, Newlyn Art Gallery. *Solo exhibition: John Piper.* (19 works). [1]p. dupl. typescript.

303 Nov. London, Dan Klein. *New ceramics by John Piper.* (94 works). Introd. by Quentin Bell. 20p.

304 Dec.–Jan. 1983. Cambridge, Kettle's Yard. *John Piper: painting in coloured light: an exhibition of stained glass and related works.* (36 works). Texts by Martin Harrison and John Piper; ed. by Ann Compton. [35]p.

1983

305 May–June. Henley-on-Thames, Bohun Gallery. *John Piper.* (39 works). [2]p. dupl. typescript and illus. card.

306 June. Aldeburgh, Festival Gallery *and* Gallery 44. *John Piper: The Britten-Pears collection, and Ceramics.* (75 works). Introd. by Peter Pears. [18]p.

307 July–Aug. King's Lynn, Fermoy Centre. *John Piper: watercolours of Windsor.* (26 works). [6]p.

1983–84

308 Nov.–Jan. London, Tate Gallery. *John Piper.* Texts by David Fraser Jenkins, John Russell, Rigby Graham, Michael Northen.

7 Selected group exhibitions

1927

309 London, Arlington Gallery. [wood engravings] and David Birch. [no catalogue traced].*

1931

310 Mar.–Apr. London, Heal & Son, Mansard Annexe. *An exhibition of watercolours, offsets from glass and stage designs, not previously exhibited by Eileen Holding, P.F. Millard, Belasyse Moffat [and] John Piper.* (14 works). [4]p.

311 Oct. London, New Burlington Galleries. *The London Group: 29th exhibition.* (2 works) 12p.

1932

312 Oct. London, New Burlington Galleries. *The London Group: 30th exhibition.* (1 work) 12p.

1933

313 Nov.–Dec. London, New Burlington Galleries. *The London Group: 31st exhibition.* (3 works) 12p.

1934

314 Mar. London, Leicester Galleries. *13th exhibition of the 7 & 5 Society.* (5 works). 8p.

1935

315 Jan. London, Experimental Theatre, Finchley Road. [no catalogue traced].*

316 Oct. London, Zwemmer Gallery. *7 & 5.* (7 works). Handlist and illus. poster.

1936

317 Apr. London, Duncan Miller Ltd. *Modern pictures for modern rooms: an exhibition of abstract art in contemporary settings:* arranged by S. John Woods and Duncan Miller. (2 works). Introd. by S. John Woods. [4]p.

318 [Apr.] London, Alex. Reid & Lefevre. *Abstract & concrete: an international exhibition of abstract painting and sculpture today.* (3 works). Introd. by Nicolete Gray. [4]p.
Also shown in Oxford, Liverpool, Newcastle and Cambridge, Feb.–June 1936.

319 Nov. London, Everyman cinema (Hampstead). *Abstract art: sculpture, paintings, reliefs:* Barbara Hepworth, Arthur Jackson, Henry Moore, Ben Nicholson, John Piper. Introd. by S. John Woods. (1 work). [4]p.

320 Nov. London, New Burlington Galleries. *London Group: 34th exhibition.* (3 works). 19p.

1937

321 [Jan.]. London, Thos Agnew. *An exhibition of paintings in connection with a scheme to provide a permanent gallery for the constant display of works by contemporary painters and sculptors.* (3 works). [4]p.

322 March. London, Leicester Galleries. *The London Group: exhibition of works by members.* (1 work). 12p.

323 Apr.–May. London A.I.A. (41 Grosvenor Sq.). *1937 exhibition: unity of artists for peace, democracy and cultural development.* (4 works). [15]p.

324 May. Edinburgh, Fine Art Society at Minto House. *Second annual exhibition of modern art.* (2 works). Introd. by Eileen Holding.*

325 July. London, London Gallery. *Exhibition of constructive art.* (2 works). Introd. by J.L. M[artin] and S. Giedion. [8]p.

326 Oct.–Nov. London, New Burlington Galleries. *The London Group: 36th exhibition.* (2 works). 16p.

327 Nov.–Dec. London, London Gallery. *Surrealist objects and poems.* (2 works). [20]p. and [8] leaves of plates.

1938

328 May–June. Gloucester, Guildhall. *Realism and Surrealism: an exhibition of several phases of contemporary art.* (3 works). 36p. Introd. by Herbert Read.

329 Sept.–Oct. London, Leicester Galleries. *Lithographs in colour: published by Contemporary Lithographs Ltd.* (2 works). [8]p.

330 Nov.–Dec. London, The Cooling Galleries. *Paintings, drawings and sculpture specially chosen for their suitability as Christmas presents by the London Group.* (1 work). [8]p.

331 Nov.–Dec. Paris, Salon d'Automne. *L'Art anglais. Independent contemporain.* (2 works).

1939

332 Jan.–Feb. London, London Gallery. *Living art in England.* (1 work). Catalogue in *The London Bulletin,* no.8–9, Jan.–Feb. 1939, pp.57 plus 1 plate p.[36].

333 May–June. London, Tate Gallery. *Mural painting in Great Britain 1919–1939: an exhibition of photographs.* (1 work). 20p., 11p. of plates.

334 Oct.–Nov. London, Leicester Galleries. *Selected paintings, drawings and pottery lent by The Contemporary Art Society.* (1 work). 18p.

1940

335 Jan.–Feb. London, Alex. Reid & Lefevre. *Art of today: some trends in British painting.* (2 works). [4]p.

336 June–July. London, Alex Reid and Lefevre. *Modern English painting, recent works.* (7 works).*

1941

337 July–Sept. Leeds, Temple Newsam. *Works by Henry Moore, John Piper, Graham Sutherland.* (43 works). Foreword by Philip Hendy, 23p. A selection from this exhibition then used as a touring C.E.M.A. exhibition, 1941–2. *see* (339).

338 Oct. London, National Gallery. *War pictures at the National Gallery.* Booklet with foreword by Eric Newton.

1941–2

339 London, Council for the Encouragement of Music and the Arts. [*Selection from the 1941 Temple Newsam exhibition*], arranged by the British Institute for Adult Education for C.E.M.A., touring Leicester, Harrogate, Brighton and Wakefield. (21 works). [16]p.

1942

340 London, National Gallery. *War pictures at the National Gallery.* Booklet with foreword by Eric Newton.

341 London, Ministry of Information. *War drawings by British artists: an exhibition of original drawings and enlarged photographs of drawings and paintings of war subjects circulated by the Ministry of Information for exhibition in schools. First selection.* (1 work). [20]p.

342 Mar.–May. London, London Museum. *New movements in art, contemporary work in England: an exhibition of recent painting and sculpture.* (2 works). 4p.

1943

343 London, Council for the Encouragement of Music and the Arts. *The artist and the Church.* (15 works: 4 copies, 11 photographs). 15p. Foreword by John Piper.

344 Oct.–Nov. London, Royal Academy. *The London Group: fifth war-time exhibition.* (1 work). 12p.

1943–4

345 London, Council for the Encouragement of Art and Music. *Exhibition of ballet design.* (8 works). 14p.

1944

346 London, Ministry of Information. *War pictures by British artists: an exhibition of official war pictures … circulated by arrangement with the Museums Association. Fourth selection.* (1 work). [12]p.

347 Jan. London, Redfern Gallery. *French and English paintings.* (7 works). [4]p.

1945

348 Paris, 28 Avenue des Champs Elysées. *Quelques contemporains Anglais.* (4 works) 12p. Organised by the British Council.

349 Mar.–Apr. New York, Buchholz Gallery. *Contemporary British artists: Ivon Hitchens, Henry Moore, Paul Nash, John Piper …* (5 works). [12]p.

350 Oct.–Nov. London, Royal Academy. *Exhibition of National War Pictures.* (13 works). 55p.

1946

351 Buffalo, Albright Art Gallery. *British contemporary painters.* (7 works). Introd. by A.C. Ritchie. 97p.

352 London, Arts Council. *British painting 1939 to 1945.* (4 works). 12p.

1950

353 May–July. London, Whitechapel Art Gallery, *Painter's progress.* (11 works). 2p.
Oct.–Nov. Birmingham, Museum and Art Gallery. *Six contemporary British painters.* (9 works). Introd. by R. James. 8p.

354 Feb. Cincinnati, Cincinnati Art Museum. *6 English moderns: Piper, Sutherland, Hepworth, Tunnard, Moore, Nicholson.* (9 works).*

1953

355 July–Oct. Cardiff, Arts Council (Welsh Committee). *British Romantic painting in the twentieth century.* (4 works). Introd. by John Petts. Travelling to Cardiff, Aberystwyth, Swansea. 18p.

1955

356 London, Arts Council. *A small anthology of modern stained glass.* (1 work). Touring exhibition, Aldeburgh Festival and elsewhere. Introd. by John Piper. 12p.

357 London, Arts Council (touring exhibition). *Some twentieth century paintings from the collection of Peter Pears and Benjamin Britten.* (4 works). Introd. by Peter Pears. 8p.

1956

358 Jan.–Feb. Edinburgh, Royal Scottish Academy. *10 English painters, 1925–1955.* (9 works). Organised by the Arts Council, Scottish Committee. [9]p.

1957

359 July–Aug. London, Zwemmer Gallery. *John Piper, Michael Rothenstein.* (20 works). [8]p.

1957–8

360 London, Arts Council. *Contemporary English theatre design.* (5 works). 16p. Shown at Guildford House, Guildford and touring.

1960

361 Sept.–Oct. Gloucester, College of Art Gallery, and Wheatstone Hall. *John Piper, Lynn Chadwick: exhibition of paintings and sculpture.* [12]p.

362 Oct.–Nov. London. Victoria and Albert Museum. *Mural art today.* (2 works). [8]p.

1961

363 Sept.–Nov. London, Arts Council (touring exhibition). *Modern stained glass.* (2 works). [23]p.

1962

364 Oct.–Nov. Cardiff, National Museum of Wales, *British art and the modern movement, 1930–1940.* (7 works). Introd. by Alan Bowness. Organised by the Arts Council, Welsh Committee. 40p.

1964

365 May. Oxford, Bear Lane Gallery. *John Piper and Kenneth Lee.* (18 works). [6]p.

1965

366 Mar.–Apr. London, Marlborough Fine Art. *Art in Britain 1930–40 centred around Axis, Circle, Unit One.* (10 works). Introd. by Herbert Read. 92p.

1966

367 Apr.–May. London, Marlborough New London Gallery. *Nolan, Piper, Richards.* (21 works). [8]p.

1967

368 Apr. London, Marlborough Fine Art. *John Piper, Ceri Richards: designs, studies for church commissions, including Liverpool Cathedral.* (71 works). [32]p.

369 May–June. Sheffield, Graves Art Gallery. *'In our view': some paintings and sculpture bought by Hans and Elspeth Juda between 1931–1967.* (22 works). 68p.

1971

370 June. Tokyo, Fuji Television Gallery. *Ceri Richards, John Piper.* (37 works). [72]p.

1972

371 Nov. London, Whitechapel Art Gallery. *Painting and drawing in Britain, 1940–1949.* (6 works). 51p. Introd. by Alan Bowness. Touring exhibition organised by the Arts Council.

1974

372 Aug.–Sept. Edinburgh, Scottish Arts Council. *Art then: eight English artists, 1924–40.* (8 works). Catalogue and introd. by David Baxandall. [48]p.

1977

373 Feb.–Apr. London, Tate Gallery. *Artists at Curwen: a celebration of the gift of artists' prints from the Curwen Studio.* (30 works). Text by Pat Gilmour. 167p.

374 July–Aug. Cardiff, Chapter Arts Centre. *Selling dreams: British and American film posters 1890–1976.* (2 works) 89p. Organised by the Welsh Arts Council.

1978

375 July–Aug. London, Royal Exchange. *Glass/light: international exhibition of stained glass.* (3 works). Texts by M. Harrison, Brian Clarke. 20p.

1979

376 Canterbury, Canterbury Cathedral. *Church buildings: an exhibition of paintings and prints: John Piper, John Ward, John Doyle.* (40 works). [14]p.

377 Aug.–Sept. Southport, Atkinson Art Gallery. *The Seven and Five Society, 1920–35,* (3 works). Introd. by Mark Glazebrook. Arranged by Michael Parkin, and travelling to the Parkin Gallery, London, Jan.–Feb. 1980. 33p.

1980

378 July–Aug. London, Tate Gallery. *Kelpra Studio: the Rose and Chris Prater gift.* (9 works). Text by Pat Gilmour, S. Turner. 111p.

1981–1982

379 Oct. 1981–Jan 1982. London, Imperial War Museum. *Neo-Romantic watercolours.* (1 work). [2]p.

1982

380 Feb.–Mar. Cambridge, Kettle's Yard. *Circle: constructive art in Britain, 1934–40.* (2 works). 88p. Text by J. Beckett, N. Bullock, J. Gage, L. Martin.

1982–3

381 Johannesburg, Art Gallery. *John Piper and English Neo-Romanticism.* (11 works). Intro. by Peter Cannon-Brookes. Organised by the 1820 Foundation in association with the National Museum of Wales, the South African National Gallery and Zimbabwe National Gallery. Travelling in South Africa.*

1983

382 July–Aug. London, Fischer Fine Art. *The British Neo-Romantics, 1935–1950.* (7 works). 40p. Organised in conjunction with National Museum of Wales.

8 Books and sections in books about the artist (selected)

BANHAM, M. & B. Hillier,
A'tonic to the nation, see Interviews (**201**)

382a BETJEMAN, John. *John Piper.* Harmondsworth: Penguin Books, 1944.

383 BLAND, Alexander. *The Royal Ballet: the first fifty years.* Garden City (New York): Doubleday, 1981. pp.71, 82, 93, 119, 212, 213.

384 BLYTH, Alan. *Remembering Britten.* London: Hutchinson, 1981. pp.28–35.

385 C., H. *The John Piper windows executed for Oundle School Chapel by Patrick Reyntiens.* Oundle: Privately printed (Nene Press, Oundle School), 1956.

386 *Circle: international survey of Constructive art;* ed. by J.L. Martin, Ben Nicholson, N. Gabo. London: Faber and Faber, 1937. Piper paintings illus. plates 25, 26.

CLARKE, B. (Ed.) *Architectural stained glass, see* Books by (**10**)

387 CLARKE, Mary. *The Sadler's Wells Ballet: a history and an appreciation.* London: Adam & Charles Black, 1955. pp.19, 21, 176, 177, 225, 279.

388 GRAHAM, Rigby. *Romantic book illustration in England 1943–1955.* Pinner (Mddx): Private Libraries Association, 1965.

389 HEWISON, Robert. *Under siege, literary life in London 1934–45.* London: Weidenfeld and Nicholson, 1977. Passim.

390 HUSSEY, The Very Rev. Walter. *The Pictorial history of Chichester Cathedral.* London: Pitkin Pictorials, 1967. pp.12–13 double page spread on the Reredos by John Piper, with text by the artist and 2 colour illus.

391 IRONSIDE, Robin. *Painting since 1939.* London: British Council, 1947. Passim.

392 *John Piper by his friends: essays presented to John Piper on his 80th birthday.* London: The Stourton Press, forthcoming 1983.
Contributors include: Sir John Betjeman, Henry Moore, Peter Pears, Patrick Reyntiens etc. John Piper has contributed some illus.*

393 LEHMAN, John (ed.). Dance critic, English ballet finds a patron. *in The Penguin new writing,* 17, Apr.–Jun. 1943, pp.129–138.

394 MASTER OF THE WORSHIPFUL COMPANY OF BAKERS *Master's appeal for the John Piper windows in Bakers Hall.* London: The Company, 1970. Fold out leaflet.

395 MIRROR *to man: the murals at the Mayo Clinic.* Rochester (Minnesota): Mayo Foundation, [s.d.]. pp.[2–3].

396 MERCHANT, W. Moelwyn. *Shakespeare and the artist.* London: Oxford University Press, 1959. Chapter 15: 'Measure for measure': an essay in visual interpretation, based on Piper drawings.

397 MITCHELL, D. and J. Evans. *Benjamin Britten. Pictures from a life, 1913–1976.* London: Faber and Faber, 1978.

398 NEWTON, Eric. *War through artists' eyes.* London: John Murray, 1945, pp.78, 85.

399 PERCIVAL, John. *Theatre in my blood.* London: The Herbert Press, 1983.

400 ROSS, Alan. *Colours of war: war art 1939–45.* London: Jonathan Cape, 1983. p.50–52.

401 ROTHENSTEIN, Sir John. *Modern English painters, vol.3: Wood to Hockney,* London: Macdonald; New York: St Martin's Press, 1974. pp.86–99.

402 SOUVENIR *publication to commemorate the consecration of the Cathedral of Christ the King, Liverpool.* Leamington Spa: English Counties Periodicals, [1967?].
Incl. section on the lantern.

403 UNIVERSITY OF THE WITWATERSRAND, Johannesburg. *The Wartenweiler Library: a brochure published on the occasion of the offical opening… 14 February 1972.* 2 tapestries by John Piper to be hung in this building.
1 reprod. in col. on the cover.

404 WEST, Anthony. *John Piper.* London: Secker and Warburg, 1979.

405 WILSON, David (Ed.) *Projecting Britain: Ealing Studios film posters;* with an introd. by Bevis Hillier. London: B.F.I. Publishing, 1982. Posters by Piper for 'Pink string and sealing wax' (1945) and 'Painted boats' (1945) on pp.48–9.

406 WOODS, S. John. *John Piper: paintings, drawings and theatre designs, 1932–1954.* London: Faber and Faber; New York: Curt Valentin, 1955. Contains 1 aquatint and 4 autolithographs produced for the book.

9 Selected periodical and newspaper articles about the artist

1935

407 Herta Wescher. John Piper, 1935. *AXIS,* no.4, Nov. 1935, pp.12–13, plus 1 plate.

408 Hugh Gordon Porteous. Piper and abstract possibilities. *AXIS,* no.4, Nov. 1935, pp.14–16.

1940

409 Osbert Sitwell. [Review of Brighton Aquatints]. *The Listener,* 4 Jan.

410 Herbert Tayler. Found, a valuable object: ['Brighton aquatints': a book review]. *Architectural Review,* Feb. 1940, (vol.87), p.69.

411 Thomas McGreevy. Leicester Galleries (John Piper; Henry Lamb): [review of 1940 exhibition] *in* In the world's art centres, London. *The Studio,* May 1940, (vol.119, no.566), p.184.

1941

412 [War-time boarded up shop window advertising the Leicester Galleries, designed by John Piper]. *Modern Publicity,* 1941, p.98.

413 Exhibition at Temple Newsam: [touring C.E.M.A. exhibition selected from Temple Newsam exhibition which commenced Leicester, Dec. 1941]. *Apollo,* Dec. 1941, (vol.34), p.157, 160.

1942

414 [Advertising design for Ealing Studios by S. John Woods and John Piper]. *Modern Publicity,* 1942–8, p.44.

415 Trevor Thomas. Moore – Piper – Sutherland exhibition: [review of 1941 group exhibition at Temple Newsam]. *The Museums Journal,* Feb. 1942, (vol.41, no.11), pp.259–261.

416 T.T. Leeds – art for the people: [review of the 1941–2 C.E.M.A. touring group exhibition]. *The Studio,* Mar. 1942, (vol.123, no.588), p.81.

417 Jan Gordon. [review of the 1941–2 C.E.M.A. touring group exhibition] *in* London commentary. *The Studio,* Apr. 1942, (vol.123, no.589), p.114–5.

1943

418 'The Quest': notes on the decor *Arabesque,* (Oxford University Ballet Club), Trinity Term, 1943. [1]p.

419 G.P. 'British Romantic artists': [review of the 1942 book by Piper]. *Journal of the Royal Society of Arts,* 20 Aug. 1943, (vol. 91, no.4646), p.528.

1944

420 'Perspex'. [review of the 1944 Redfern Gallery group exhibition] *in* Current shows and comments. *Apollo,* Jan. 1944, (vol.39, no.228), pp.1–2.

421 Richard Seddon. Artists of note: John Piper. *The Artist,* Jan. 1944, (vol.26, no.5), pp.110–2.

B. Myerscough Walker. Modern art explained by modern artists… *The Artist,* May 1944.
see Interviews (**198**)

1945

422 Christopher Hussey. The twilight of the great house: [review of the 1945 one-man exhibition of] paintings by John Piper at the Leicester Galleries. *Country Life,* 26 Jan. 1945, (vol.97), p.153.

423 John Russell. John Piper. *Magazine of Art,* (USA), Apr. 1945, (vol.38, no.4), pp.144-7.

424 D.K.B[axandall]. 'John Piper', by John Betjeman: [a review of the book in the Penguin modern painters series]. *The Museums Journal,* Oct. 1945, (vol.45, no.7), pp.124–5.

1946

425 Edith Hoffman. 'John Piper', by John Betjeman: [book review] *in* The Literature of art. *Burlington Magazine,* Jan. 1946, (vol.88), p.25.

426 N.A.D. Wallis. The Penguin Modern Painters… 'Matthew Smith'. 'John Piper'. [review of the book

by John Betjeman]. *Journal of the Royal Society of Arts*, 18 Jan. 1946, (vol.94), p.130.

427 Nelson Lansdale. The Old Vic brings new art: [set designs for 'Oedipus']. *Art News*, May 1946, (vol.45, no.3), pp.48–9, 69.

1947

428 H.A. Cronache: Londra: Una mostra di John Piper. *Emporium*, Feb. 1947, (vol.105, no.626), p.85.

1948

429 Stuart Preston. Spotlight on: Koerner, Piper [and other artists]: [review of 1948 one-man exhibition at Buchholz Gallery]. *Art News*, Feb. 1948, (vol.46, no.12), pp.29, 49.

430 Judith Kaye Reed. Piper, Modern English: [review of the 1948 one-man exhibition at the Buchholz Gallery]. *Art Digest*, 15 Feb. 1948, (vol.22, no.10), p.11.

431 Stage design. *Vogue*, Sept. 1948, pp.86–7, 110, 112, 116.

1949

432 Romantic opera 1949: [Piper's sets for the New York production of the 'Rape of Lucretia']. *Art News*, Jan. 1949, (vol.47, no.9), p.24.

433 Philip Hendy. [review of 1948 one-man exhibition at Leicester Galleries] *in* English watercolours. *Britain Today*, Feb. 1949, (no.154), pp.37–40.

434 Geoffrey Grigson. John Piper's England. *The Listener*, 28 Apr. 1949, p.724.

435 S. John Woods. John Piper as a topographical illustrator. *Image: a quarterly of the visual arts*, no.2, Autumn 1949, pp.3–18.

436 C[hristopher] H[ussey]. Murals for Rio de Janerio by John Piper at the Victoria and Albert Museum: [review of 1949 one-man exhibition at the V. and A.]. *Country Life*, 2 Dec. 1949, (vol.106), pp.1649–50.

1950

437 Sir Phillip Hendy. John Piper. *Britain Today*, Feb. 1950, (no.166), pp.37–40.

1951

438 Gerald Barry. The Festival gardens are taking shape. p.17 *in* The Festival is Britains. *Picture Post*, 6 Jan. 1951, (vol.50, no.1), pp.12–20.

439 John Cranko. Beach inspired 'Sea Change': [on the ballet 'Sea Change']. *Dance and Dancers*, Mar. 1951, (vol.2, no.3), p.10.

440 Christopher Hussey. The Festival gardens. *Country Life*, 15 June 1951, (vol.109), pp.1898, 1900, 1902, (2 illus. of the Main Vista, p.1898).

441 Peter Williams. Decor, *in* 'Harlequin in April'. *Dance and Dancers*, July 1951, (vol.2, no.7), pp.14–15.

442 Glyndebourne: ['Don Giovanni']. *Opera*, Sept. 1951, (vol.2, no.10), pp.508–13, 520–1.

443 Austen Kark. 'Billy Budd': a musical event of more than usual importance is Britten's 'Billy Budd'. *Bandwagon*, [Nov.] 1951.

444 Albert Savarus. John Piper crée les decors du 'Billy Budd' de Britten. *Les Beaux-Arts* (Brussels), 7 Dec. 1951, p.5.*

445 An all-men opera set on board ship: Benjamin Britten's 'Billy Budd'. *The Illustrated London News*, 8 Dec. 1951, p.929, (chiefly illus.).

446 'Billy Budd': the first performance of Benjamin Britten's fifth opera at Covent Garden. *The Sphere*, 8 Dec. 1951, p.388, (chiefly illus.).

447 John Piper. (Portrait gallery). *The Sunday Times*, 9 Dec. 1951, p.8.

448 A new English Opera wins its spurs. ['Billy Budd']. *The Tatler* 19 Dec. 1951. pp.656–7.

449 Philip Hope-Wallace. 'Billy Budd'. *Picture Post*, 22 Dec. 1951, pp.30–2.

1952

450 Karen Lancaster. John Piper as a designer for the theatre. *Adelphi*, (vol.29, no.1), [1952], pp.19–25.

451 'Billy Budd': The story; First impressions by Winton Dean, Scott Goddard, Fred Goldbeck. *Opera*, Jan. 1952, (vol.3, no.1), pp.4–16.

452 [M.S.]. Stage and artist in the television era: 1952 cross section: [2 illus. of the sets for 'Billy Budd']. *Art News*, Feb. 1952, (vol.50, no.10), pp.22–5, 59.

453 Anthony Cowper. John Piper. (Design for ballet, 1). *Dance and Dancers*, Feb. 1952. (vol.3, no.2), p.8.

454 S. John Woods. John Piper. (Portrait of the artist, no.99), *Art News and Review*, 15 Nov. 1952, (vol.4, no.21), p.[1].

455 Romantic realist. *Time* (USA), 1 Dec. 1952, pp.54, 57.

1953

456 Scott Goddard. Daring designs for 'Gloriana'. *News Chronicle*, 9 June 1953.

457 Presented in a gala performance before Her Majesty on June 8: Britten's Coronation opera 'Gloriana'. *The Illustrated London News*, 13 June 1953, pp.987–9.

458 Robert Muller. 'Gloriana' is born. *Picture Post*, 13 June 1953, pp.67–8.

459 Elizabeth H.C. Corathiel. John Piper. (Creative artists in the theatre, 6). *Theatre World*, July 1953, (vol.49, no.342), pp.16–18.

460 'Gloriana' at the Royal Opera. *Music and musicians*, Aug. 1953, p.9

461 Stephen Spender. English artists vs. English painting. *Art News*, Nov. 1953, (vol.52, no.7). pp.14–17, 46–9. (Piper mentioned p.47).

1954

462 John Commander. John Piper: scenografo di Britten. *La Biennale di Venezia*. Sept.–Oct. 1954. (no.22), p.33.

463 Personalities and events of the week: people in the public eye. To be a trustee of the Tate Gallery: Mr. John Piper: [portrait]. *Illustrated London News*, 4 Dec. 1954, (vol.225), p.102.

1955

464 F[airfield] P[orter]. John Piper: [review of 1955 Curt Valentin one-man exhibition]. *Art News*, Feb. 1955, (vol.53, no.10), p.60.

465 [Douglas Cooper]. An interim report on the work of John Piper: [review of 'John Piper paintings, drawings and theatre designs' by S. John Woods]. *Times Literary Supplement*, 17 June 1955, p.336.

466 Lawrence Alloway. Romantic summer: [review of 1955 Leicester Galleries one-man exhibition] *in* Summer events: London. *Art News*, Summ. 1955, (vol.54, no.4), p.69

467 Vernis. John Piper: [review of 1955 one-man exhibition at Leicester Galleries]. *in* International Studio. *Connoisseur*, Aug. 1955, (vol.136, no.547), p.41

468 Richard Seddon. John Piper: an interim report: [book review of 'John Piper, paintings, dawings and theatre designs', by S. John Woods]. *The Studio*, Dec. 1955, (vol.150, no.753). pp.187–191.

1956

469 [Illustration featuring curtains designed by Piper in the background]. p.58 *in* Rooms and furniture. *Decorative Art: the Studio year book of furnishing and decoration*, 1956–1957.

470 Christopher West. 'The Magic Flute' in 1956. *Opera*, Jan. 1956, (vol.7, no.1), pp.8–13.

471 Stained glass at Oundle. *Architectural Review*, Aug. 1956, (vol.120), pp.118–9.

472 C[hristopher] H[ussey]. New windows at Oundle. *Country Life*, 2 Aug. 1956, (vol.120), p.248.

473 [Maurice Lavanoux]. Peterborough – Oundle, England, September 30 1956: [new windows designed by John Piper for the chapel] *in* The Editor's diary: XXI. *Liturgical Arts*, Nov. 1956, (vol.25, no.1), p.22.

1957

474 'The Prince of the Pagodas'. *The Times*, 2 Jan. 1957, p.3.

475 J[ames] S[chuyler]. John Piper: [review of 1957 Durlacher Bros. one-man exhibition] *in* Reviews and previews. *Art News*, Mar. 1957, (vol.56, no.1), p.9.

476 V[ernon] Y[oung]. John Piper: [review of the 1957 one-man exhibition at Durlacher Bros.]. *Arts*, Mar. 1957, (vol.31, no.6), p.53.

477 Passim: the Piper painting [commissioned of and for the Hospital]. *Guy's Hospital Gazette*, 27 Apr. 1957, p.[1].

478 Cathedral on BTA poster: [Canterbury]. *Advertisers' Weekly*, 20 Dec. 1957.

1958

479 How Piper makes a mural in mosaics: [mural for B.B.C Television Centre]. *The Times*, 4 Dec. 1958, p.3.

1959

480 Jean Yves Mock. Piper and Ben Shahn at the Leicester Galleries, *in* Notes from London and Paris. *Apollo*, Dec. 1959, (vol.70), pp.188–9.

1960

481 Horace Shipp. Modernism in service: [review of 1960 Arthur Jeffress one-man exhibition] *in* Current shows and comments. *Apollo*, Jul. 1960, (vol.72), p.2.

482 Robert Meville. [review of the 1960 one-man exhibition at Arthur Jeffress]. p.224 *in* Exhibitions. *Architectural Review*, Sept. 1960, (vol.128), pp.222–4.

483 G.S. Whittet. [review of the 1960 one-man exhibition at Arthur Jeffress] *in* London commentary. *The Studio*. Sept. 1960, (vol.160, no.809), pp.108–9.

1961

484 Shakespeare by Benjamin Britten: 'A Midsummer Night's Dream' at the Royal Opera House, Covent Garden. *Illustrated London News*, 4 Feb. 1961, p.19.

485 'A Midsummer Night's Dream': Britten's latest opera at Covent Garden. *The Sphere*, 11 Feb. 1961, pp.214–5.

486 'A Midsummer Night's Dream'. *Music and Musicians*, March 1961, p.15.

487 J[ohn] W[arrack]. 'A Midsummer Night's Dream', Covent Garden, February 2. *Opera*, Mar. 1961, (vol.12, no.3), pp.201–5.

488 G[ene] R. S[wenson]. John Piper: [review of 1961 Durlacher Bros. one-man exhibition] *in* Reviews and previews. *Art News*, Nov. 1961, (vol.60, no.7), p.17.

489 V[ivien] R[aynor]. John Piper: [review of the 1961 one-man exhibition at Durlacher Bros.]. *Arts Magazine*, Dec. 1961, (vol.36, no.3), p.53.

490 Stuart Preston. New York: [including review of 1961 one-man exhibition at Durlacher Bros]. *in* Current and forthcoming exhibitions. *Burlington Magazine*, Dec. 1961, (vol.103), p.526.

1962

491 Alice Hope. Modern art in an old cowshed. *Daily Telegraph and Morning Post*, 24 Apr. 1962, p.9.

492 John Russell. The glass: 'a great blaze of individual genius': [Coventry Cathedral]. *The Sunday Times Colour Section*, 20 May 1962, pp.16–18. (whole issue on Coventry Cathedral).

493 The Cathedral of St Michael, Coventry. *Builder*, 25 May 1962, pp.1067–85 (p.1074 texts; p.1075 illus. of Baptistery window).

494 Cathedral Church of St Michael, Coventry. *Architectural Review*, July 1962, (vol.132), pp.36–42 (pp.40–1 on Baptistery window).

495 G.S. Whittet. [review of 1962 one-man exhibition at Arthur Jeffress] *in* London commentary: the R.A., Armitage, Tindle and others. *The Studio*, July 1962, (vol.164, no.831), p.34.

496 John Russell. Piper. (The world of art: London letter). *Art in America*, Fall 1962, (vol.50, no.3), pp.110–3.

497 R. Furneaux Jordan. Coventry Cathedral. *The Studio*, Aug. 1962, (vol.164, no.832), pp.54–7.

498 British avant-garde in the 1930s. (The Arts):

[review of the 1962 exhibition, British Art and the modern movement]. *The Times*, 17 Oct. 1962, p.18.

499 Wyndham Goodden. Details from Coventry [including vestments by Piper]. *Design*, Dec. 1962, (no.168), pp.38–50 (section on Piper pp.44–5).

1963

500 V[alerie] P[etersen]. John Piper: [review of 1962 Landry Gallery one-man exhibition] *in* Reviews and previews. *Art News*, Feb. 1963, (vol.61, no.10), p.12.

501 S[idney] T[illim]. John Piper: [review of the 1962 one-man exhibition at Landry Gallery, New York] *in* In the Galleries. *Arts Magazine*, Feb. 1963, (vol.37, no.5), pp.45–6.

502 Edwin Mullins. [review of 1963 Marlborough New London one-man exhibition] *in* How are the elders faring? *Apollo*, Apr. 1963, (vol.77, no.14), p.324.

503 Keith Roberts. London: [including a review of the 1963 one-man exhibition at Marlborough] *in* Current and forthcoming exhibitions. *Burlington Magazine*, Apr. 1963 (vol. 105), p.178.

504 Robert Melville. [review of 1963 one-man exhibition at Marlborough]. *in* Exhibitions. *Architectural Review*, June 1963, (vol.133), p.439.

1964

505 Mr Piper's art in retrospect: [review of the 1964 Marlborough New London one-man exhibition]. *The Times*, 28 Mar. 1964, p.5.

506 Joseph Rykwert. [review of 1964 one-man exhibition at the Marlborough New London] *in* Mostre a Londra. *Domus*, June 1964, (no.415), unpaged. (English text).

507 James Burr. [review of 1964 Marlborough New London retrospective exhibition] *in* From neglect: round the London galleries. *Apollo*, Mar. 1964, (vol.79, no.25), p.238.

508 Norbert Lynton. Pied Piper: [review of the 1964 retrospective exhibition at Marlborough New London]. *New Statesman*, 27 Mar. 1964, (vol.67, no.1724), pp.500, 502.

509 Keith Roberts. London: [including review of the 1964 retrospective exhibition at the Marlborough New London] *in*, Current and forthcoming exhibitions. *Burlington Magazine*, May 1964, (vol.106), pp.243–4.

1965

510 Cyril Barrett. Art in Britain 1930–40, centred around Axis, Circle, Unit One: [review of the 1965 group exhibition Axis, Circle, Unit One, at Marlborough Fine Art]. *Kunstwerk*, July 1965, (vol.19, no.1), pp.12–15.
Myfanwy Piper. Back in the thirties. *Art and Literature*, 7, Winter 1965, p.136.

1966

511 David Thompson. [review of 1966 Marlborough New London group exhibition], *in* London commentary: concentric circles. *Studio International*, June 1966, (vol.171, no.878), pp.269–270.

512 Marjorie Bruce-Milne. Nature impels John Piper's art. *The Christian Science Monitor*, 16 Feb., 1966, p.4

513 Edwin Mullins. Weaving a work of modern art: [Chichester Cathedral tapestry]. *Weekend Telegraph*, 23 Sept. 1966, pp. 35–7.

1967

514 The Metropolitan Cathedral of Christ the King, Liverpool, England. *Architectural Design*, June 1967, (vol.37), pp.256–264. (incl. article on the Cathedral glass by P. Reyntiens).

515 Alastair Gordon. [review of the 1967 touring one-man exhibition] *in* Art in the modern manner. *Connoisseur*, June 1967, (vol.165), p.128.

516 John Piper. The Liverpool lantern. *Studio International*, June 1967, *see* articles by Piper. **(114)**

517 R.T. Hodges Paul. John Piper: studies for the Chichester Cathedral tapestry: [review of an exhibition at the] David Paul Gallery Chichester. *Arts Review*, 2 Sept. 1967, (vol.19, no.17), p.314.

518 Tom Driberg. At 63 still the prolific Piper. *Evening Standard*, 7 Sept. 1967, p.7.

519 John Fitzmaurice Mills. The new Liverpool Metropolitan Cathedral. *Connoisseur*, Dec. 1967, (vol.166), pp.225–231.

1968

520 John Peter. A note on John Piper's towers and churches. *Malahat Review*, no.6, Apr. 1968, pp.62–[72]. pp.62–64 text followed by 8p. of plates.

1969

521 James Burr. [review of 1969 Marlborough one-man exhibition] *in* Divergent directions: London galleries. *Apollo*, June 1969, (vol.89, no.88), p.472.

1970

522 Edward Lucie-Smith *and* Patricia White. [review of 1969 one-man Marlborough New London exhibition] in *Art in Britain, 1969–1970*, London: Dent, 1970.

1971

523 Richard Buckle. Variations on a theme of Titian (1). *Art and Artists*, Aug. 1971, (vol.6, no.5), pp.46–49.

1972

524 Rigby Graham. John Piper as book illustrator. *American Book Collector*, Jan. 1972, (vol.22, no.4), pp.10–20.

525 This artist has designs on life: [the Witwatersrand University Library tapestry]; pictures by Len Gallacher. *Rand Daily Mail*, 26 Jan. 1972, p.7

526 O. Blakeston. John Piper: [review of the 1972 Marlborough one-man exhibition]. *Arts Review*, 25 Mar. 1972, (vol.24, no.6), p.166.

527 Evan Anthony. Piper currency. (Art): [review of 1972 Marlborough one-man exhibition] *Spectator*, 25 Mar. 1972, p.487.

528 James Burr. [review of 1972 Marlborough one-man exhibition] *in* Purely for pleasure. *Apollo*, Apr. 1972, (vol.95, no.122), p.327.

529 William Gaunt. Adventures with John Piper: [review of 1972 Marlborough one-man exhibition]. *The Times*, 5 April 1972, p.7.

530 Bernard Denvir. [review of 1972 Marlborough Gallery one-man exhibition] *in* London letter. *Art International*, May 1972, (vol.16, no.5), p.39.

531 Keith Roberts. London: [including review of the 1972 Marlborough one-man exhibition] *in* Current and forthcoming exhibitions. *Burlington Magazine*, May 1972, (vol.114), p.354.

532 Clive Jacques. John Piper: [review of the 1972 one-man exhibition at the Yarrow, Oundle School]. *Arts Review*, 21 Oct. 1972, (vol.24, no.21), p.654.

1973

533 Karen Usborne. John Piper: [review of the 1973 one-man exhibition at] Marjorie Parr Gallery. *Arts Review*, 10 Feb. 1973, (vol.25, no.3), p.64.

534 Karen Usborne. A profile of John Piper. *Arts Review*, 24 Feb. 1973, (vol.25, no.4), p.95.

535 Pat Gilmour. Graphics: [on John Piper and the autographic print]. *Arts Review*, 7 Apr. 1973, (vol.25, no.7), p.223.

536 William Mann. 'Owen Wingrave': Royal Opera House. *The Times*, 11 May 1973, p.11.

537 Harold Rosenthal. 'Owen Wingrave', (London Opera diary). *Opera*, July 1973, (vol.24, no.7), pp.643–5.

538 Nick Arber. John Piper: [review of the 1973 one-man exhibition at] Turnpike Gallery, Leigh, Lancs. *Arts Review*, 28 July 1973, (vol.25, no.15), p.518.

539 Graham Hughes. Modern medals: [on the exhibition of modern medals at Goldsmith's Hall, July 1973,

including medal(s) made for the exhibition by Piper]. *Crafts*, no.3, July–Aug. 1973, pp.36–7.

540 Leonard Wyatt. John Piper: [review of the 1973 one-man exhibition at] Playhouse Gallery, Harlow. *Arts Review*, 11 Aug. 1973, (vol.25, no.16), p.550.

541 Alan Blyth. 'Death in Venice': Aldeburgh Festival. *Opera*, Aug. 1973, (vol.24, no.8), pp.688–91.

542 Pat Gilmour. John Piper: 'Death in Venice': [review of the 1973 one-man exhibition at] Marlborough Graphics. *Arts Review*, 17 Nov. 1973, (vol.25, no.23), p.785.

543 A Piper tapestry for the Rothschild Intercontinental Bank [at 120 Moorgate – the Boardroom]. *Apollo*, Dec. 1973, (vol.98, no.142), p.522 (col. plate only).

1974

544 N. Arber. John Piper: [review of the 1974 one-man exhibition at the Portland Gallery, Manchester]. *Arts Review*, 8 Mar. 1974, (vol.26, no.5), p.115.

545 Barbara Wright. John Piper, Phyllis Morgans: [review of the 1974 one-man exhibition at] Buxton Mill Galleries. *Arts Review*, 19 Apr. 1974, (vol.26, no.8), p.214.

1975

546 Christopher Neve. A passion for places: John Piper's recent work, [on the occasion of the 1975 Marlborough Fine Art one-man exhibition]. *Country Life*, 25 Sept. 1975, (vol.158), pp.752–3.

547 Noel Barber. John Piper. (Art profile): [review of 1975 Marlborough one-man exhibition]. *Spectator*, 27 Sept. 1975, p.419.

548 William Packer. John Piper, Marlborough Fine Art: [review of 1975 one-man exhibition]. *Financial Times*, 2 Oct. 1975

549 Terence Mullaly. John Piper, 72, is better than ever: [review of 1975 Marlborough one-man exhibition]. *The Daily Telegraph*, 14 Oct. 1975.

550 Richard Shone. John Piper: [review of the 1975 one-man exhibition at] Marlborough Fine Art. *Arts Review*, 17 Oct. 1975, (vol.27, no.21), p.592.

551 Lavinia Learmont. [review of 1975 Marlborough Gallery one-man exhibition] *in* London. *Art and Artists*, Nov. 1975, (vol.10, no.8), p.50.

552 Keith Roberts. London: [including review of the 1975 Marlborough one-man exhibition] *in*, Current and forthcoming exhibitions. *Burlington Magazine*, Nov. 1975, (vol.117), p.751.

553 Rosalind Thuillier. John Piper: eye and camera: [review of the 1975 one-man exhibition at] Bohun Gallery, Henley-on-Thames. *Arts Review*, 28 Nov. 1975, (vol.27, no.24), p.694.

1976

554 Sarah Griffiths. War painting: a no-man's land between history and reportage. *Leeds Arts Calendar*, no.78, 1976, pp.24–32, (includes notes on Piper's 'M.O.W.T. vessel in dry dock at Fowey' p.30, and illus. p.26).

555 R.A.C. Cobbe. Examination of modern paintings: technical information received from artists. *Studies in Conservation*, vol.21, Feb. 1976, p.27.

556 Antonia Williams. The pied Pipers: [a visit to the Pipers' home]. *Vogue* (London), 15 Mar. 1976, pp.118–21.

557 Francis Watson. John Piper: [review of the 1976 one-man exhibition at] Marjorie Parr Gallery. *Arts Review*, 11 June 1976, (vol.28, no.12), p.295.

1977

558 Waldemar Januszczak. John Piper, Kendal: [review of 1977 one-man exhibition at Abbot Hall Gallery]. *The Guardian*, 9 July 1977, p.10.

559 Kenneth Loveland. Fishguard – Hoddinott's new work: 'What the old man does is always right', Fishguard Festival, July 27. *Opera*, Autumn 1977, Festival issue, pp.48–9.

560 Francis Watson. John Piper: [review of the 1977 Marlborough one-man exhibition]. *Arts Review*, 28 Oct. 1977, (vol.29, no.22), p.649.

561 James Burr. [review of the 1977 Marlborough one-man exhibition] *in* A real surrealist in London: Round the galleries. *Apollo*, Nov. 1977, (vol.106, no.189), p.422.

562 Roger Berthoud. The painter who loves working with others. *The Times*, 4 Nov. 1977, p13.

563 Paddy Kitchen. John Piper, Marlborough Fine Art: [review of 1977 one-man exhibition]. *The Times*, 8 Nov. 1977, p.11.

564 Malcolm Quantrill. [review of the 1977 Marlborough one-man exhibition] *in* London letter. *Art International*, Dec. 1977, (vol.21, no.6), pp.61–2.

565 Keith Roberts. London: [including a review of the 1977 Marlborough one-man exhibition] *in* Current and forthcoming exhibitions. *Burlington Magazine*, Dec. 1977, (vol.119), p.877.

1978

566 Bernard Denvir [review of 1978 Marlborough one-man exhibition] in London. *Art and Artists*, Jan. 1978, (vol.12, no.9), p.41.

567 Susumu Takiguchi. [John Piper: life and work]. *Japan Art News*, 1 Sept. 1978, p.8. (in Japanese).

568 Isabelle Anscombe. A Matisse to go round your neck: [Piper among artists designing scarf squares]. *The Times*, 16 Sept. 1978, p.10.

569 Rosalind Thuillier. John Piper: [review of the 1978 one-man exhibition at] Bohun Gallery, Henley-on-Thames. *Arts Review*, 24 Nov. 1978, (vol.30, no.23), p.649.

1979

Martina Margetts. A Piper portfolio. *Crafts*, Jan./Feb. 1979. *see* Interviews **(202)**

570 Rachel Billington. Painterly pleasures: [review of] 'John Piper' by Anthony West. *Financial Times*, 14 Apr. 1979, p.18.

571 William Feaver. Piper's many tunes: [the Tate Gallery firework display, and a review of the 1979 one-man exhibition at Oxford and Colchester]. *The Observer*, 10 June 1979, p.15.

572 Marina Vaizey. John Piper. Oxford Museum of Modern Art: [review of 1979 one-man exhibition]. *Arts Review*, 22 June 1979, (vol.31, no.12), pp.330–1.

573 Richard Ingrams: County Counsel: [the Shell guides]. *Sunday Telegraph Magazine*, 18 Nov. 1979, pp.17, 21.

1980

574 John Piper: [review of the 1980 one-man exhibition in the] Regimental Chapel, Manchester Cathedral. *Arts Review*, 7 Nov. 1980, (vol.32, no.22), p.518.

1981

575 Robert Medley. The Group Theatre 1932–39. *London Magazine*, Jan. 1981, (vol.20, no.10), pp.47–60.

576 John Piper's studios. *Studio International*, vol.195, no.991/2, 1981, pp.92–3.

577 Gervase Jackson-Stops. The Sitwell's Tuscan Castle: watercolours by John Piper: [on the occasion of the 1981 Maclean Gallery one-man exhibition]. *Country Life*, 29 Jan. 1981, (vol.169). pp.284, 287.

578 P[aul] A[tterbury]. John Piper: the Sitwell's Montegufoni: [review of the 1981 one-man exhibition at the Maclean Gallery] *in* The arts reviewed, Great Britain. *Connoisseur*, Feb. 1981, (vol.206, no.828), p.86.

579 Felix Pickering. Selling castles in the air: [review of the 1981 Maclean Gallery one-man exhibition]. *Times Literary Supplement*, 13 Feb. 1981, p.167.

580 Alan Blyth. Britten's inevitable relationship with the Pipers. *The Times*, 4 June 1981, p.13.

581 Peter Davey. Robinson College, Cambridge. *Architectural Review*, Aug. 1981, (vol.170), pp.83–7. Includes discussion and illustration of Piper's stained glass for the Chapel.

1982

582 Max Wykes-Joyce. [review of the 1982 one-man exhibition] John Piper ceramics, [at] Dan Klein Decorative Arts . . . in Exhibition reviews. *Art and Artists*, Nov. 1982, (no.194). p.31.

583 Michael Archer. A painter and his pots: John Piper's ceramics. *Country Life*, 2 Dec. 1982, (vol.172), pp.1834–5.

1983

Graham Hughes. John Piper, interviewed. *Arts Review Year Book*, 1983, *see* Interviews **(206)**

List of Lenders

The Friends of the Tate Gallery

The Friends of the Tate Gallery is a society which aims to help buy works of art that will enrich the collections of the Tate Gallery. It also aims to stimulate interest in all aspects of art.

Although the Tate has an annual purchase grant from the Treasury, this is far short of what is required, so subscriptions and donations from Friends of the Tate are urgently needed to enable the Gallery to improve the National Collection of British painting to 1900 and keep the Modern Collection of painting and sculpture up to date. Since 1958 the Society has raised well over £500,000 towards the purchase of an impressive list of works of art, and has also received a number of important works from individual donors for presentation to the Gallery.

The Friends are governed by a council – an independent body – although the Director of the Gallery is automatically a member. The Society is incorporated as a company limited by guarantee and recognised as a charity.

Advantages of membership include:

Special entry to the Gallery at times the public are not admitted. Free entry to, and invitations to private views of, paying exhibitions at the Gallery. Opportunities to attend lectures, private views at other galleries, films, parties, and of making visits in the United Kingdom and abroad organised by the Society. Use of the Reference Library in special circumstances. Tate Gallery publications, including greetings cards, etc. and art magazines at reduced prices. Use of the Members' Room in the Gallery.

A single membership includes husband and wife in all subscription categories*

Benefactor £1,500. Life membership.

Patron £150 or over annually. Five fully transferable guest cards.

Corporate £75 or over annually. Subscription for corporate bodies and companies. Two fully transferable guest cards.

Associate £40 or over annually. Two fully transferable guest cards.

Member £10.00 annually or £9.00 if a Deed of Covenant is signed.

Educational & Museum £8.00 annually or £7.00 if a Deed of Covenant is signed. For the staff of museums, public galleries and recognised educational bodies.

Young Friends £7.00 annually. For persons under 26.

*The rates quoted above were correct at time of going to press.

For further information apply to:

The Organising Secretary,
The Friends of the Tate Gallery,
Tate Gallery, Millbank, London SW1P 4RG,
Telephone: 01-834 2742 or 01-821 1313.